2/12

D1484880

Schnutt

WITHDRAWN

Encyclopedia of Sculpture Techniques

Encyclopedia of Sculpture Techniques

John W. Mills

BATSFORD

First published in 2001
First paperback edition published in 2005 by
Batsford
10 Southcombe Street
London W14 ORA

An Imprint of Anova Books Company Limited

ISBN 9780713489309

A CIP catalogue record for this book is available from the British Library.

15 14 13 12 11 10 09
10 9 8 7 6 5 4 3

Printed in Malaysia by Times

This book can be ordered direct from the publisher at the website:
www.anovabooks.com, or try your local bookshop.

Distributed in the United States and Canada by Sterling Publishing Co.,
387 Park Avenue South, New York, NY 10016, USA

Introduction 2001 edition

I am often asked my opinion of what is currently fashionable in sculpture in the art press, because what is frequently displayed today appears to be at variance with what I have expounded over the years. Writing this book, in its original form, 39 years ago, I extolled the virtue of a deep understanding of technique and processes as a liberating factor in the creative life of an artist; my view has not changed.

There appears to be an inverted attitude towards the value of skills in much of the praise of sculpture today. The current gallery art world seems to accept only innovation, the search for new ideas, as the most meaningful and true activity of the artist. This may be so, but the notion of 'new is best' is questionable when the innovative work is expressed in ephemeral materials, even detritus of varying kinds, requiring little or no personal skill from the sculptor.

However, 'ephemera' by their very nature rapidly come and go. Images achieved quickly and which are photogenic become fodder for media manipulation. The constant production and exposure of photographs and film of such fashionable work has a strong influence – it appears that easily expressed images offer the strongest attraction. They may also gain media coverage and repetition, which then runs the risk of becoming banal. Traditional skills are brushed off as being unnecessary and inhibiting.

A strong culture has a wide and stable foundation that provides reference against which to measure 'innovation' – an important factor in cultural growth – but it needs 'consolidation' to make progress. The same principle is reflected in the arts; the experimental leap into the dark can only be made from a stable footing. True innovation depends upon the skills that are the result of accumulative, consolidated knowledge, which affects and liberates the fertile mind.

Expressing oneself in response to the living world is a constant factor in the well-being of the human race – the purpose of the arts. It requires the ability to consider such factors as the suitability of image and material, stability and durability of construction, and interaction with other elements of the site.

Modern materials and their continuous development affect processes and influence techniques a great deal, but this does not alter the underlying need to acquire and understand the skills that lie at the heart of tradition.

John Mills, Hinxworth 2001

Introduction 1991 edition

This book is intended to help guide the novice sculptor towards a thorough knowledge of the practical aspects of his art. The greater the sculptor's knowledge and understanding of the materials and methods available to him, the freer and more confident he will be to use them to produce images that express just what he intends. A good idea should not be limited by a poor sense of technique; conversely, technique should not get in the way of the creative process by becoming more important than the image expressed; it is only the means to the end. The end should be a sculpture that fully represents the sculptor's ideas; he should be able to say, 'What you see before you is what I intended should be there'.

Studies of methods and materials should start early in training. In tandem, of course, with the encouragement of personal expression. Properly absorbed, the knowledge and experience thus gained will become almost instinctive. In this way the sculptor achieves an understanding of the interaction of ideas and technical processes. This enables the mature artist to transcend 'known' technique, thus enhancing the possibility of discovering personal, original imagery.

John Mills, Hinxworth

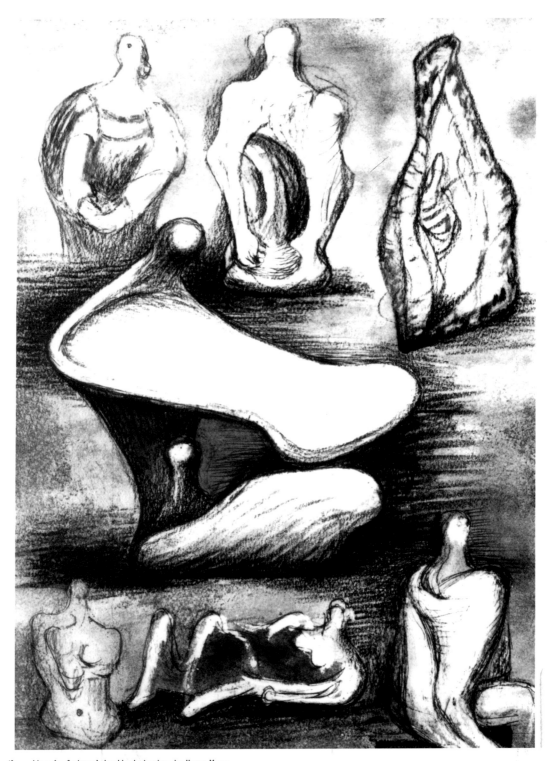

'Seven Ideas for Sculpture' sketchbook drawings by Henry Moore.

Tribute to Henry Moore

On the occasion of my last visit to the studio of Henry Moore, my companions and I were set the current studio conundrum. He told us he was working on a carving using a particularly beautiful and unusual stone given to him as a gift by the stoneyard he used in Pietrasanta. Moore said to me, 'Even you will not be able to identify it; I will be interested to know what you think it is'.

We were certainly not prepared for the stone which greeted us when we entered the studio. The sculpture, later entitled *Hollow Square With Points*, was in colour striations with pink, grey, red and some white veins, in a kind of Bargello configuration. It was quite lovely. Now I had recently visited some caves in the Ardèche, and I suddenly realized I was looking at none other than a stalagmite. Henry greeted my announcement with a long pause: I was the first to solve the riddle. Then, turning to me with a sparkle in his eye, he said, 'Tell it in your next book'.

And so, Henry, I have, and in so doing I acknowledge my gratitude to you, who, ever since our first meeting in 1958, were always so generous with your time and encouragement.

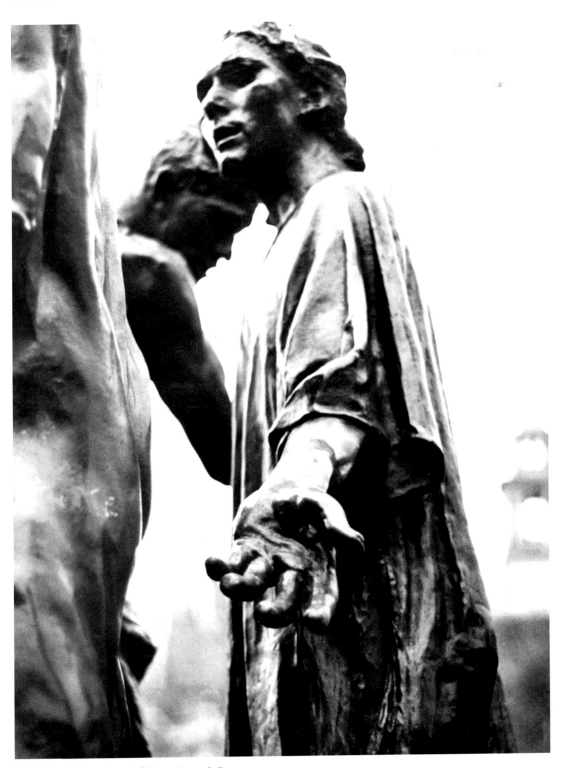

A detail from *The Burghers of Calais* by Auguste Rodin.

ACCELERATORS

The chemicals added to resins to speed up the hardening process. Sometimes known as promoters, these chemicals control the speed of the crosslinking (polymerization) as the liquid changes to a solid. Accelerators allow the sculptor a degree of control over the hardening process.

ACCIDENTAL FORM

This is the form that results from the natural characteristics of a material such as: the quick setting qualities of plaster of Paris; the sort of surface that results from hot metal cutting; the surfaces that make 'found objects' often so interesting; and so on. In sculpture such accidental forms can be seductive, corresponding in kind and impression to the ragged edges of fragments, providing room for the viewer's own imagination and the sculptor's freedom of expression. However, if the volume or area of accidental form is greater than the deliberate and intended form and surface, made by the sculptor's handling of the materials, the image can be weakened – overcome by the stronger identity of the material. A proper balance of these elements is desirable.

Elisabeth Frink's work at its best contains such a balance. This principle applies very much to assemblage sculpture: if the identity of the objects used is greater than that of the image made, the sculpture is suspect. George Fullard's sculptures are fine examples of how an image can transcend the nature of the diverse materials used to make it (see also illustration on page 26).

ACIDS
(*see* **Patina, Patination**)

A wide range of acids is used in the manufacture of sculpture; some are inherent in the material used to produce the sculpture. For instance dibasic acid reacting with glycol is the basis of polyester resin. Mostly, acids are used to make formulas to provide cleaning agents or liquids to etch a surface, or to colour it. For instance acetic acid in a 5 per cent solution with water will retard the setting time of plaster of Paris; it can also be used to turn copper and bronze green. Nitric acid in a 10 per cent solution with water can be used to etch or pickle and, therefore, clean a bronze casting – it removes firescale from bronze and silver. Mild steel dissolved in nitric acid to form a saturated solution makes a useful home brew of ferric nitrate: if copper is used instead of mild steel, the resulting solution is cupric nitrate and both liquids are useful colouring agents for bronze and copper.

ACRYLIC RESINS
(*see* **Perspex, Plastics, Plexiglass, Vacuum Forming**)

Polymethyl methacrylate, acrylic resin, is a very beautiful material. It is the most transparent of all resins, even better than those polyesters that have been improved to make quality embedding resins that require good transparency. Acrylics are manufactured in a wide range of colours; over fifty are readily available in sheet form of varying thickness, and in block form, either specially cast by the manufacturer, or laminated to a required thickness. It is made in extrusions of various kinds, making tubes, pipes and rods of varying size and section, and it can be purchased as glue lacquer and as a painting medium.

In its liquid state acrylic is most commonly used as an adhesive to attach acrylic sheets. It is a complex resin to cast, requiring sophisticated equipment and techniques usually prohibitive to the sculpture studio. However, manufacturers can be approached to help produce large cast items. The costs are high but the results have a unique beauty.

One of the characteristics of acrylic is the effect of 'light piping', that is the transmission of light

through the sheet from edge to edge, with little or no loss no matter how complex the section. In complicated assemblages this characteristic can be exploited to great effect.

Acrylic is thermoplastic and can be bent and formed with heat, so therefore it can be vacuum formed. It can be easily sawn, cut and tapped. It can be highly polished but its main failing is its vulnerability to scratching and damage by a wide variety of everyday fluids. The various cleaning fluids, such as acetone, methylated spirit (denatured alcohol), petrol (gasoline) and so on, will make the surface milky opaque and ruin its prime effect. Despite this, acrylics are weather resistant and serve well as signs, windows and lenses, so therefore can be used by sculptors in similar form.

ADHESIVES (GLUES)

Glues made from starch or from rendered-down animal products were the stalwarts of all studios, used in a wide range of gluing jobs on wood and paper until World War II, when the need was identified for a quick-acting, tough adhesive, able to maintain its strength under stress, for use in the construction of wood-framed aircraft. Since then further developments in the aerospace industry have added to the number of adhesives now on the market. It would require a special publication to try to list all the glues now manufactured and to give their appropriate applications, from those used to lock nuts and bolts together temporarily, to those used to fix various aircraft components together permanently. I am, therefore, only indicating here some basic adhesives that are widely available and of real use in the sculptor's studio. Seek advice from the manufacturers as to the most suitable adhesive for any particular project, taking into consideration the methods and materials you want to use.

Paste glues made from starch and water

Glues made from flour, corn or potato starch by adding water to make a paste, are the most basic. They are useful for making papier mâché, and for gluing paper and cardboard.

Egg-white

This can also be used as an adhesive for paper by simply applying it to one surface and pressing another to it. A very tight bond is achieved when the egg-white has dried.

Glues made from animal products

Probably among the most difficult to find today. They are the most traditional and oldest adhesives, made by rendering down bones or skins (or both) of animals and fish. These glues are purchased in lump, flake or sheet form and made liquid in a porringer. They are mainly used on wood. Some craftsmen still prefer to use them on fine joinery and marquetry because they claim that they are more sympathetic to the movement of the wood during the life of the item as conditions change.

Shellac

Can be used as an adhesive, with the advantage that, once hard, it can be softened by the application of gentle heat which allows for relocation of pieces. Shellac is used widely in marquetry, and is the basis for most dry mounting tissue. It should not be used on fine paper works.

Casein glue

An alkaline, made from chemically treated milk curd. It is purchased in powder form that, when mixed with water, makes a very strong adhesive with good resistance to dry heat and moisture. Being an alkali it will stain some blond woods.

Urea-formaldehyde

A glue developed for the construction of wooden aircraft frames. It can hold joints that are to be placed under stress and strain, and is therefore very useful for making bent-wood laminations. It will not stain the wood.

Phenol and resorcinol formaldehyde

Provide glues that are very strong indeed and not affected by adverse atmospheric conditions; such glues can even resist boiling water. These are the kinds of adhesives to use on wooden sculptures to be placed in the open air. The glues may even prove to be longer lasting than the pieces of timber they are employed to glue, unless these are made suitably weather resistant with paint, oil or varnish.

Polyvinyl acetate (PVA)

Another studio workhorse, and among its many uses is as an adhesive. Purchased ready for use, it can be employed to glue timber, card and some plastics. It is also manufactured especially as a proprietary wood glue and can be found in a number of variations, e.g. fast-curing, waterproof when cured, etc.

Epoxy resins

Form the basis of a very large range of proprietary adhesives, and can be used to glue most materials to each other or one to another, e.g. glass to glass, glass to wood, wood to concrete, etc. It is made to suit various applications and materials, and can be purchased as a five-minute curing glue, a metal filler glue of all kinds, a glue with a wood filler; it can even be bought in strip form to be blended with a catalyst to make a dough, suitable for gluing, filling and building up. Glues made from epoxies are the ideal adhesives for those engaged in assemblage and for gluing mixed media.

Cyanoacrylates

The glues marketed as 'super' glues. These work by extracting the faint traces of moisture from the materials brought together to be glued. They were developed for gluing rubber, but it was found that they could be used to glue various different materials. They work quickly and depend largely on the close contact of surface areas.

The use of all glues depends upon the close fit of the surfaces to be stuck together. It is worth spending time making a well-tailored joint before gluing it; in this way you will achieve the strongest possible join. Some glues, notably PVA, epoxies and the formaldehydes, allow the mixing of sawdust or some other filler, to enable holes and cracks to be filled; but this should not be done to compensate for poor joinery!

AGGREGATES

Inert materials mixed with a binder to form a stable solid. A binder can be any material that changes from liquid to solid – plaster, cement, wax or resin. In the case of cements, the aggregate is of great importance. The strength of the resulting mortar or concrete depends upon the nature and size of the material chosen as the aggregate. The ratio of binder (cement) to aggregate is determined by the surface area of the particles of material, i.e. the smaller the particles, the greater the surface to be stuck; smaller particles touch in a greater number of places, therefore more binder is required to make a satisfactory solid.

Most cast concrete sculptures, requiring a faithful reproduction of the original clay surface, will need a fine aggregate, equal almost in mesh size to that of the cement binder, resulting in a mix ratio of 1–1. Concrete mixes, devised for greater compressive strength, will use coarser aggregates sometimes up to 19mm (¾in), resulting in ratios of as much as 1–6.

Generally, aggregates are added to provide bulk and sometimes colour as well. Moreover, refractory materials used as aggregates with plaster or cement provide solids capable of withstanding high temperatures, and so can be used to build furnaces and kilns, and to make investment materials, necessary to metal casting.

AGGREGATE TRANSFER

In conjunction with the use of expanded polystyrene or polyurethane on shuttering, it can provide attractive possibilities. Selected aggregates, placed by hand, are glued to the shuttering or mould surface using water-soluble glue. The

Dionysos in marble, from the Atheneum Acropolis. *The British Museum, London.*

concrete, when poured, compacted, set and hardened, picks up the aggregate, transferring it from the shuttering panels. When the shuttering or mould is removed, water is used first, to dissolve the adhesive. Various items, motifs of various materials – non-ferrous metals, resins, glass, ceramic, mosaic, enamel – can be integrated into a design by this transfer technique.

Most exposed aggregate techniques are devised to remove the 'fines' (the fine particles of concrete that fill the interstices) from the surface. Brushing and washing is done before the concrete hardens. Some tooling is done at this stage too (e.g. combing and scraping). Grinding and polishing, and blasting with sand or shot, is done at a prescribed time during hardening, according to the kind of cement used.

ALABASTER

A dense, translucent, fine-grained calcite. This stone is easily carved but care must be taken to prevent stunning (bruising the stone) which will result in white, opaque marks in the stone, penetrating, according to the force used, up to 25mm (1in) in depth. Avoid the use of punches and bouchards on unspoilt alabaster. Already bruised alabaster can be boiled in water to make the whole stone opaque and uniform in colour, size of course dictating whether this is possible.

ALLOYS

Mixed metals. To produce non-ferrous metals suitable for casting, particularly bronze, other metals are added. They provide the basic metal, copper, with greater fluidity and hardness, in varying degrees according to the proportions used. Tin, zinc and lead, when added to copper in the proportion of 85 per cent copper to 5 per cent each of tin, zinc and lead (85–5–5–5), produce the alloy known as admiralty standard bronze, gunmetal, or navy bronze. Other mixes provide other alloys; there is a great range of possibilities from which to choose according to the object to be cast and its application.

Gold and silver have been used in particular bronze alloys, apparently imbuing the cast object with noble properties, commensurate with the nobility of the gold or silver. Alloys using aluminium as a base are almost too numerous to list. Alloyed with bronze in the formula it produces a very hard metal capable of retaining a bright polish.

ALUMINIUM

A modern metal gained from bauxite, and much favoured, after bronze, for sculpture. This metal, like all the others, is produced industrially in a wide range of alloys to suit an almost infinite range of

Turning Woman by Ralph Brown, bronze, 1960.

applications. Often their colour and physical properties vary little, and so their interest to sculptors is limited. Sculpture needs structural strength relative to volume, durability, resistance to atmospheric corrosion, ease of casting, ease of forming, density of surface, good natural colour and the ability to take a patina.

ARC WELDING

An alternative to oxy-acetylene welding that, because it uses an electrical appliance without gas, can offer certain advantages. Housing bottles of gas, for instance, can sometimes be a problem. It is also a cleaner process than gas welding.

Geoffrey Clarke sculpture cast in aluminium. The original was cut from polystyrene (Styrofoam).

A simple explanation of the principle of electric welding is as follows: an electric current passing through an electrode (which is usually also the filler rod) touches the parent metals to be joined, creating an arc which melts the metal at the point of contact. Filler rod is fed into the molten metal to make the weld. The heat generation is very quick and local. No pre-heating is required which makes it possible to weld sheet metal without distortion. The local heating characteristic of electric arc welding makes it possible, with the right power, to weld heavy sections of metal quickly without the need for extended pre-heating required with oxy-acetylene.

The basic equipment for arc welding is the appliance which transforms an electric current to the necessary voltage output required to create the arc. From the appliance run two leads, one for the electrode holder (positive lead) and one for an earth/the ground clamp. The holder grips the

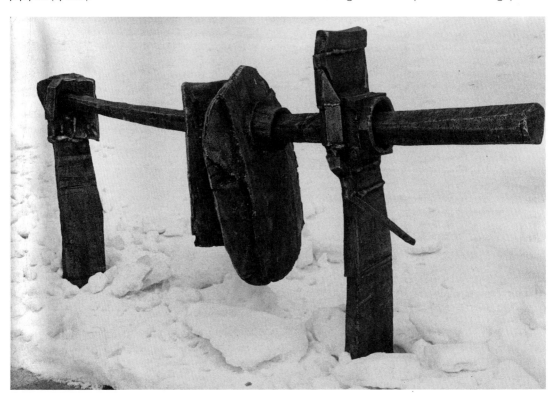

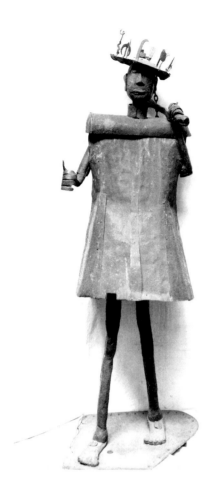

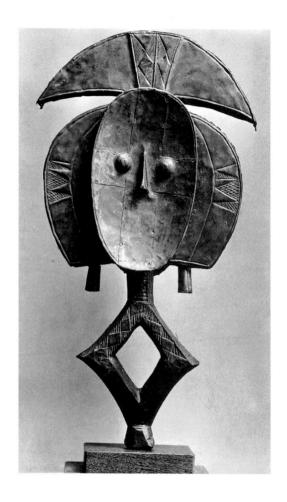

African God of War sculpture by the Ebo.

African fetish figure of 'Bakotas' made from copper and wood. Of Congo origin.

specially flux-coated welding rod (or electrode) and passes the current from the transformer to the tip of the welding rod. The parent metals to be welded must be earthed. Slag is formed at the arc weld, caused by the flux of the electrode. This has to be chipped away with a special hammer before further welding can be done. This hammer can also be used to clear the slag from the edges of metal which has been cut with a cutting torch.

The light which comes from the electric arc is extremely intense, more intense than that from an oxy-acetylene flame, so a special mask of very thick, very dark glass is necessary. This mask covers the whole face and head to protect it from the arc light, which can burn. Protective clothing is also required because of this heat, and leather gloves are worn to protect the hands and arms.

If other people are in the same work area, they must be shielded from the glare of the arc with suitable curtains or screens, remembering that the glare can bounce off glass, and such reflected light is just as dangerous.

With simple electric arc welding the technique differs from gas welding in that the heat source and the filler rod are one and the same. A transformer is the basis of all arc welding equipment and in its various forms it can deliver current of the correct kind for the type of welding required. Controls on the appliance permit the current and its intensity to be adjusted. Transformers delivering AC (alternating current) or DC (direct current) are available, but for the sculptor, usually working with disparate metals, a combined AC/DC welder is a better choice. From the transformer run two heavy-duty, sheathed cables; one ends with an earth (the ground) clamp, the other with the electrode holder. The earthing/grounding clamp is attached to the metal to be welded, the appliance is turned on and the electrode put over the spot to be welded.

The electrode, being the filler rod also, has been selected according to the metal being welded. The face mask is lowered over the eyes at this point, creating a blackout: because of the intensity of the arc light it must be struck in the dark. The electrode is carefully scratched over the surface of the metal and immediately lifted to achieve and maintain an arc. If the electrode is lifted too far, the arc will go out; if left too low, the electrode will stick to the work. Practice quickly makes the sculptor adept at striking the arc, and once struck the light is bright enough to see the work clearly and to make the weld.

On thin gauge metal the bead can be run in one pass along the join. On thicker sections the arc should weave to give adequate cover and fill the weld correctly with just the right amount of heat penetration so as to avoid burning the metal. On very thick sections several passes will be necessary, chipping away the slag left by the flux after each run.

Because of the heavy coating of slag which has to be removed by hammering, some sculptors consider electric welding a less refined method than gas welding. Use of the crude chipping hammer certainly can't be avoided: it is impossible to weld over the coating of slag. Moreover, simple electric welding is not very satisfactory on non-ferrous metals and stainless steel so, during World War II, research into making high-quality welds on these metals was carried out and resulted in the development of heliarc welding. This involves using an inert gas such as helium or argon to shield the weld from atmospheric effect, thus obviating the need for fluxes.

TIG (tungsten-inert-gas) and MIG (metal-inert-gas) welding are the two principal kinds of welding that arrived in studios as a result of this research.

RIGHT Armatures made to support clay, which can be made to any size.
1. *An armature fixed to a back iron.*
2. *A free-standing armature (self-supporting).*
A *Butterflies made from wire and wooden lath. Many of these will be needed to support synthetic clay.*
B *Malleable armature wire, usually of aluminium.*
C *The attachment at the back iron is best made at the lower torso.*
D *Wooden, cork or polyester filling, to take up the bulk of the form. Used on all large volumes on both kinds of armature.*
E *Malleable armature wire, copper wire or thick galvanized wire provides the most useful support for fingers.*
F *Wire bound loosely around the armature prevents clay slipping down; this must be securely attached to the top of the mark.*
G *Wooden laths attached to the armature help to give rigidity as moisture is taken up causing the lath to swell.*
H *Turn the ends of the malleable armature wire to prevent the figure breaking at the ankle as it is modelled.*
I *The best method for fixing the self-supporting iron of the free-standing armature.*
J *Make sure the work is standing on a substantial base board because it may stand for a long time.*

TIG in particular has taken a major role in the recent developments in foundry practice. Welded joints on bronze and aluminium castings are now the norm.

TIG welding

Uses a tungsten electrode to make the arc. A non-consumable electrode, in this case held in an insulated torch which provides an outlet for the inert gas to be delivered as the arc, is struck. Today this gas is usually argon and it shields the molten metal, preventing oxygen from getting to the weld, so that you end up with a very clean, fluid welding bead. The filler rod is fed in by hand, and, once the arc has been struck, the work positions of torch and filler rod are much the same as with oxy-acetylene.

MIG welding

Much the same as TIG but the electrode is consumable and is in the form of a roll of filler wire which feeds the weld automatically, making long, uninterrupted welds possible. Both appliances are water-cooled and relatively expensive. If a studio is to be equipped for only one kind of electric welding the TIG welder will prove the most versatile, especially if the appliance combines AC and DC and is capable of delivering 300–500 amps. Cutting heads can be supplied to fit such equipment, giving heliarc the virtues of both gas and electric welding.

The comparative ease of electric welding can be deceptive in the learning process, and to my mind welding techniques are best learnt using oxy-acetylene. The logic of the application of heat and the choice and use of fluxes, the characteristics of metals as they show themselves during welding, are more easily understood with the slower gas techniques, and can be assimilated more readily and thoroughly.

Mild steel can be welded without flux, but all other metals require the use of such cover according to their alloy. Manufacturers' advice should be sought, especially if you are intending to join, by welding or brazing, dissimilar metals. The range of fluxes now available makes it possible to combine a wide range of metals, for instance copper alloys with aluminium, using the correct flux.

To describe the different characteristics of metals as they are welded provides very interesting reading, and there are tomes devoted entirely to this subject. However, it is wiser to seek other professionals' advice and instruction to add to your own knowledge and experience.

The secret of welded sculpture, and the construction of welded sculpture, is in the jigging, or placing of component parts in the most favourable position for welding or brazing. Random welding (simply sticking one piece of metal to another and having done so reheating and fashioning this into some semblance of an image) does not very often pay dividends, whereas a successful sculpture will be intelligently and sensibly planned and constructed. This means that pieces are cut to fit, and edges are cleaned well enough at least to make a secure bond by welding. The sculpture will then appear to grow into existence.

ARMATURE (SUPPORT)

Refers to the internal support constructed to give a sculpture tensile strength, rather like the skeleton in human and animal forms. The armature is designed according to the nature of the material it is to support or reinforce. Most substances have only compressive strength – they can be piled up, but not stretched, without support. Knowledge of the characteristics of the material to be strengthened is important, but each

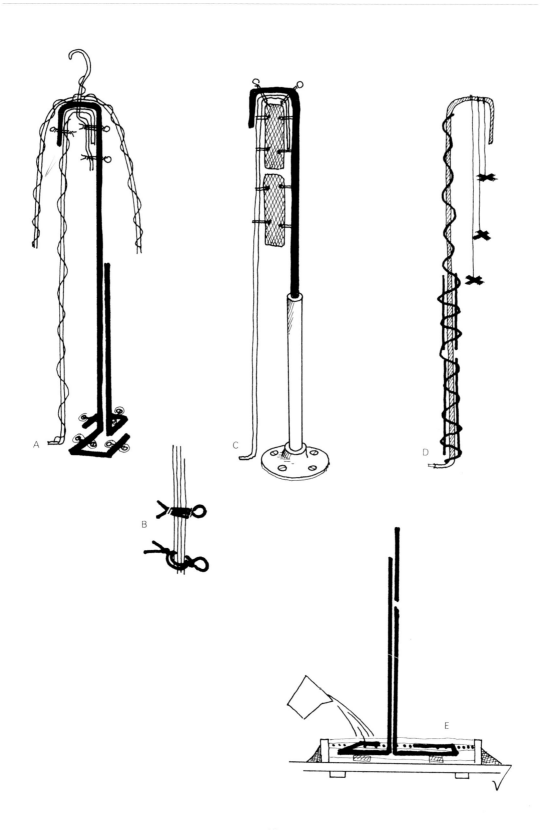

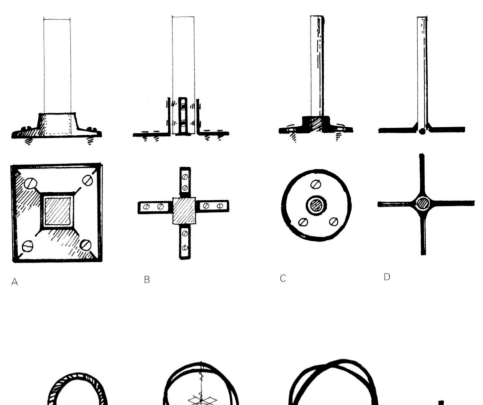

A B C D

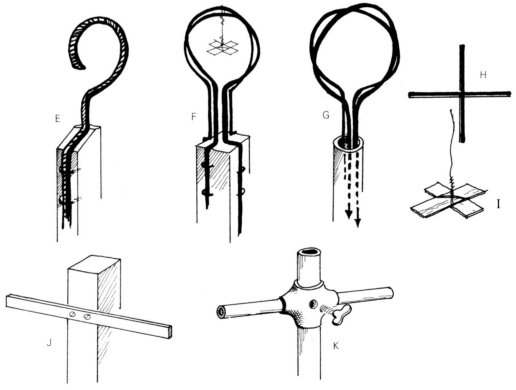

E F G H

I

J K

Page 19
A A free-standing armature.
B A wire tourniquet, the strongest use of binding wire.
C A free-standing armature made using threaded gas piping and a base flange.
D Malleable wire attached to a free-standing support, together with butterflies to support the bulk.
E A method of fixing a free-standing armature support in a plaster of Paris base, useful for clay or plaster direct.

Page 20
A A manufactured head peg, with a wooden peg bolted through a cast metal flange.
B A variation on the traditional head peg, made up using four metal brackets to give support.
C A threaded gas pipe and base flange head peg.
D A variation of C with metal rods welded to the bottom of the tube to give support, which can be used without a base board.
E A Victorian armature of lead attached to the head peg.
F An armature of lead or malleable aluminium, which can be stapled to a wooden head peg.
G A tube that allows the armature to be simply inserted deep to provide adequate support.
H The plan of the two loops of armature wire.
I A butterfly support made from a wooden lath and wire that can be hung inside the head armature to give greater support to the weight of clay (essential on larger volumes).
J A cross member for modelling shoulders nailed to a wooden head peg.
K A shoulder support made from piping.

Page 22
Some supports for armatures
A and B Head pegs made from threaded gas pipe with a base flange secured to a strong base board. The cross member caters for a full torso (bust).
C and D A variation on the traditional back iron support made from threaded gas piping. This can be made to almost any size but must always be bolted right through any strong base board.
E The traditional back iron.
F A large back iron capable of supporting a life-size figure. These traditional forms are made to cater for all sizes but most commonly are made to $^1/_4$ $^1/_2$ $^2/_3$ and fully life-size.

project will carry with it unique design requirements, so only a general description can be given here.

Supporting clay

For modelling clay, an armature that is both secure and stable is needed, taking into consideration the weight of clay. A life-size figure in clay will weigh approximately 50 per cent more than its human counterpart. The construction of the armature must also allow for easy dismantling to remove the clay and its support from the plaster mould during the casting process. Avoid welded armatures if possible.

The increasing use of synthetic clays has affected the kinds of armature required. Water-based clay allows a certain latitude in the design and building of the armature. If wood is introduced into its construction, for instance, water from the clay will cause the wood to swell and tighten on to the metal support, but with synthetic clay this will not happen. The armature consequently has to be much stronger and to include more butterfly suspension (see diagram p.19 (I)) to support this inert, non-changing material.

Supporting other materials

Unlike clay, plaster of Paris, cements and resins are all brittle when hard and so require additives to reinforce them as well as needing stable, strong armatures. The strongest possible armature should be designed and constructed, permitting the full exploitation of the material. Remember that working directly with these substances encourages a combination of the modelling and carving processes – the support must therefore cater for this. Jute scrim (burlap), for instance, when added to plaster gives greater strength and a degree of flexibility and also helps secure the plaster to its support. Additives such as sawdust, wood-wool,

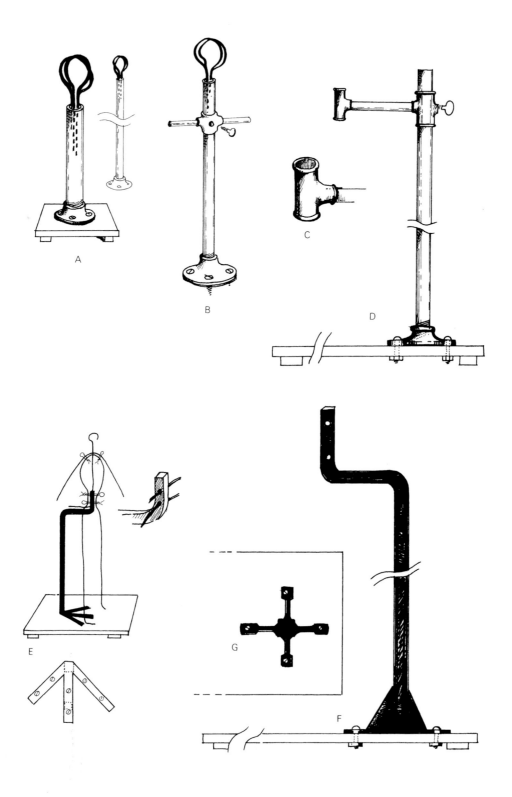

A

B

C

D

E

F

G

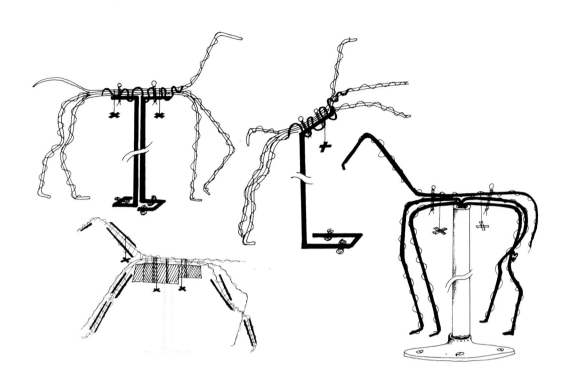

Armatures for animal sculptures.

fibreglass, newspaper, vermiculite, polystyrene (Styrofoam) can all be used with these basic binders to help build bulk, lighten the load and allow the exploitation of texture. They generally enhance the workability of the material and allow for its free working about the armature, thus leading to a high degree of freedom for the sculptor to explore particular images and forms.

. I have illustrated some basic armature constructions, to be used only as a guide showing the principles of manufacture common to all armatures and to safe working.

ASSEMBLAGE

The term given to sculpture made by assembling objects to make a three-dimensional image. Many sculptors practise this art form, and the range of materials assembled can be bewildering; the only limitation is in how successfully the assemblage is made. The most successful assemblages are those in which the image achieved transcends the identity of the objects used (see page 25). Skill in joining the various items collected together will help to this end. Welding, brazing and soldering are methods often employed in assemblage, but they are limited to fixing metal to metal. Disparate and dissimilar materials require a greater knowledge and research into all manner of fastening from joinery, through an understanding of adhesives, to a knowledge of industrial fastenings such as bolts, screws and nails of various kinds. Time spent investigating such methods will be time well spent.

AUGER

A corkscrew-shaped boring tool, of varying length and diameter, designed to pull itself through wood and to remove waste material cleanly. It is used to

bore long holes through timber and is often used to drill through the heartwood of a log to prevent cracking as the log seasons, dries and shrinks.

AUGER BITS

Corkscrew-shaped drill bits for use with either a brace or a power drill. They serve the same function as an auger.

BAT

The name given to a slab of porous material used as a surface on which to prepare clay. These are most commonly made of plaster of Paris but marble, stone or concrete can also be used. Very wet clay is laid out on the bat to air dry, and to dry by losing moisture into the porous material of the bat itself. When the clay has reached the desired consistency, it is pounded (wedged) on the bat, in preparation for modelling, etc.

BONDED
(GLASS, BRONZE, ALUMINIUM, MARBLE, ETC.)

This is the description preferred in the USA for items that are made using resin and named fillers. Particles of the filler are effectively bonded by whatever resin is used to make a solid; glass fibre can be included in the mix. The misleading description 'cold cast bronze', too often used, should be avoided as it falls foul of the UK's Trades Descriptions Act.

BOZZETTO
(*see* Maquette, Sketch Model)

This is the Italian name for sketch model. It is not as commonly used, in the English-speaking world, as the French word *maquette*. However, it is used widely in the discussion and appraisal of Italian sculpture and has the advantage of both singular (*bozzetto*) and plural (*bozzetti*) usage.

BRONZE

Speculation regarding the discovery of molten metal, leading to the mixture of various metals to form alloys, can be a romantic game. Imagine the wonder of a man who, upon raking a hot fire, finds a shiny hot liquid, and his greater wonder when, having cooled, this liquid becomes as hard as the hardest stone. Of the basic metals we know today those that readily presented themselves to prehistoric man were lead, tin, copper, zinc, silver and gold.

In the Bronze Age, copper was the most abundant metal and, when mixed with a small amount of tin, gave birth to the alloy we know as bronze. Bronze (90 parts copper to 10 parts tin) is a non-ferrous metal (without iron), thus having a good resistance to atmospheric corrosion and being relatively easy to handle. It is probably the most widely used metal in sculpture and has been so through the ages.

There is now a whole range of metals and elements that can be mixed to make non-ferrous alloys, and although most metals can be used in their

Name	copper	tin	lead	zinc	silicon	iron	manganese
				(measured in per cent)			
Leaded bronze LG2 (gunmetal navy bronze, statuary bronze)	85	5	5	3			
Leaded bronze LG3 (architectural bronze)	86	7	2	5			
Silicon bronze (herculoy)	91			4	5		
Silicon bronze	96				3		1
Coinage bronze	95	4		1			
Manganese bronze	58			40		2	

Sitting Watchers I by Lyn Chadwick, bronze, 1975.

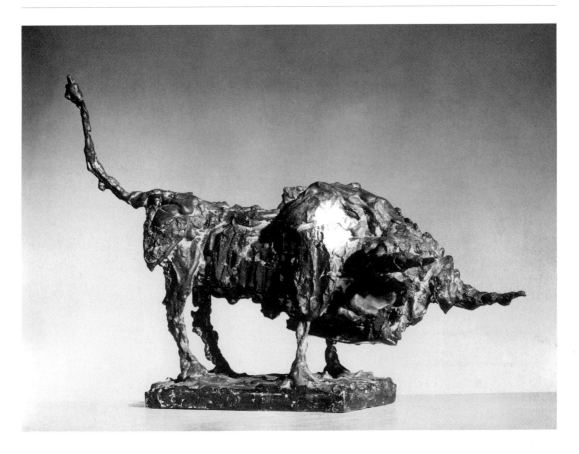

Sketch for The Bull by Robert Clatworthy, bronze, 1958. Tate Britain Collection.

pure state, mixing (blending/smelting) them offers greater control over their individual peculiarities to make working them easier.

Pure bronze is rarely used: industry, for various reasons and applications, has evolved a range of copper alloys, referred to as bronze or 'yellow metals'. The chart on page 24 describes some of those bronzes most commonly used by sculptors.

For a long time the skills required by the art bronze foundryman were shrouded in mystery. This may have been deliberate, and was perhaps necessary to protect the craftsmen and safeguard their work. It is not necessary today. The art bronze foundry Morris Singer (one of the eight largest in

the world) remarked that it is better from their point of view that clients should know what happens within the foundry walls. Casting, chasing and patination must receive informed criticism from clients if a high standard of work is to be maintained.

Contemporary techniques are refined to a point of absolute fidelity to the original work. Indeed, the excellence of surface reproduction on the Benin bronzes that so distinguishes them is now almost routinely possible. Auguste Rodin, Michelangelo's equal in clay and bronze, expected faithful reproduction of every detail on all castings. The Benin castings were produced in primitive conditions, Rodin's in sophisticated foundries developed in Europe since the Industrial Revolution. This standard is now referred to as 'fingerprint quality', meaning that even the artist's fingerprints are

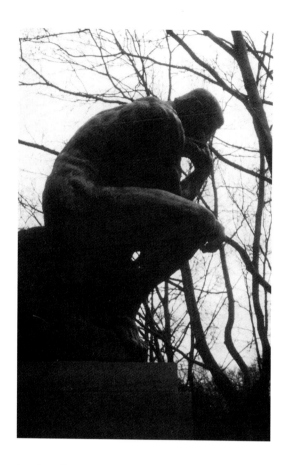

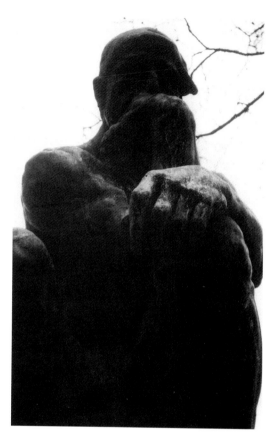

A casting of *The Thinker* by Auguste Rodin in Philadelphia.

Another casting of *The Thinker,* showing a heavy-weathered patina.

transferred from the original. Perhaps Michelangelo, who expressed an extreme dislike for bronze, would have regarded it more favourably had he enjoyed this high level of reproduction, without the months and months of labour chasing the metal casting to gain any quality at all. The development of flexible moulding materials and fine investments has contributed to high-fidelity surface reproduction.

What happens between delivering the original (master cast) to the foundry and receiving back the final bronze still, however, remains a mystery to many a sculptor. This has been partly instrumental in the rise of foundry prices for art bronze. Ridiculous

comments by ill-informed clients, expecting more than is possible, recasting because of ignorant complaints, have made more work and so pushed the inevitable contingency cost per cast sky-high. This high cost has prompted many sculptors to turn to other materials and to produce their own bronze castings. The cycle may perhaps be completed by these sculptors teaching in art colleges and schools of sculpture, from which a better informed clientele will emerge to use the large-scale foundries in the future.

By setting up what have come to be known as 'backyard foundries' to make their own castings sculptors have not only indirectly helped maintain

general standards in commercial and non-commercial foundries, but have re-established the need in the individual for real skills and wide knowledge of technical processes. This is the sort of knowledge which contributed to great works of art in the past.

BUST
(*see* **Portrait Head**)

Portrait sculpture that includes any form below the neck is referred to as a 'bust'. This form of portrait usually finishes just below the chest but can include features as low down the figure as the knees; more than this and the work is a portrait figure.

CARVING

The act of cutting away waste material to reveal an image contained within the block.

Carving banker

A sturdy structure, usually made of timber, capable of carrying the weight of selected stone or wood and able to stand up to the wear and tear of the carving process. Bankers often have a turntable top that enables the sculptor to rotate the work so as to resolve the work in all its views (see diagram opposite).

CAST

The positive form that has been produced via the moulding/casting process.

CASTING

The act of filling a mould (negative) with a material that will harden to take and exactly reproduce the volume and surface detail of the mould.

Castings are either solid or hollow. Large works should be cast hollow but small forms, where weight is of little consequence, can be cast solid; a hollow form, however, has the greater strength. Moulds should be designed to cater for

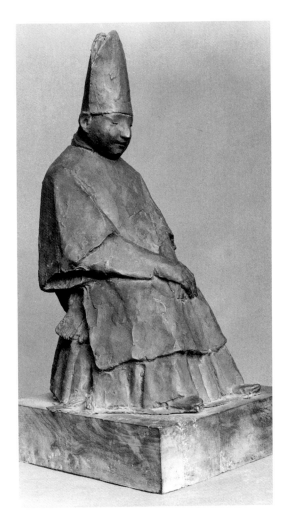

Cardinal by Giacomo Manzu, bronze, 1947. It was modelled direct in wax for *cire perdue* casting.

either of these solutions, as well as to suit the casting material used. These materials fall into two categories, those that can be poured to fill a mould and those that are packed or painted to a mould surface to make a hollow casting. Moulds from which hollow casts are made differ from those that are simply turned upside down and filled with the casting medium in that the entire mould surface needs to be accessible to apply the filling.

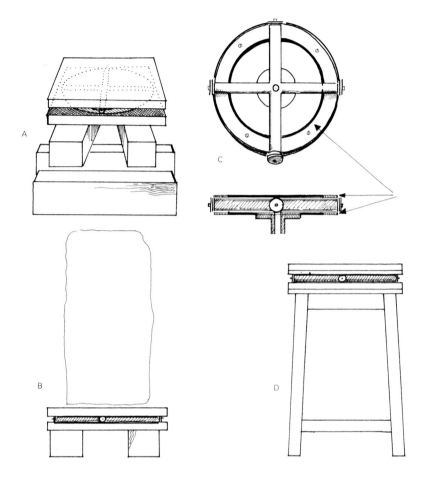

A A turntable banker mounted on balks of timber, easily adjusted to a safe working height. This is usually used to accommodate large blocks (B).

C A spider, or fifth wheel, which is the turn mechanism. This is made to function under great weight.

D A typical banker with turntable top, an essential piece of equipment.

Casting with clay

Castings of clay to be fired can be made from plaster of Paris piece moulds. Indeed, most normal household crockery is made by casting with clay from such a mould. There are two basic methods.

The first and oldest method is the technique of pressing clay by hand into a plaster piece mould. The clay must be of good quality and even in consistency. It is used to build up, by pressing, an evenly distributed thickness over the mould surface. This technique has been used for many centuries; indeed, there are examples of press-mould casting from almost every

culture. In the British Museum those from Mesopotamia must be among the earliest examples. Most good archaeological museums will have examples of products made using this technique, and a study of such examples will prove valuable. The mould for very simple things can easily be made of fired clay; in the past they often were.

The second method is to use a liquid clay (slip) which is poured into the prepared mould, filling it. The porous mould sucks moisture from the clay slip, causing a deposit of clay to be evenly distributed on the mould surface. The longer the mould stands filled with slip, the thicker the deposit of clay will be. When the required thickness has been deposited the remaining liquid is poured off.

For press moulding the mould must be open-ended, to allow the hand access for pressing the clay and for closing the seams also, to consolidate the clay thickness. An opening is also necessary for pouring the liquid clay into and out of the mould when this second method is used.

Press moulding

The preparation of the mould is important. It should be bone dry and lightly dusted with French chalk or talcum powder. Do not allow the dust to build up in any hollows in the mould; an air line or old-fashioned fire bellows are useful to blow off excess dust.

Prepare enough clay to complete the job in hand. Wedge or knead it to an even consistency and colour, making sure it is free from lumps, air pockets and any foreign matter. It should be very plastic but not sticky to handle.

Select the mould or pieces of mould to be filled first. An open dish mould can, of course, be filled in one operation. A mould with two or more pieces should be tackled by filling the main mould or larger pieces first.

Press into the middle of the mould, or piece of mould, a wedge of clay. Press it out in all directions.

Add another wedge of clay to the first (it is important to add clay to clay and not to add the new wedge *beside* the clay already on the mould) and again press outwards in all directions. Similarly, with more wedges of clay, press and spread outwards until the mould is covered evenly over its whole surface. French chalk from the mould surface should not be allowed to get between the applications of clay. If it does, it will form a barrier and prevent adhesion of clay to clay. Complete the pressing, filling up to the seam edges. Complete the next piece or pieces of mould in the same way.

If the cast requires strengthening, place ribs of clay to provide this. They should be placed during the build-up. A honeycomb or cellular structure is the most suitable for clay forms, affording maximum strength. The amount of cellular support depends upon the volume of the form, and consequently on the area of surface to be supported.

Place completed caps (see page 35) to the main mould, first wetting the clay at the seams to make a better adhesion. Fill the seam and strengthen from inside the form. Place and fill the seams of each cap in the order necessary to complete the form. When placed to the main mould the caps must be secured (see diagram page 35).

Having completed the filling, stand the mould upright, if possible on an open shelf upon battens of wood to allow air to circulate. Cover the mould with newspaper or a light fabric and allow the clay filling to become leather-hard. This may take a few days to achieve; do not hasten the drying artificially. When the clay is leather-hard, carefully remove the mould. You will notice that the filling shrinks from the mould, making it easier to remove.

The casting is now ready to be cleaned off and prepared for the final image.

Pomono by Marino Marini, bronze.

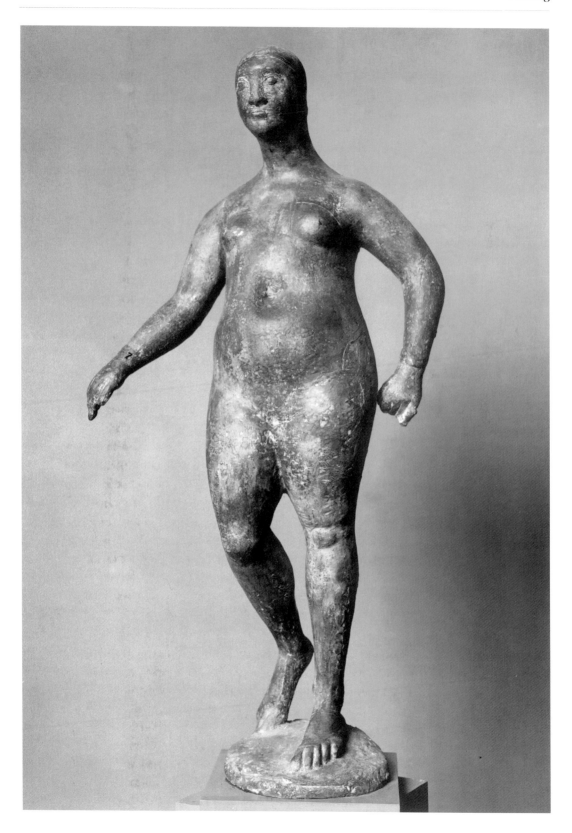

Slip casting

A much quicker process, in the initial stages, than press moulding. The procedure is as follows.

Prepare the mould, which must be dry and lightly dusted with French chalk. If the mould has more than one piece and is without a piece mould jacket, the pieces must be secured together. This can be done with thick rubber bands which can be cut from an automobile inner tube.

Prepare the slip to be used in the casting; have at least enough to fill the mould. Clay slip can be made from any fine-grained clay by adding water. Sodium silicate or soda ash added in the proportion of 0.5 per cent will help to make a clay slip quickly. More complex bodies for slip casting can be used, but it is wise to seek the advice of a ceramics artist who is familiar with the material available in particular areas.

Pour the prepared slip slowly and smoothly into the mould. Vibrate the mould gently to release any air bubbles. Leave the filled mould long enough to deposit the required thickness on the mould surface, then pour off the excess fluid.

Leave the mould and cast on an open shelf, supported on wood battens to allow the air to circulate. Stand the mould upright if possible and cover with newspaper or a light fabric, to help make the drying out process slow and even. Remove the mould when the clay filling is leather-hard. It will have shrunk from the mould and will therefore be easy to remove.

The casting can now be cleaned off and prepared for the final treatment.

Important points to watch

- The amount, consistency and purity of the clay for pressing, and slip for casting.
- The even thickness of the material laid over the mould surface.
- The proper strengthening of a clay press cast.

These forms on the whole can be larger than slip cast forms.

- The castings must be evenly and gradually dried out, in the mould and after. It is best to do this in a controlled, warm atmosphere (not hot). Do not artificially dry the cast as this may lead to uneven shrinkage and cracking.

Casting with concrete

In situ (on-site) casting

Some projects allow the exploitation of the casting facilities that exist together with all the other on-site facilities of a major building site. Cement and concrete are the major items useful to the sculptor for such work, and sculpture in the round and in relief can be made *in situ*. Moulds can be prefabricated and shipped to the site or made right there to be installed as any other concrete work, using accepted building practices.

Imported moulds often take the form of plastic liners added to wooden or steel shuttering. Either foamed or rigid plastic is used according to the required effect, and the need or not of repeat casting. Foamed plastic (polystyrene/Styrofoam) allows for bold, rugged design. The mould can be dissolved away or simply torn from the hard concrete, providing a very direct way of working, with commensurate excitement and involvement.

Rigid plastic, glass-reinforced polyester (GRP) or polyvinyl chloride (PVC) or some other such plastic product is used for repeat castings, to continue a running motif on a façade or to make complex composite forms in the round, etc. Any combination of materials can, of course, be employed according to the imagination and sense of adventure the sculptor enjoys. However, careful planning is of the utmost importance when working directly on site: planning regarding surface treatment, such as release/parting agents to allow safe removal from the concrete; planning regarding

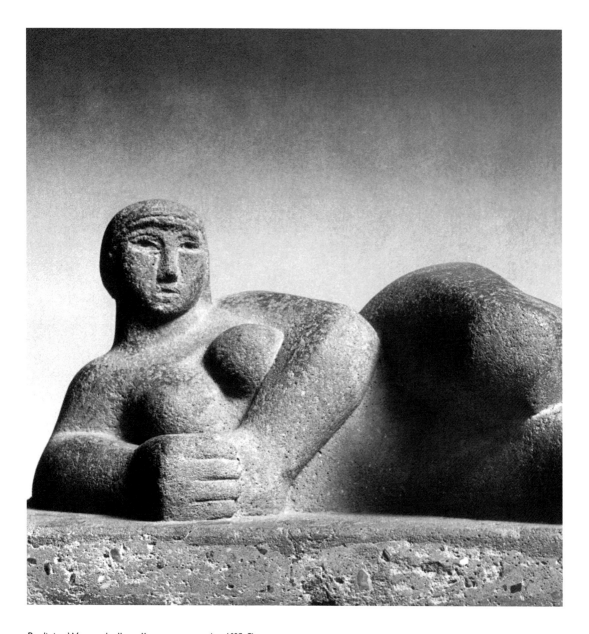

Reclining Woman by Henry Moore, concrete casting, 1927. The
surface has been worked on after casting.

complex undercut forms that may require a piece mould or an improvized equivalent. If you are using on-site labour and skills, remember time is at a premium, so check all contingencies so that you can make the best use of them.

Cutting into the ground in front of the actual site to make very large reliefs is a technique sometimes employed. This is a way of making, in effect, large sandboxes which can be modelled and embellished in various ways, and then simply filled with concrete. Suitably reinforced with steel and with appropriate fixings designed and placed, these panels can be simply hoisted into position, once the concrete has set, hardened and cured. Once in place, the sculptor can work on the surface to achieve the required finish. All kinds of embellishments can be added to the mould surface to enhance the final effect (see Sand Box Casting and Aggregate Transfer).

Sculptures are seldom cast solid today, for reasons of weight, lack of tensile strength and the general inconvenience associated with heavy weight and bulk – factors to be avoided whenever possible. Very small castings, however, are often made solid for speed and expediency. This is done by simply overfilling sections of prepared mould, usually consisting of only two pieces, using the goo (a paste of neat cement and water) and the stiffer mix with fibre included. The overfilling is built up on the mould sections which are immediately squeezed together. Excess concrete is forced out via the seams, and once the mould has been securely bound it is left to set, harden and cure according to the type of cement used.

The most basic method of casting solid concrete can be witnessed on building sites throughout the world. A suitable concrete mix is poured or dumped into a prepared open cavity, then vibrated to consolidate the casting by forcing out any trapped air, which in turn causes the aggregate to settle evenly. Excess moisture rises to the surface and is removed. The concrete is then left to set, harden and cure according to its type. When the concrete has reached a suitable degree of hardness, the material forming the cavity (shuttering) can be removed to reveal a stable, solid shape.

This description is of the crudest method of casting concrete. There are, of course, many variations on this basic technique, catering for almost any casting contingency. Methods for making the cavity using shuttering of various kinds can be very sophisticated. The machinery for vibrating the concrete once it is placed in situ is also sophisticated, making it possible to achieve the best distribution of the fines in the concrete mix to make the densest solid with the finest reproduction of surface, a feature often exploited by architects of the so-called 'brutalist' school of architecture, who employed rough-sawn timber as shuttering and expected that rough texture to be reproduced on the surfaces of their façades.

Sculptural embellishment of buildings is often cast in situ, utilizing the industrial process already referred to. This allows sculpture of enormous size and surface area to be achieved quickly and with a wide range of texture and quality, taking advantage at the same time of the facilities that can be found only on a building site – the labour force, large items of equipment, large volumes of concrete being manufactured hourly, etc. – plus no end of experience (see Shuttering and Sand Box Casting).

Large aggregate casting

The mould is prepared, treated with a release agent (see Release/Parting Agents) and soaked. The concrete mix is determined and a dry mix (see Dry Mix), sufficient to do the work in hand, is mixed to be even in colour throughout. The work in hand may be the complete filling of both caps

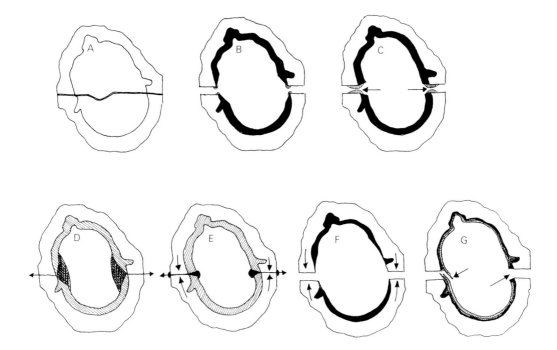

Moulding and casting a head:

A The mould division. Note the positioning of an ear in each section of mould to ensure it is filled correctly.

B The seam edge ensures the seam is filled, even if you can get at the seam from the inside.

C The squeezed seam filling and its effect, shown in E.

D A properly filled seam, with access available from inside the form.

F The filling feathered off towards the seam to be filled by pouring and rolling the form.

G The overlap at the seam edge of a resin and fibreglass casting, subsequently trimmed to an angle suitable for filling.

and main mould, or, according to the size of the work, perhaps only part.

A paste of neat goo is made. It should be the consistency of thick cream: as it is applied with a brush it must not be too stiff. A paste, or goo, using cement and fine aggregate can be used instead of neat cement and water.

Water must now be added to the dry mix to make the wet mix. Either small quantities can be made from the dry mix, or the entire mix can be made wet. This will depend on the size and area of the work, or section of work, to be filled. The wet mix should be just wet enough to bind together when squeezed by hand.

Commencing with the caps, apply a substantial layer of goo to the surface of the soaked mould, brushing well into texture and detail. Apply evenly to cover high points on the mould surface (these, of course, will be hollows on the positive form).

On to this neat cement, place the larger aggregate mix and press it firmly down – that is, 'tamp' it. The required cast thickness is arrived at by careful compacting and building. Build mild-steel reinforcing into this concrete thickness, and cover well (see Reinforcing).

When the concrete is sufficiently compacted it will give a dull ring. A wooden mallet is useful for this job and finer wooden implements can be

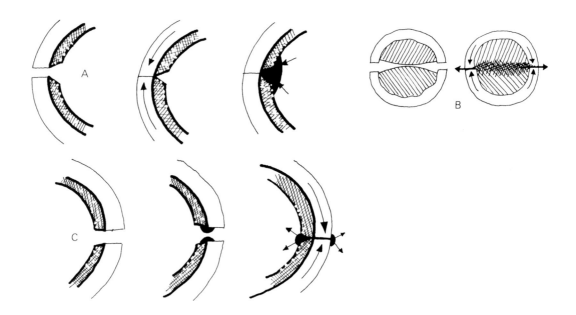

made to tamp in small restricted forms.

Remove any excess moisture that makes its way up from the mould surface. If it remains it will cause the surface to dust and may weaken the concrete. Complete all the caps, up to the seam edges.

The seam edges are of the utmost importance, throughout the moulding/casting process. They must be formed in such a way as to permit the closure of the mould, by fitting the caps to the main mould, also permitting proper filling at the seams to join and fill the sections of casting. Wash the plaster faces clean of any obstructions. Treat the main mould in the same way:

- Apply goo evenly over the surface.
- Build the large aggregate mix up on this, while the goo is wet, and compact to the required thickness.
- Make and place mild-steel reinforcing. It must be built integrally in the concrete thickness. The main mould will take most of the reinforcing, because it contains the bulk of the form.

A The angle of filling at the seams necessary to make a strong filling from the inside.

B and C The filling of a seam or form by squeezing. B shows a solid form being filled and C shows the shallow angle of filling at the seam edge that is filled by squeezing.

- Form the seam edges and clean off the plaster seam faces.

Overhanging surfaces can be filled in stages, filling section by section, rolling or turning the mould on its cradle when previous sections have set (see diagram page 39).

The caps and main mould, filled and completed, must be covered with wet cloths and plastic sheet to encourage proper setting and hardening.

When the sections have hardened they are ready to be fixed together to complete the casting process. Fixing the caps to the main mould is done using one or a combination of the following techniques.

Pouring

Secure the caps to the main mould, making sure of proper register and secure them by tying using plaster of Paris and scrim (burlap/hemp), or by clamping (see page 49). A cavity is now formed within the inner surfaces of concrete filling, which should be wet. Pour concrete into this cavity to fill it, and tamp or vibrate the concrete to consolidate it.

This technique has been used, for instance, for filling the legs of a standing figure, with a mild-steel reinforcing in the centre of the forms.

Packing

First secure the caps to the main mould (see diagram opposite), making sure of proper register. Secure one cap at a time. When secure, the presented opening permits you to fill the seams by packing, which is done by applying first the goo and second a large aggregate filling. This joins the sections of casting and fills the seam (see diagram) and must be well compacted.

Squeezing

Inject the squeezed filling of the seams as the caps are placed and secured to the main mould. The angles of the seam faces must be planned to leave as small a space as possible to be filled. Up to these edges, on both the main mould and caps, build up a layer of goo to overlap concrete and plaster.

Place the cap on to the main mould, and squeeze the neat cement to fill the seam. It squeezes out all round the mould and into the casting to fill the seam.

The most satisfactory method of fixing and filling caps and seams is a combination of squeezing and packing, but this can be done only if the inner surfaces of the filling are accessible. These processes apply to all casting media.

Fine aggregate casting

Fine aggregates of dust-sieve size, 120 mesh, mixed in the ratio 1–1, can be wet-mixed to make a paste that can be easily built up on the surface of the mould. This paste makes the casting process fairly simple. There is no need for haste because the relatively slow setting speed of concrete does not call for speed, and application of the filler to the mould surface can be evenly paced. The build-up of the cast thickness can be carried out methodically too. Glass fibre is always used with these mixes to give tensile strength.

The general casting process using fine dust aggregates is given here, and particular castings can be worked out fairly simply from the following description.

Prepare the mould, apply the necessary release agent and soak the mould. It is wise to start with the caps, so that the filling in these is firm and ready to be placed to the main mould when filled.

Dry-mix sufficient concrete to complete the work immediately in hand. From this dry mix make a small bowlful of wet mix (goo), the consistency of a paste or thick cream, so it can be brushed on to a mould surface. Make another bowl of wet mix, stiffer in consistency and of a larger volume. These mixes can be made while the mould is soaking.

Prepare chopped strand mat glass fibre at this stage also. Divide manufactured mat to produce two thinner layers and cut shapes or tear to fit the mould.

Apply a substantial layer of goo, 5–6mm ($\frac{3}{16}$–$\frac{1}{4}$in) to the mould surface, beginning with the caps. This must be evenly applied to cover the surface, taking care to cover the high points of the mould (low points on the positive form). Do each cap separately, and do not try to cover too great an area at first. Use a brush for this first layer.

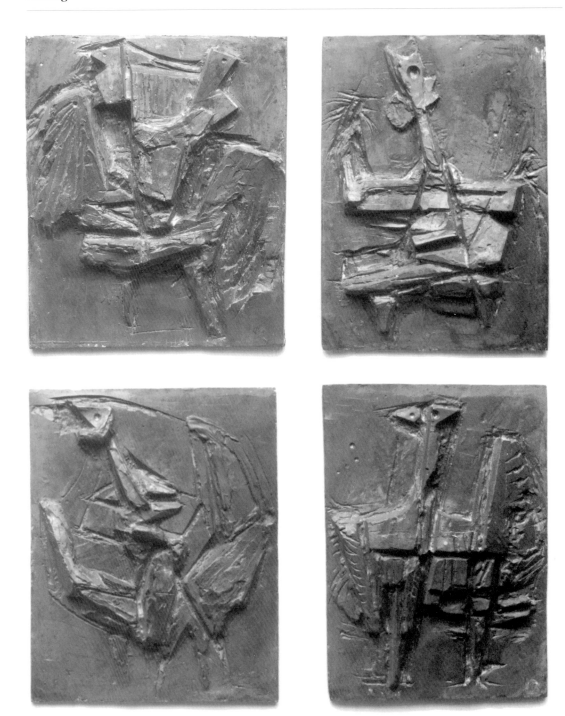

Four Reliefs by Bernard Meadows, ciment fondu, 1959. Tate Britain Collection.

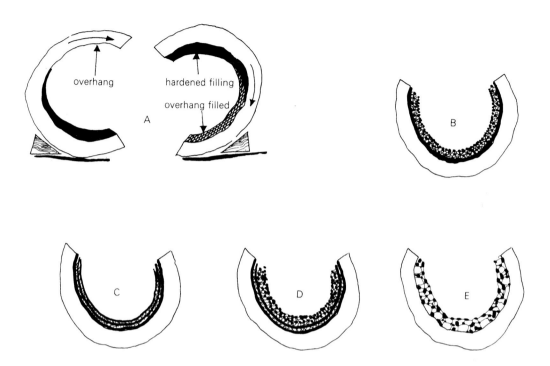

A *Dealing with an overhang.*
B *The layers of concrete over a surface layer of 'goo'.*
C *The lamination of cement and fibreglass.*
D *The same as C but backed up with a layer of coarser concrete, particularly strong and suitable for large work.*
E *The mould filled with concrete, which can be enlivened by placing selected aggregate or any additive directly on to the mould surface, to be revealed by grinding, etc., on the final cast surface.*

Into this thickness of concrete place the first of the two layers of laminates of glass fibre. By carefully placing and patting, make the fibre cover the concrete. It must not be pushed down on to the surface of the mould. Take a brush and stipple the fibre with goo to saturate it.

Now, using the stiffer mix, build up a thickness

of concrete evenly and carefully over the first layers. This should build the cast thickness up to a little more than 7mm (¼in), but it may be varied according to the thickness of the first layer.

Any mild-steel reinforcing can be shaped and placed at this stage but most of this is contained in the main mould (*see Reinforcing*).

On to this second layer of concrete, place another layer of fibre, again patting and stippling. Then, with the stiffer mix, build up the cast thickness to about 15mm (½in). This build-up should be trowelled to a tight surface. In this way a double surface tension is achieved in the cast thickness, giving additional strength. Now shape the seam edges.

Mop up any excess moisture that appears on the concrete as it is worked, because, if left, it will affect the casting.

To summarize:

- Prepare a goo and a stiff concrete mix.
- Paint a layer of goo evenly on to the prepared mould.
- Carefully place glass fibre mat, patting and stippling to saturate.
- Apply a second layer of concrete from the stiffer mix.
- Apply the second layer of fibre.
- Build up the cast thickness, including any mild-steel reinforcing in this build-up. Trowel to a tight surface finish.
- Shape, trim and clean the seam edges.
- Complete the casting by fixing caps to the main mould.

This final moment of completing the casting by fixing the caps is the critical stage of the process. The seam edges must be clean, and designed according to the final processes. Glass fibre overlap can be folded back to give a little extra strength to the seam edge. The method combining squeezing and packing (see Squeezing) is the most useful. There is no need to wait for the filling to harden. After the initial set, the caps can be fitted and filled without risk of the concrete dropping. Overhanging sections can also be filled with comparative ease.

When the mould-filling is completed, cover with wet cloths and plastic sheet to enable proper setting, hardening and curing.

The two casting techniques described are quite different. It may be that the job demands a combination of the two. No two works of sculpture are exactly the same. Differences in image and form make various demands, and a good working knowledge of the casting processes available enlarges your scope and range of expression.

Both techniques can be used to make castings from waste-moulds, piece moulds of plaster of Paris or reinforced polyester resin, from the various kinds of flexible mould, and from built-up moulds, i.e. shuttering or moulds built *in situ* for direct working. Proper allowance, however, must always be made for release and hydration.

Casting from life

A process used to achieve the kind of image known as photorealism. The simplest material used for this type of cast is proprietary plaster bandage, the same as that used in hospitals to make plaster cases around injured limbs. This is a bandage saturated with plaster of Paris, so that when dipped in water the plaster is activated and sets quickly (approximately two to three minutes).

First, mark the planned divisions of the mould on the subject using a water-soluble marker. When this is dry, cover the skin with petroleum jelly. Any hair should be shaved, tied back or well lubricated. Cut the bandage into manageable strips – about 30cm (12in) long – then dip them one at a time into warm water and apply the strips to the surface. Fold the bandage back at the drawn line, making this as neat as possible. Build up a thickness of about 3mm ($\frac{3}{16}$in) and reinforce the build-up with ribs of plaster bandage where extra strength is required. Leave this to harden on the body.

Next, treat the folded seam edge with a release agent, clay wash or petroleum jelly, and make the next section of mould, paying careful attention to the meeting of the caps to ensure a good seam. Build up the bandages in exactly the same way as for the first section, and continue until all sections of the mould are complete. Large areas may require strengthening to prevent warping, but do remember that this is not a comfortable situation for the model, so plan each section carefully.

Once the process has been completed, treat the surface according to the filling and cast that are required.

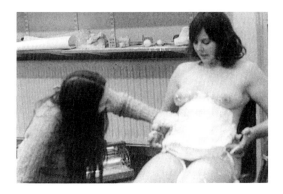

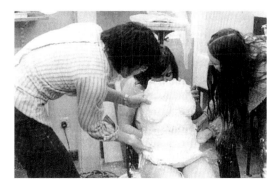

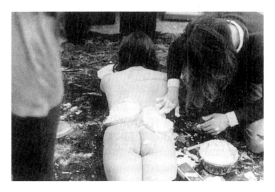

Plaster bandage mould from life. Note the markings on the body to indicate the planned division of the mould.

When making a cast from a living head, seal the ears with lubricated cotton wool, and do not cover the nostrils. Use straws or small plastic tubes as vents to allow the subject to breath, and remember that as the plaster expands on setting the discomfort of the model is increased, and the form can become distorted.

Casting metal

Metals have been put to the service and decoration of man since the Bronze Age and the development of techniques, simple and complex, peculiar to metalworking has continued since that time. Principal among these skills has been that of casting.

The skill of casting grew from the techniques for producing metal images by placing metal over carved wood covered with bitumen. Thin sheet-metal was annealed and beaten to fit tightly over the pattern. The surface of the metal was worked by chasing and burnishing, usually to an exquisite finish of detail and quality. The Sumerian culture produced some powerful sculptural images in this way, but possibly the most exquisite example is the portrait of the Egyptian pharaoh, Tutankhamen, in which gold was inlaid with precious stones.

This technique, although obvious, was a most tedious way of achieving a metal sculpture. The form had to be made at least three times over. Casting made possible a more substantial thickness of metal, with the advantage of being easier to work; the image needed to be made only once.

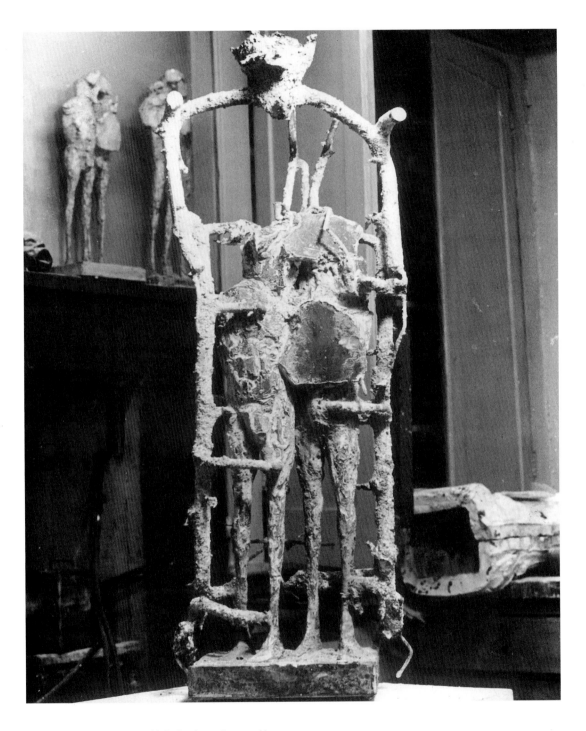

Bronze casting fresh out of the mould, showing the pouring gate with
the funnel at the top. The casting now has to be cleaned and chased.

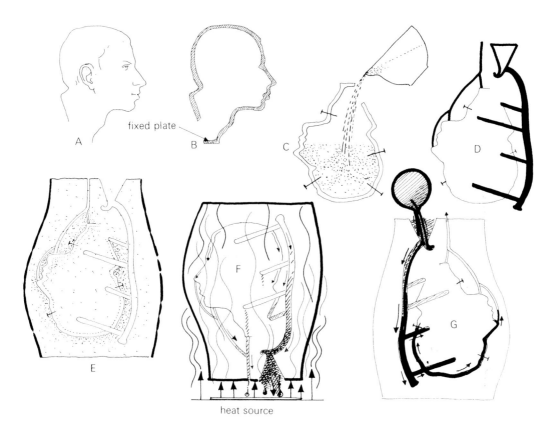

fixed plate

A

B

C

D

E

F

heat source

G

The lost wax process (cire perdue):

A *The master cast.*

B *A hollow wax made from A.*

C *Refractory material is poured into the hollow wax to make an inner mould and two iron pins inserted.*

D *A system of wax rods fixed on to the wax surface.*

E *The whole assembly is covered with a refractory mould reinforced with wire.*

F *The structure is placed in a kiln and the wax melted out (lost).*

G *Molten bronze is poured into the resulting cavity.*

The technique probably developed from those already practised: the method commonly used for making clay images (making a small master mould for producing preformed items to be included in larger works) was possibly used in the fabrication of metal images over wood and bitumen. Small metal castings could have been made easily. The qualities and possibilities of molten metal may have been discovered accidentally; we do not know. We do know, however, of the skills that arose because they can be studied from surviving examples, although we can only speculate upon how these skills were discovered. The results are what distinguish the Bronze and Iron Ages from the Stone Age and lead directly to the origins of modern technology.

The earliest known bronze cast is Indian, dating from about 5000BC. It is an extraordinary fact that almost every known culture or civilization

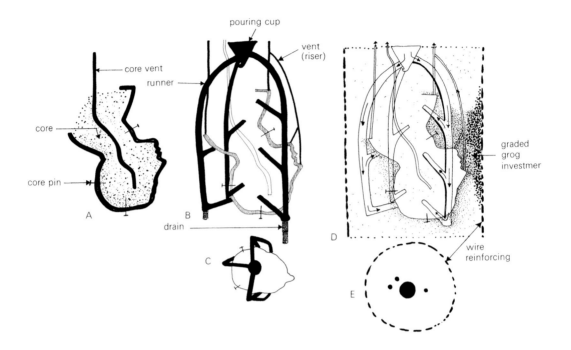

pouring cup

vent
(riser)

core vent

runner

core

graded
grog
investmer

core pin

A

B

drain

D

C

wire
reinforcing

E

Stages in the manufacture of an investment mould:

A *A hollow wax casting with the core in place, including the core vent and pins.*

B *The pouring gate and the system of runners or risers (sprues). This system is the indirect method and the metal will flow as indicated by the arrows at D. Note the drain rod included in the mould that cannot be inverted to bake out (this will be plugged before the metal is poured).*

C *The plan of the pouring gate; in this case three runners have been led from the runner cap.*

D *The build-up of the investment, using various grades of ground refractory from 120 to 30 mesh. Chicken wire provides the reinforcing also indicated in E.*

schools for discerning sculptors and students.

In the past, artists and craftsmen were required to have a knowledge of metals and metalworking. Indeed the guilds demanded high standards of skill before admitting artisans to their circle. The foundation of these guilds in the Gothic period in Europe was a kind of guarantee of workmanship for prospective patrons. Leonardo da Vinci, working to these standards, not only designed metal war machines, but also a method for casting in bronze an over life-size equestrian portrait. Michelangelo, possibly the most fluent carver of marble since the Renaissance, also produced, albeit reluctantly, a fine larger-than-life bronze portrait of Pope Julius for the city of Bologna. The legendary description of the casting of Perseus by the sculptor Benvenuto Cellini has become compulsory reading on many fine art courses. The Renaissance artists and their skills are perhaps too often quoted, but their examples are the stuff on which the modern Western art world has been fed for so long.

throughout the world evolved bronze casting techniques. Museums are virtual warehouses of bronzes from all periods of history following the Bronze Age. These collections are important

The eloquence of Chinese bronzes, sculpture and vessels reflects consummate technical skill. The bronze images from the Benin tribe of Nigeria must be seen to be believed, and these works are more directly related to contemporary skills, both in technique and the attitude towards form and statement. They are superb examples of investment casting using the lost wax (*cire perdue*) process.

Casting metal: lost wax (*cire perdue*)

The casting of metal objects via the lost wax/*cire perdue* process can be explained quite simply. The object to be cast is first made of wax. The wax is then covered with a refractory material, able to withstand temperatures up to 600°C. This mould is then heated to make the wax melt and run out, becoming 'lost', leaving a cavity. Molten metal is prepared next and poured into the cavity, replacing the wax. The refractory material is then broken away revealing the cast metal object.

The practice of metal casting based on the lost wax method has become very sophisticated, however, and requires considerable experience to be able to carry out with confidence the various procedures involved. Many sculptors now do cast metal, particularly bronze, and many colleges include an element of bronze casting in their sculpture curriculum. Whilst working at the University of Michigan, I was involved with students pouring 1,200kg (600lb) of bronze once a week, over a two-month period, culminating in a final pouring session of 3,600kg (1800lb). Such an experience is common in the USA and indicates the advances made in the acquisition of skills relating to metal casting today.

The wax original

This is prepared by moulding from a master cast, usually by means of a flexible moulding compound.

From such a mould, a wax casting is prepared, known as 'the wax'. The sculptor may produce his own wax for the foundry. If the wax is prepared at the foundry, the sculptor will be asked to check it against the master. Any touching up, cleaning off of seam flashes, signing, and inscribing the edition number is done at this stage. Bronze sculptures are often produced in small editions, usually six in number, sometimes more. Each casting must have its edition number marked on it and this is best done in the wax, the number of the particular casting shown over the total edition number, e.g. 2/6. Such editioning allows casting costs to be spread over the whole series.

Filling with core material

This is poured to fill a hollow wax and is usually made up of 1 part plaster to 3 parts grog (ground ceramic). Before filling the core, the wax is weighed to determine the amount of metal to be used. The ratio of 1lb of wax to 10lb of bronze is usual, plus the estimated weight of 'risers' and 'runners' (see diagram page 43). Most experienced casters estimate this by the size of the crucible, which is manufactured to calibrations of 1lb capacities (there is no metric equivalent). The core material must be poured to fill the wax completely. If a piece mould or flexible is used, it is convenient to pour the core while the wax is held in the mould. It may be possible to return the wax to the mould, after weighing it, to pour the core. This will prevent any damage to the wax when vibrated to release trapped air bubbles, and will help ensure a well-consolidated core. Core vents are placed whilst the core is still liquid.

Next, place the core vent. Large cores require a substantial core vent; smaller forms can be vented by inserting a waxed string in the core – this is held firm by braided wire so that it can be placed more conveniently.

Tack iron pins/core pins (see page 43) into the core, through the wax, with sufficient projection from the face of the wax to be gripped by the mould (see Investment). These pins, placed at strategic intervals about the work, ensure that the core and investment stay in the same relative position when the wax is melted out. If there were no pins, obviously the core would move about loosely once the wax had gone. This would result in the passage of the molten metal being blocked, and the casting would be a failure.

Preparations for pouring

The pouring gate has to be designed and fitted. This is the name given to the system of channels through which the molten metal flows and gases escape. The metal flows via the pouring funnel, through the runners and into the mould cavity. The runners extend from the funnel to carefully placed points on the sculpture to ensure the quickest and smoothest flow of metal.

The metal must run quickly to every part of the mould cavity without chilling. Gases created by the metal run before it, driving out air from the mould at the same time. These gases and air escape up the risers, which are vents taken from those features of the positive form likely to trap air and prevent the flow of metal.

Air traps will normally occur at undercut forms, protruding from the main form, when this is in position to be filled.

Placing the investment or mould

Place this around the finely prepared wax which has been fitted with its pouring gate, or 'sprued up', as American sculptors would say (see Sprue).

An investment can be made of plaster of Paris mixed with grog (ground cement). The grog should be sieved to make three grades:

fine, 120 mesh, to mix with the first application; fairly coarse, 60 mesh, for beginning the mould build-up; and very coarse, 30 mesh, to complete the mould. This mixture of materials is still used by most foundries in preference to proprietary investments. It is obviously cheaper in large quantities, and is known as 'solid investment'.

To achieve reproduction of the finest detail, carefully apply the investment to the wax surface. (Treat this first with methylated spirit/denatured alcohol to remove any grease.) Paint on the initial layer of mould with a very soft brush. Do this quickly over the entire surface, including the pouring gate. Glue size added to the water will retard the investment to aid painting this first layer. Be sure to leave a well-keyed surface to make the best adhesion to the next layer. After this initial surface the mould must be built up to make a substantial thickness, which by its nature maintains a maximum strength when baked, the sieve size of grog increasing as the mould grows. The final application can be reinforced with wire for extra strength. Some alternative methods for placing the investment are by pouring or dipping.

Baking

This melts out the wax to form the mould cavity and also dries out the mould thoroughly, thus preparing it to receive the molten metal. The baking process is best begun when the investment is fresh as this helps the wax to drain quickly. The mould is baked in a kiln fired by gas, oil, wood, coke, coal or electricity – any fuel in fact as long as the heat can be built up fairly slowly and maintained at a red heat. The traditional method is to build a kiln around a number of moulds over a fire box. The contents of the kiln are baked to a temperature of 600°C and maintained at this red heat for 24–36 hours.

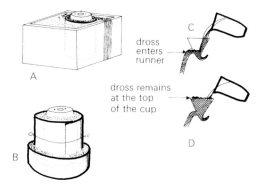

dross
enters
runner

dross remains
at the top
of the cup

A

B

C

D

A *Baked investment mould safely packed in a free-standing sand box. It is shown placed in a metal sleeve, which is only necessary when the volume of sand is restricted.*
B *The baked investment mould secure in a metal sleeve and a shallow drum, which is safe but should be used only in extremes.*
C *The wrong way to pour metal into the pouring cup: this allows dross to enter the mould and spoil the casting.*
D *The correct method of pouring molten metal: keep the pouring cup full so that any dross will remain floating above the entry to the runners.*

They must be maintained at this heat for long enough to burn out the wax and any carbon deposit, and to drive off any moisture from the investment. Although the main body of wax will melt and quickly run off when heated, small amounts may be absorbed into the porous investment, and must be burnt out. This is more often the case when you cannot bake a freshly made mould but have to wait for a number to be prepared. Visually, the properly baked mould will be free from any carbon deposit, with no grey showing.

Packing

The baked mould must be packed to hold it firmly in place and is the final process before melting the metal to pour. Place in an open box or pit, then pack damp sand firmly around the mould until only the funnel and riser openings are visible. These openings should be covered to protect them and to prevent sand dropping into the mould cavity. The packing keeps the mould in position for pouring and prevents the mould cracking and the metal running out. Before packing the mould, some casters place a reinforcement of scrim and plaster to prevent cracking. Prepare the metal during the packing operation and, when ready, pour into the mould in a steady flow, filling the runner cup and keeping it filled until the mould is full and metal appears at the risers (see Melting and Pouring Metal).

Casting with plaster of Paris – solid

Prepare, clean and treat the mould with the appropriate release agent (see Release/Parting Agents). Shape and treat any reinforcing required in the final casting (see Reinforcing), remembering that the casting has to be strong enough to withstand the shock of being chipped or levered from the mould, and to resist the normal wear and tear of studio life, particularly when used as the master pattern for foundry work.

The prepared main mould and caps must now be soaked, to prevent them taking moisture from the fresh plaster filling. If possible, immerse the mould in clean water, leaving it in until all air bubbles stop rising, indicating saturation. If this is not possible, use a hose or substantial spray to soak the mould. When the mould is removed from the water, moisture should stay on the surface and not be absorbed into the plaster.

Fix in place any reinforcing irons using small blobs of plaster, and making sure that nothing obstructs the entry to the mould. When this is

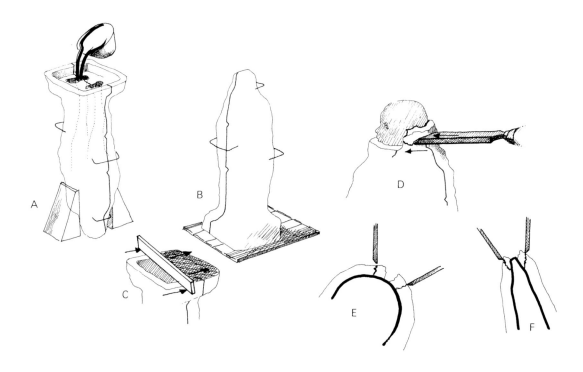

A *Plaster waste mould being filled, inverted and propped up. Plaster is poured through one entry only.*

B *When filled and levelled (C) the mould is placed upright after the plaster has set. This will make the top harder sooner, ready for chipping out.*

D *The angle of the chisel when chipping away the waste mould, which should be at right angles to the cast.*

E *The plaster is fractured and burst from the cast surface, not cut; use a blunt chisel.*

F *Do not hold the chisel at right angles to the surface if the form is slender. Try to make the impact of the mallet and chisel be absorbed into the mass. Do not cut across a slender section or it will break.*

done place the caps in position and fix with plaster and scrim (hemp/burlap) sealing all round the seam line. Allow the fixing to harden.

Turn the mould upside down, check that the opening is clear, and prop it securely. Make a fresh mix of plaster and pour it into the mould to fill it completely. Wherever possible, pour through one opening only and pour consistently into one side of that opening. Try also to make the pour in one mix. Pour the plaster steadily, vibrating the mould as you do so by gently tapping and shaking. This will enable any air to rise and escape (as will pouring through one opening only or to one side of a larger access hole). Avoid pouring the filling too quickly.

It is a wise precaution to have a helper standing by with some clay, ready to plug any leak that might appear. If no helper is available make provision for plugging any such leak, whilst not interrupting the pour for too long.

The process I have described is the same when using a flexible mould, the only difference being in

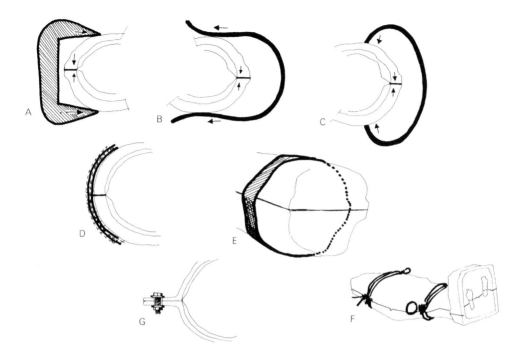

Methods for fixing mould sections together for filling:

A Joiner's clamp that tightens as it is hammered on.

B and C Mild steel, studio-made versions of the joiner's clamp, made as the work demands.

D Scrim (burlap/hemp) and plaster used to fix a mould section. This is most useful when the filling being used is a slow-setting material or whenever hard pressure is to be used during the filling process.

E Strips of car inner tube make good binders.

F A simple wire tournequet, which can be used satisfactorily on small moulds.

G A section through a typical mould seam made of GRP, showing the method of closure – a nut and bolt with adequate washers.

the preparation of the mould prior to filling. This is done according to the nature of the flexible compound used.

When the mould is full, trim off any excess setting plaster and leave it to set. When this has taken place stand the mould the right way up and allow it to harden in this position. The casting is then ready to be chipped out (see Chipping Out).

Casting with plaster of Paris – hollow

Prepare the mould for casting, clean and treat with the appropriate release agent (see Release/Parting Agents). Now soak the mould, saturating it with clean water so that moisture stays on the surface and is not absorbed into the plaster. Treat the main mould and caps both in the same way. Apply an even layer of fresh plaster to the surface of the mould, aiming for a thickness of about 6mm (¼in), according to the size of the sculpture. Clean off the seam edges after each application of plaster, whilst it is still wet. Be scrupulous about this as it will affect the good register of caps to main mould, and the thickness of the cast seam. Next, add a second layer of plaster, reinforced with jute scrim (burlap/hemp). Aim for a similar plaster thickness as even as possible, making sure to build up on the

high points of the mould (hollows on the final casting). If you allow plaster to run off these high points the hollows will become holes on the casting. Do not build up the thickness at the seam edges, but allow it to taper off, unless the cap requires a squeeze filling (see Squeezing). Always spray surfaces that are to receive fresh plaster with clean water to ensure good adhesion and a sound plaster thickness.

Shape and fix, with scrim and plaster, any reinforcing required (see Reinforcing).

When making this filling remember that some expansion occurs as plaster sets, so the thinner the layer of plaster the better, and, because of this, caps should not be left lying flat, but propped on edge to prevent distortion. Aim for a total thickness of about 12mm ($\frac{1}{2}$in).

Check again that all seam edges are clean on the caps and main mould. Check also that they fit correctly and that no filling obstructs their proper fit; make any adjustments necessary.

Decide on the order of placing the caps, maintaining access to the inside of the casting for as long as possible. Place and secure the first cap with scrim (hemp/burlap) and plaster. Once this is done, place fresh plaster to overlap the filling of cap and main mould along the seam and back this up with scrim (hemp/burlap). Clean the seam edge and place the next cap, secure it and fill the seam. Continue to do this until the last cap is in place and the filling complete.

The seams of manageable moulds can be filled by pouring plaster into the sealed mould and rolling the mould as the plaster sets around the seam. If space allows, some reinforcing scrim (hemp/burlap) should be introduced as well, to give extra strength.

This pouring and rolling procedure can be used to make a complete casting in a sealed mould. Great care must be taken, however, to ensure an even distribution of plaster. This is a problem with complex forms and heavily textured surfaces so this casting technique is not so greatly favoured.

Casting with wax

Prepare the wax, by melting it and allowing it to cool until just before it becomes cloudy on the surface. This state will become familiar as you gain experience of melting and using wax. Allow a small amount to cool in a separate, smaller vessel, while keeping the larger amount molten and hot to draw from.

Prepare the mould whilst preparing the wax. A plaster mould needs simply to be wet; a flexible mould needs to be clean. Apply the first layer of wax to the surface of the mould. Do this with a fully charged brush, just *placing* it to deposit the wax on the mould. Do not try to *paint* on this layer because the wax will chill on the brush and drag, pulling itself from the surface. Cover the entire mould surface evenly with wax applied in this manner.

You can paint on the second layer of wax. Work quickly; try not to let the brush stick and drag. Keep dipping the brush into the wax to make it spread.

Using some softened wax, build up and thicken high points and protrusions on the mould surface, remembering that these will be hollows or low points on the cast. The reason for building them up in this way is to ensure that they maintain their coverage when molten wax is poured into, and then out of, the mould.

Clean off at the seam and trim along the seam edge with a sharp knife. Place the sections of mould together and secure them with rubber bands, or with string and wooden wedges.

Pour molten wax into the mould as soon as it has cooled and its surface has become cloudy. If you pour it in before this it will be too hot.

Allow the filled mould to stand a while, so that a chilled deposit of wax is made on the inner

Prepared plaster waste mould ready for casting a polyester resin. Note the wood supports, which enable the mould to be handled easily (see also illustration page 59).

surface of the cast. When this deposit is the thickness required, 3–5mm (⅛–³⁄₁₆in), pour off the surplus wax. Then allow the casting to cool and harden in the mould. This process can be accelerated by pouring cold water into the casting. (It is at this point that the core of refractory material can be placed, to prepare the wax casting to be invested and made ready for bronze casting, see Core entry, and diagram C, page 48.)

Carefully remove the mould when the wax is hard. Clean the casting, make good any defects by adding molten wax and modelling with a heated metal spatula. Remove any seam flashes and prepare the casting for whatever its final state is to be, the intermediary stage of a metal casting, or a wax final material of the intended image.

Casting with resin (polyester)

Prepare the mould, which should be dry (see Release/Parting Agents). Mix a large quantity of resin and filler, plus accelerator. Prepare enough to complete the work.

From the large quantity take a smaller amount, mix in the catalyst necessary, and apply this to the surface of the mould. This is the gel coat. If the mould has inclined or vertical surfaces, add a thixotropic agent; this will prevent the resin draining and running off. Make the gel coat as even as possible. Clean any brushes immediately after application, before they get gummed up. Specially

prepared gel coat resins are manufactured.

If the texture on the surface is deep, apply a second coat of resin to build up the gel coat. A substantial gel coat is an advantage if work is to be done on the surface of the cast. Cut the glass fibre to fit the mould without overlap at the seams.

Mix another small amount of resin and catalyst. With this make the first lamination by stippling the glass fibre to the gel coat, when the latter has hardened. Build up the laminations to the required thickness – 6mm (¼in) maximum. See page 35 for diagram of layers of lamination. Fix any other reinforcement during the laminating lay-up.

Keep the seam edges clean and turn any fibres back into the lamination or trim them off. The

seam edges can be built up using a thixotropic mix. The shape at the seam edges and faces should be as in the diagram on page 35.

Treat the caps and main mould as described above until the whole mould surface has been cast, the laminations built up to the required thickness, and all seam edges and surfaces trimmed and prepared, ready to be fixed together. Ensure that all the caps fit snugly to the main mould, and to each other. Trim with file or hacksaw any protrusions which prevent a close fit.

Fix the caps, one by one, to the main mould. Use the squeeze method (see Squeezing), securing the caps in position with clamps. Then reinforce each seam on the inside, with glass fibre and resin, whenever possible. Allow the resin finally to gel and cure when the final cap has been placed.

Chip off the waste mould carefully; this can be done more easily if it is soaked first. Take care also in

John McCarthy's concrete and water fountain contructed on site.

Part of the process of making a plaster piece mould. The craftsman is making sure that the section he has just made can be removed, before making the next piece. He is working from the plaster original.

prising off piece moulds so that you avoid chipping and damaging the pieces. These should be taken from the cast in the planned order and replaced in the mould case. (If you use plaster of Paris to make a piece mould for resin it is best to choose a low-expansion, hardened plaster for the job.)

CEMENTS

These materials as we know them today are fairly sophisticated binding agents, used to make concrete and mortar of various kinds. Their origins can be detected in Roman architecture and engineering, where they were devised to aid the building of coffered vaults and complex walls with a freedom prohibited by stone.

Cement is manufactured in the same way as plaster of Paris. Calcium aluminium silicate is heated and ground to a powder to make Portland cement, which takes its name from the stone of Portland, in southern England, that it resembles. Alumina, similarly heated and ground, produces high alumina cement, a fast-setting binder, which has proved most useful to sculptors.

Industry produces a wide range of cements, used according to specific needs in architecture and civil engineering. They are made to have good

Wax positives, with the spruing system (the pouring gate) in place and the first coating of colloidal silica slurry applied, ready to start the build-up of the ceramic shell mould.

resistance to atmospheric corrosion and to intense heat and are mixed with specific aggregates to gain particular properties. Thus the needs of sculptors are well catered for. These substances are relatively cheap and easy to handle but must be stored in a dry place. Because they attract water (are hygroscopic), they cause trouble in climates of high humidity, such as that of Bermuda, where their use and storage can be seriously affected.

CERAMIC FIBRE

Made from blown alumino-silicate, this is probably one of the most useful items for furnace and kiln construction to have been recently discovered. A furnace lining can be made by simply gluing ceramic fibre directly to the inside of a drum, using sodium silicate. A 50mm (2in) blanket of fibre is all that is required to make an adequate furnace. I have seen the bottom of the drum left open and the whole thing stood on dry sand, but it is wiser to make a solid base using a suitable refractory castable cement. The opening for the heat source can be cut through both the steel and fibre. The lid should be constructed of sheet metal (the top of the drum cut off is ideal) and lined with fibre; a hole to give access to the pot is needed and the

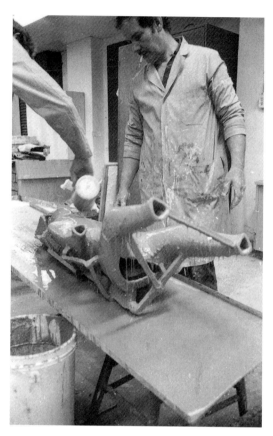

During the 1960s, Art Lee introduced the ceramic shell process to art bronze in Toronto. He is shown here with his assistant, applying the coloidal silica slurry and refrectory aggregate in the mould build-up.

The slurry build-up; note the spruing system.

furnace is ready. It can be made in a few hours.

The fibre will become friable after the first firing but, providing it does not receive any undue knocks, it will remain intact and usable for some time, according to the frequency of use. Of course, unlike other furnace lining, ceramic fibre is easily replaced, so relining a furnace is not a daunting task anyway.

CERAMIC SHELL CASTING

Probably the newest metal casting term in the sculptor's vocabulary. It is an investment casting process developed after World War II to provide high-fidelity engineering castings requiring little or no machining, devised particularly for application in the aircraft and defence industries. This process was perfected by 1950 but did not become widely available to sculptors then because of the high cost of both the materials and the equipment required. These factors, however, have now been resolved: ingenious sculptors, by experimentation and by a generous exchange of information regarding experiences and ideas resulting from experiments, have brought this new lost wax process into the studio.

The technique has evolved from the devising of a very strong refractory binder which, when used

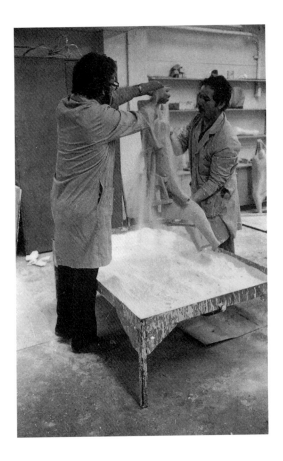 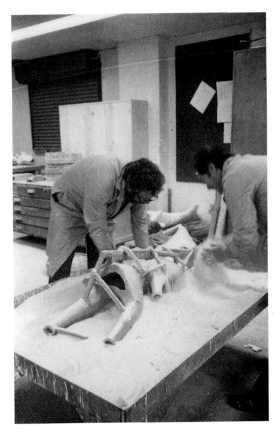

The ceramic shell build-up is in process, the colloidal silica slurry has been applied and the dry, dusty aggregate is being piled on to adhere as heavily as possible, in order to make a strong mould.

in conjunction with a compatible refractory aggregate, produces a strong lightweight investment mould. The binder is a colloidal silica which, when mixed with silica flour, combines to make a slurry. This slurry is used at the first coat of the investment build-up. Subsequent applications are made, including larger particles fused silica stucco, to build an eventual mould thickness of about 7mm (¼in). Once this mould has been de-waxed and baked at 1000°C, it is so strong that it can easily withstand the thermal shock of the molten metal without being supported in sand (see Firing for Ceramic Shell and De-waxing).

CHAIN SAW

Not really a saw, this modern wood-cutting tool is a chain driven around a solid bar. Each link of the chain carries a sharp gouge, driven around the bar as it is placed against the timber. These links gouge out the wood at great speed. The machines are powered by petrol (gasoline) or electrically driven motors, and are made in a range of sizes with cutting bars from 150mm (6in) to 900mm (36in) or more. They are used primarily for tree felling and pruning but are being used more and more by sculptors to remove waste material or to define or block out an image quickly. Some sculptors, indeed, use only the chain saw making very rugged forms.

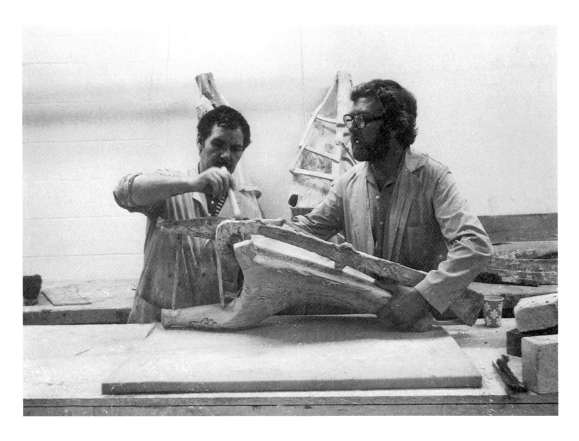

Pay thorough attention when making the build in difficult places; no areas must be left without the ceramic shell build-up. Any flaws that appear can be repaired with fire cement, but it is wiser to make the mould as complete as possible.

Care must be taken whenever you use a chain saw. The manufacturer's manual usually includes notes on safe use of the machine and should be taken seriously. Wear protective clothing, ear guards, gloves, goggles and suitable footwear. Keep the chain sharp and ground to the correct angle and also maintain the chain tension correctly. These last two points are important not only from a safety point of view, but for reasons of control they affect the proper direction of the cut. Badly adjusted tension and cutting angle will cause damage to the chain and bar, making control impossible. Neglect in these matters could prove to be very expensive!

The chain must ride at a constant level around the bar, and each link gouge must be identically sharpened and shaped. The maintenance of any power tool is of the utmost importance and chain saws are no exception. Proceed with caution.

Properly maintained and sensibly used, the chain saw is a great aid to the sculptor and has probably made a major contribution to the renaissance that is detectable in the art of wood carving today.

CHASING

The craft of working a cast metal surface to replace any loss of detail that occurs during casting process. Various metal-working tools are used, but the final detailing is achieved using matting tools (these are sometimes referred to as chasing tools).

CHERRY RED

This is the colour, when hot, of materials that need heating to be able to be worked. Metal for annealing and forging; glass to be shaped, moulded or modelled. 'Glowing Red' is a similar term used when referring to very hot metals, observed in the crucible just about ready to be poured.

CHIPPING OUT

The process of removing a waste mould, usually made from plaster of Paris. Using a wooden mallet and a blunted joiner's chisel, the plaster mould is carefully chipped away to reveal the casting. The wooden mallet, striking the wooden handle of the joiner's chisel, muffles the shock of the blow sufficiently to protect the casting, an important factor, especially if the casting is also plaster, or a fragile wax. The blunted chisel causes the mould pieces to break away from the surface; a sharp chisel would cut through the mould and into the surface of the cast. The effect of the release agent will now be appreciated as the mould fractures and lifts from the cast surface (see Release/Parting Agents). *Do not* try to prise off large sections from fragile castings, such as plaster, cement or wax. It may be possible to prise sections of mould from the tougher materials such as resin or concrete, but even with these harder materials it is not a wise procedure.

When chipping out a wax casting from a waste mould, it is a good idea to tap the mould all over to make a myriad of small cracks. In this way the wax can be carefully revealed with little risk of exerting undue stress on the casting by leaving large pieces of mould to be chipped off.

Direct the chisel so that you chip *into* the mass of the mould and cast and not *across* it. This will help to avoid breaking off any projecting items. Start whenever possible by revealing a high point on the sculpture, then gradually chip away the mould to expose more and more of the casting.

The value of a coloured warning coat will be appreciated at this point, especially if the mould and cast are of the same material and colour. Continue chipping until the mould is reduced to waste and the complete casting exposed. The very last vestige of mould must be removed: fine dental tools are useful aids to cleaning plaster that clings to deep texture.

CIRE PERDUE

Cire perdue is an imported French term frequently used in preference to the English translation 'lost wax', possibly because this technique came to Britain via France and French artisans.

CLAY

The most basic substance, common in one form or another, to most parts of the world and to most cultures. It is a stiff, tenacious material, formed during the erosion of igneous rock by wind and water, dropped over centuries on river beds. These deposits have often provided the basis for particular ceramic industries from prehistoric times up to the twenty-first century. The various brick field and ceramic towns, such as Stoke-on-Trent in England and Limoges in France, are examples of this.

Residual or primary clay is the purest, found close to the stone from which it derives; this becomes China clay or kaolin, from which porcelain is manufactured.

Sedimentary or secondary clay is primary clay that has been washed downriver collecting organic matter on its way, together with minerals and oxides. When this collection is deposited and settles, the organic matter decays and blends to

John W Mills chipping out a GRP casting from a plaster waste mould.

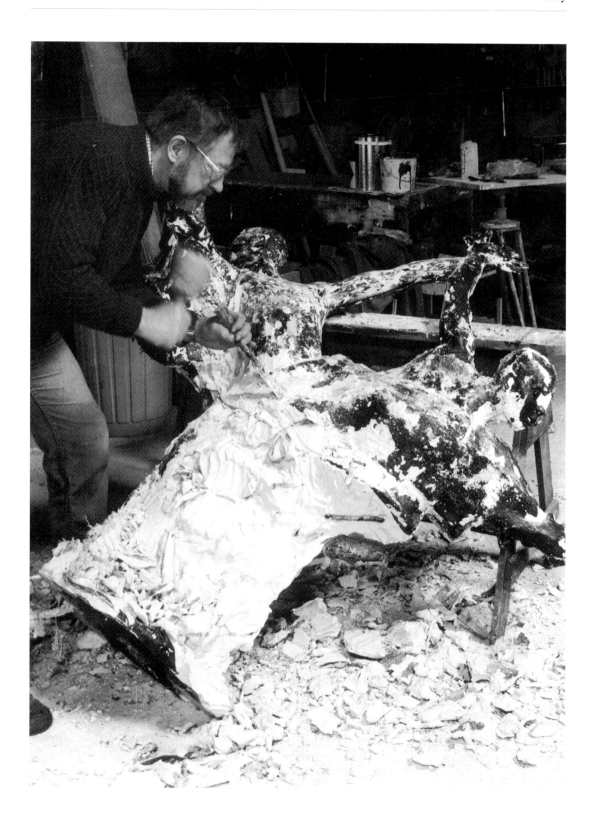

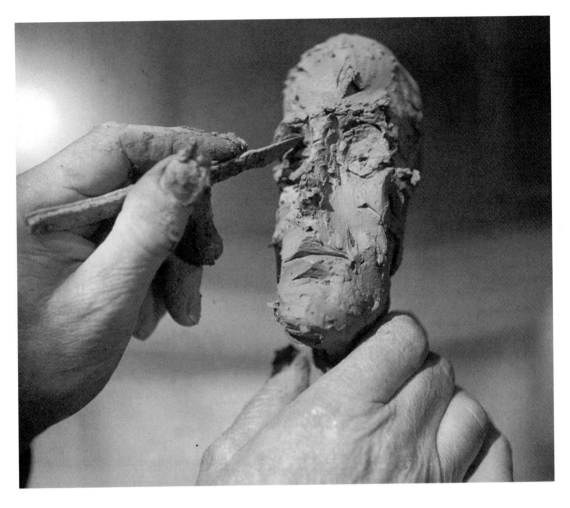

The hands of Alberto Giacometti modelling a clay head.

make the material most commonly used in clay cultures to make all manner of terracotta. Various mixes of the sedimentary clays form the bulk of clay used by artists.

Clay is easily fashioned; it has a tactile, squashy character that positively invites image making. There are very few cultures that have left no clay images; the Eskimo and Easter Islanders are among them. All civilizations which have used clay have, remarkably, produced images and vessels of a similar character, even when no communication has been possible across centuries or around the world. By studying this phenomenon, it is possible to learn the lesson of unsupported clay, as well as to appreciate the gift of the freedom of expression that clay allows.

Clay suitable for modelling is readily available in most places and can be purchased in various forms, ready for use. Clay of good plasticity is needed. Poor quality clay has little or no plasticity and is often short, that is, it is not possible to stretch the clay without it quickly breaking, thus making it difficult to work. By mixing poor quality clay, however, with a finer one, or by storing it for

John Mills starting the clay build up of the image of *Rembrandt*.

The clay is being handled quite freely and the image emerges. In the background is a head of *William Blake* that was made in direct plaster.

a while, a workable clay can be made. The organic matter in secondary clay, when this is kept damp, will continue to decay and ferment thus adding plasticity to the clay body. Over long periods of time, being worked and stored in the studio, clay will mature to a fine state for use as an exclusive modelling medium (not suitable, usually, for baking). Further organic matter, picked up during modelling and preparation, adds to the quality of the mix. Sculptors often jealously guard their store of modelling clay. Clays used for firing to make terracotta are, however, another matter.

Armatures (see Armature/Support) are required to support modelling clay to make complex forms of various kinds, and these structures will be better designed as you develop a good working knowledge of clay. Clay which contains coarse sand or grog is largely unsuitable as a modelling material, because it allows water to penetrate the body of material and break down the adhesion of particles: the clay is liable to collapse and fall from the armature. Clay is often required to stay secure on its armature for some time – some sculptors keep a work in progress

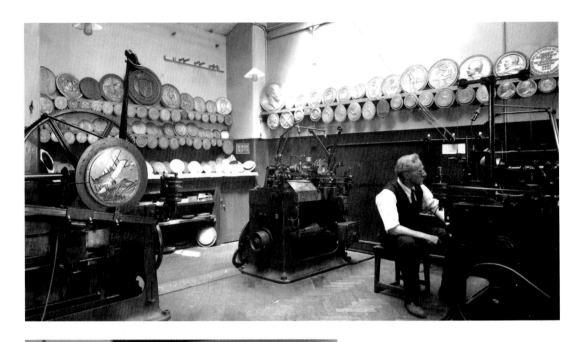

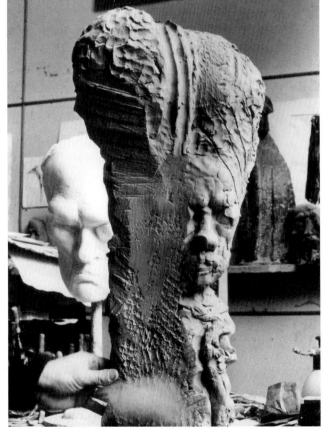

ABOVE The die-making workshop of the Royal Mint, UK, showing the pantograph machines that reduce the relief image to whatever size is required for coins or medals. On the shelves are many original plasters.

LEFT The image of *Rembrandt* continues (see previous page) to develop. The marks of fingers and various modelling tools can be seen on the clay.

over a number of months or even years. Coarse clay is therefore best kept for firing. Natural, water-based clays harden gradually when they are exposed to the air and should be kept well wrapped with wet cloths and plastic sheet when being modelled. Regular spraying with a fine water spray is essential as work progresses. The worst conditions for working clay are in air-conditioned environments or in the open air. A combination of wind and sun provides the quickest drying conditions. Freezing, of course, must be avoided at all costs; as frozen clay thaws it will collapse totally. (This can be countered by using synthetic clay.)

How you store clay in the studio is important. Galvanized metal or heavy-duty plastic containers make the best storage vessels for wet clay. If you use a number of containers you can store clay of different consistencies to suit particular needs. Clean the clay after use as best you can; take out any particles of plaster or metal – if iron remains in the clay it will rust and make a dry, crumbly pocket within the body of the clay. Store dry clay in suitable containers – it will be half the weight of wet clay – and keep them sealed to prevent contamination.

Dry clay can be easily reconstituted by immersing it in water. This will result in a slurry which is then laid out on porous plaster or wooden slabs so that it can dry to the consistency that is required.

CLEANING UP

The term given to working on the casting once it is removed from the mould. A perfect casting, that is, one that does not require further work, is seldom, if ever, achieved. Seam flashing has to be

Giacomo Manzù's *Dancer* in bronze, 1966–67, Detroit.

removed; any air bubbles, which appear as small depressions or holes in the cast surface, require filling. Large holes which might have occurred as a result of heavy-handed chipping out, or negligent coverage of the mould surface during casting, etc., require patching. The whole cast surface must be pulled together according to the artist's wishes, in readiness for any colouring or additional work (see Finishes).

COINS (*see* **Relief**)

Coins have been significant, if small, cultural examples of relief sculpture for thousands of years. The demands on the artist's/craftsman's skills in making coinage are extreme. Moulding and casting is perhaps the oldest technique for making repeated copies of an object that could be used as currency; however, the need for quick production and large quantities led eventually to the striking of coins and therefore the production of a die. The die is a chisel-like tool with a blunt, flat striking surface on which the coin imagery has been engraved. The engraving is in reverse (the intaglio cut into the flat surface), and when this is hit with a hammer on to a soft metal such as gold, silver or copper, a coin is struck and the image stands proud from the flat surface.

This technique was later replaced with mechanical processes resulting in the modern Mint. The dies are now produced on three-dimensional pantographs with computer-aided cutters, working from an artist's original work, which is usually made from plaster of Paris. The image must not include undercut shapes due to the eventual hammer action of the die stamping (striking) the coin. The height of relief is determined by the nature and size of the coin (sometimes the press will be required to strike the coin or medal a number of times if the imagery is heavy). The pantograph copies every detail of the artist's original work and reduces it to the size of the required die, ready for the press to carry out the striking. (See photograph of Royal Mint, page 62.)

CONCRETE

A material that now has an assured place in the sculptor's repertoire of materials and related skills, and is used in many ways. Studio application involves high-fidelity casting, as accurate in the reproduction of detail as any material allows, whilst most of the industrial applications of concrete can be utilized by sculptors working on large projects.

The term concrete, when used by sculptors, tends to include all mixtures using cement as a basic binding agent. In the building and construction industry, the name is given to those substances resulting from a mixture of cement, a small aggregate such as sand, plus a large stone aggregate with a gradation of particle size from 3mm (⅛in) to 25mm (1in). Such concrete has great compressive strength but no tensile strength, which has to be given in the form of metal reinforcing.

Reinforced concrete is made by pouring a concrete mix into a cavity in which high-tensile steel rods are included to provide tensile strength.

Pre-stressed concrete is usually factory-made. Concrete is poured into a mould, in which steel reinforcing is already in place, held under tension. This tension is maintained until the concrete has set, hardened and cured. Such pre-stressed concrete castings can be fine in form, able to span an area and retain maximum strength. This is a fundamental reason for some important developments in architecture and civil engineering during the twentieth century, most notably in bridge construction and the design and building of stadiums, where concrete has enabled the architect and engineer to achieve vast spans of uninterrupted roofing over football stadiums, ice rinks, etc.

CONCRETE MIXING (DRY AND WET)

Mixing or making the concrete mix to be used is a most important factor in the process of casting. First of all, estimate the total amount of material required to complete the job in hand. Measure the proportions accurately, using a bowl or bucket or some such vessel. Dry-mix these materials thoroughly until the colour is even throughout: make sure there are no pockets of unmixed ingredients remaining. The dry mix is now ready to be made into wet mix.

From the dry mix, take enough material to deal with a particular area of the mould, or to complete a particular section of work. Try to estimate how much can be done at any one time. It is not wise to wet-mix the whole dry mixture; for a large mould this will only result in waste. For a small mould it may be safe to mix the total amount; however, this depends on the speed at which you work.

To make the wet mix, add water gradually, mixing thoroughly until the consistency of the mix is as required. This will vary according to the aggregate. With a large aggregate, sand or other coarse materials, giving a small surface area, the mix should be fairly dry in character. Pat the mix and it should become moist on the surface. When squeezed in the hand this mix should remain firm in the forced shape.

If a wetter mix is required, add more water, and therefore more cement (these should always be added in the same proportion). Smaller aggregates, offering a greater surface area, need more water to make a satisfactory mix. A mix the consistency of thick cream is most satisfactory. A cement and fine aggregate mix can be made similar in consistency to clay. This is useful when filling a mould to ensure an even coverage of the mould surface.

I must stress again the importance of mixing both dry and wet mixes evenly. An even colour, without patches of unmixed aggregate, is the aim. Any unmixed patches will usually appear on the surface of the cast, and ruin the quality of the work. Mixing is made easier if you have a suitable mixing vessel. A polythene bath is ideal for mixing mortar and small batches of concrete. I use one to make the dry mix and another, or a plastic bowl, to make the wet mix. Or you can make a mixing box painted on the inside with polyester resin and glass fibre, to create a satisfactory, resistant surface. Remember to curve all joins so as to facilitate mixing. You can also line it with polythene as a temporary measure.

Coarser aggregates, because of their smaller surface area, are mixed in the ratio of 1 part cement to 6 parts of large aggregate (2 parts gravel, 4 parts sand); this is a concrete. A mortar mix using only sand as an aggregate is 1 part cement to 3 parts sand; 1–3 because the surface area of the aggregate is greater. Finer aggregates, such as pumice powder, brick dust, or very fine mesh-washed sand are mixed in equal proportions, because the surface area of the aggregate is larger still. It is unwise to increase the proportion of the aggregate when its sieve size is almost the same as the size of the cement. The perfect aggregate contains particles evenly graded between the largest and the smallest, and is clean and dry. Always use a consistent measure throughout a job to be certain of mixes.

The water added to make the mix should be clean and should be added in proportion to the amount of cement in the mixture. The more cement used, the more water it is possible to add, whilst still retaining the strength and character of the mix. Water added in too great a quantity to a mixture, with a small proportion of cement, will simply filter the cement down through the aggregate. The wet mix should never be liquid, however. If, when using sand or larger aggregate, it

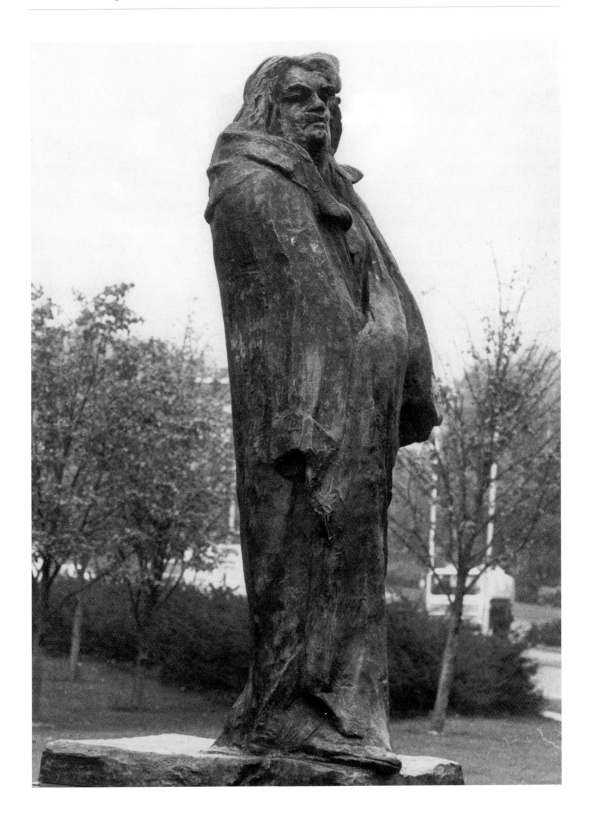

is necessary to make a wetter mix than usual, then add more cement as well. The actual amount of water added to make a mix workable varies according to the nature of the job.

The coarser aggregates are naturally rugged in appearance and should be selected with this character in mind. Sand as an aggregate can be used to achieve both a fairly fine casting and a more rugged, open character. For a fine-fidelity surface, together with the compressive strength of large aggregates, apply a mixture of finer material (neat cement, for instance) to the surface of the mould first. Fine aggregates afford reproduction of the slightest detail, even fingerprints!

To gain greater strength from the fine aggregate mixes, add in layers of laminations, glass fibre or terylene fibre. This will serve to give the casting greater tensile strength, and produce a very durable, lightweight, final piece of work. Of course, these various mixtures can be combined and should be selected according to colour, appearance and compressive or tensile strength. When selecting and purchasing an aggregate, take care that it does not harbour any material which will contaminate the cement and prevent it from setting, particularly important when dealing with aluminous cements. Keep all the ingredients of a mix, including the water, as clean as possible.

The following is a list of mixes I have found most useful. There are many more, however, and you can experiment yourself, but be sure to test a new mix or a new batch of materials.

1 part cement to 3 parts sharp sand
1 part cement to 3 parts silver sand
1 part cement to 1 part marble dust plus 3 parts marble chips from 3mm (⅛in)

1 part cement to 1 part marble dust plus 3 parts granite chips from 3mm (⅛in)
1 part cement to 3 parts grog (ground ceramic)
1 part cement to 3 parts ground stone (any good-quality stone)
1 part cement to 1 part pumice powder plus 2 parts plastic granules (useful for exposed aggregate work)
2 parts cement to 2 parts marble dust plus 1 part pulverized fuel ash
1 part cement to 1 part pumice powder
1 part cement to 1 part brick dust
1 part cement to 1 part mixed brick dust and marble dust

You can also experiment with combinations of various mixes.

Setting, hardening and curing

When water is added to the dry concrete mix, the process of hydration begins, causing the cement to solidify and bind the aggregate. The initial change from a fluid to a solid condition is known as the setting, not to be confused with hardening which is the strength development time, after setting. Curing is the period of maintaining the development of strength in the solid, by prolonging favourable conditions. Hardening, and therefore curing, will cease as the solid dries out. Proper cure will depend upon the retention of moisture in the concrete. The development of strength in the solid concrete goes on indefinitely, if conditions are favourable. The following chart can be used as a rough guide:

High alumina cement has the quickest setting and hardening times; it cures sufficiently in 24 hours to

	Setting time	Hardening time	Curing time
Portland cement	10 hrs	3 days	21 days
Rapid hardening Portland	10 hrs	24 hrs	7 days
High alumina cement	3 hrs	7 hrs	24 hrs

be used. Of course, if it is kept under favourable, moist conditions the cure will go on very slowly developing strength. This applies to all types of concrete. In terms of actual compressive strength, results shown in pounds per square inch have developed as follows:

Because of the strength variability of aggregates, these figures are given only as a guide and are not definitive.

	24 hrs	3 days	28 days
Portland cement	—	1,500	4,000
Rapid hardening Portland	500	2,300	5,000
High alumina cement	5,600	7,300	8,500

In practice, this means that when a mould has been filled, both filling and mould must be covered with wet cloths and plastic. High alumina cements must not be allowed to dehydrate, and the best results are achieved by covering completely with saturated cloths and sealing this moisture in by wrapping tightly with plastic sheeting for 24 hours. Portland cements require less moisture than high alumina cements and so are wrapped in wet-wrung, but *not* saturated, cloths. They can be allowed to dry out slowly according to the chosen hardening and curing time. The longer they remain wet, the stronger the concrete.

It is best not to leave a mould uncovered after filling or during the filling process. Crazing and cracking will occur if the concrete is allowed to dry out too quickly and, therefore, shrink. Little or no volumetric shrinkage will take place if the concrete is properly cured.

CORE

The mould of the inner surface of a metal casting. It maintains the correct cavity and therefore determines the metal thickness. In lost wax casting, the hollow wax is filled with investment to make the core, which is suitably reinforced and vented. Pins are driven through the wax into the core, remaining proud of the wax surface to be picked up and included in the investment mould. These pins retain the correct disposition of the core and investment mould when the wax is melted out.

In sand casting, the inner mould is made by taking a core sand impression from the completed sand piece mould, which is then pared down by the required thickness to determine the metal wall. Some foundries line the sand mould with a layer of polystyrene before taking the core impression, which will then require only minor adjustments to gain the necessary volume and mould cavity. When placed in the mould assembly, jiggers, or metal pins, are used to locate the core and keep it in its correct alignment.

CORE PINS

The metal devices which hold the core and mould in their correct disposition during metal casting, to maintain the planned metal thickness. These pins are usually of ferrous metal: common iron nails are used most often. Stainless steel pins are more expensive but are reusable, with care. Non-ferrous pins can be used but there is always the danger that the molten metal will soften the pins and cause the core to move. Non-ferrous pins would therefore need to be thicker than those otherwise used. By using non-ferrous pins, you will not obviate the need for drilling out and tapping, or welding, the hole to gain a sound surface. Oxidization will occur around the pins, even of the same metal, and leave a dark ring.

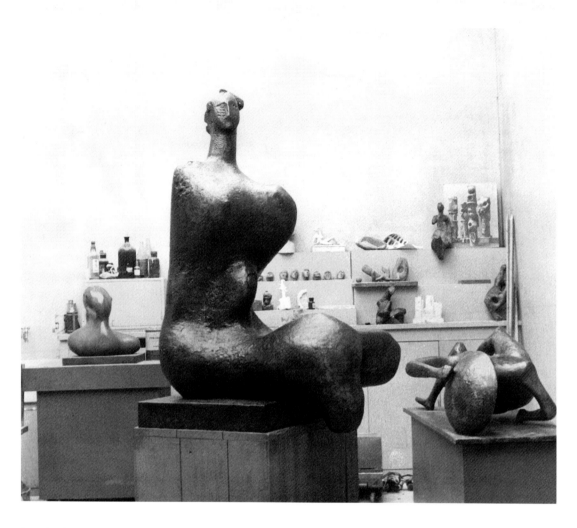

Henry Moore's studio showing a completed bronze and a range of maquettes.

CRUCIBLE

The vessel in which metal is melted and made ready for pouring. Crucibles made of silicon carbide are the most common and durable. Other high-temperature refractory castables are used to make crucibles for specific purposes, for instance industrial-grade porcelain crucibles are made to melt precious metals, and for controlled laboratory experiments. Sculptors, however, are primarily concerned with the tough foundry item, always referred to as 'the pot'.

The crucible is a crucial factor in any metal-casting process and should be treated with respect at all times. After each pour, whilst the crucible is hot, scrape any residue of flux or metal from the sides, and take care to ensure that nothing sticks to it in the furnace. To prevent this, stand the crucible on cardboard which will carbonize during the burn, or alternatively on sand. The crucible will then lift out clean from the furnace. Standing the

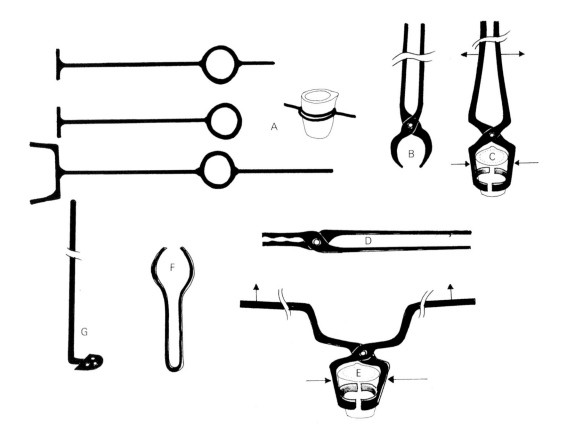

A selection of foundry tools representing the basic needs for use with the furnace and crucible in metal casting:

A Shank and ring, one-man and two-man versions.

B and D Tongs of various kinds, essential when handling hot metal.

C Crucible tongs designed to grab the crucible as the handles are held apart.

E Two-man crucible tongs: the principle is the same and as the two men lift, so the tongs grab the crucible more securely.

F Small crucible tongs as used on crucibles that hold only a few grams (ounces) of metal.

G The skimmer, used to remove dross from the molten metal before pouring.

crucible on stilts in the furnace is not good practice; the stilts will inevitably stick to it and have to be knocked away, damaging the pot. Such stilts also make the pot unstable during the melt and charging of the crucible.

DE-WAXING

A technique sometimes employed in traditional lost wax casting, but more often part of the mould preparation for ceramic shell investment casting. Traditional solid investments can just be placed in a steam-generating atmosphere, and contained there long enough for the wax to melt without being absorbed into the mould material. This procedure allows the wax to be run out and reclaimed, whilst at the same time giving an

Assassins I by Elisabeth Frink, 1963. Made with the process of direct plaster moulding.

indication of the amount of wax that has been evacuated from the mould, suggesting thereby how much further baking time is needed. Once the mould has been de-waxed, it can be placed in a kiln and baked, bringing it up to a temperature of 600°C.

De-waxing is an economical process in mould preparation; it takes a little longer but has the bonus of reclaiming expensive wax. Ceramic shell moulds must be de-waxed prior to baking, so that the wax can be evacuated without expanding and cracking the mould wall. These moulds are subjected to a pre-heat greater than that at which the wax melts, anything from 200–1000°C. I have described a means of achieving this under the heading 'Firing for Ceramic Shell', but such de-waxing can also be achieved by using an autoclave, immersing the complete mould in a bath of molten wax held at its hottest temperature, or under infra-red heaters.

DIRECT MOULDING

A means of making sculpture by manufacturing the negative first. Almost all castable materials can be shaped in this way, provided that an appropriate moulding material is used. For instance, a negative form carved from foam resin (polystyrene/Styrofoam) will allow castings to be made in plaster and concrete; if the foam is painted with an emulsion paint as a preparation, castings of resin (GRP) can be taken. Julius Schmidt at the Cranbrook School of Art, Michigan, perfected the technique of constructing moulds of foundry casting sand, usually resin bonded, from which he made cast-iron sculpture. Large metal sculpture, cast in one piece, or by casting units to be assembled, etc., can be made using these skills. The process is particularly applicable to making relief sculpture (see Sand Box Casting).

Bronze Age man understood this technique well; it was one of the methods he used to make axe and arrow heads. He carved the desired shape in stone or chalk and simply poured the molten metal into this pre-shaped cavity, making an open casting in most cases. Complex four-finned arrow heads would later require closed moulds, which he made in the same direct way, cutting or modelling matching mould sections. Blocks of stone survive from this time which carry as many as eight different-sized negative patterns for axe heads.

All the malleable materials can be used in this way. Clay is an obvious case; terracotta moulds can be modelled from which castings in clay, via the slip cast or press-casting techniques, can be produced. Of course, terracotta moulds are also suitable for receiving molten metal of all kinds, providing the mould is absolutely dry; any moisture presents a real hazard. Soft clay will enable castings of plaster, cement and concrete, resin (if the mould is allowed to become leather-hard first) and wax. Some of the earlier sculptures of Eduardo Paolozzi exploited this latter combination of clay and wax.

Some medal makers work the mould (die) directly, a technique which often imparts a certain bravura quality to the work, but one which has, nevertheless, prompted a renewed interest in the art of medal making. The practice of filling plastic bags, balloons and industrial containers is a form of direct moulding but one more given to eccentricity! Sand box casting is another pleasurable technique that can act as an introduction to casting processes whilst enabling the sculptor to produce sculptures which contain an element of accidental form.

DIRECT PLASTER

The expression given to building a sculpture with plaster of Paris directly.

DIRECT PLASTER AIDS

Plaster, because of its brittle nature when hard, will require reinforcement of some kind. You will have

to decide whether or not any proposed sculpture requires a complex armature (see Armature). There are a variety of other strengthening aids as well.

Jute scrim, burlap, hemp or gauze

These aids provide fibrous strength and bulk, plus a small degree of flexibility. Jute scrim is particularly useful; it is manufactured in rolls of various widths, and when dipped in plaster can be used to bind the plaster securely to the armature and to fix pieces of armature together.

Woodwool or woodshavings, sawdust, vermiculite or mica

Added to the plaster, these will help to build bulk quickly. The latter two do not hold water and so help reduce the weight of the final form considerably. They also help retain the sharpness of any tool used.

Polystyrene (Styrofoam)

Probably the most useful modern aid to building directly with plaster. It can be used in the construction of the armature and, in addition, can be cut or broken into strips or pieces which, dipped in or coated with plaster, can be easily stuck piece to piece. A stiff wire pushed through one piece of foam into another will hold them temporarily whilst the plaster hardens. The foam can easily be cut to make any changes. This useful material provides strength as well as bulk.

Polyurethane foam

Can be used in the same way as polystyrene. It is a finer, stronger material, but more expensive.

Wood

Can be used in the same way as the foams but is not so flexible. Because of its porosity, water affects its value; the wood will retain moisture and this can be detrimental to the plaster. Also, wood contained in a plaster form is liable to expand and contract with changes in atmosphere and this will cause some cracking. All wood by-products react in this way.

Paper and card

In their various forms these can be included in a plaster build-up, to gain bulk and speed. Obviously, they have a similar disadvantage to wood in that they retain moisture.

Polycell

A small amount of this polycellulose material added to plaster will cause the fresh plaster to bond without soaking the older surface: the whole work can be kept free of water. Other proprietary polycellulose materials will do the same job – experiment to learn how best to use them.

DIRECT PLASTER BUILD-UP

Having made the bowl of plaster, take the scrim and dip it into the mix; two or three pieces can be prepared at once. Then carefully bind these strips of plaster-soaked scrim around the armature. Do this in a spiral to prevent the scrim and plaster sliding down the metal and to provide a key for successive applications of plaster. Use gauze or thin strips of even scrim for fine forms. If you use a blanket of scrim or burlap/hemp, follow the same procedure.

As the plaster stiffens, it is used to continue the build-up. Use the hands and fingers for large volumes, and work quickly but not carelessly. Work on smaller forms using metal spatulas (not wooden tools). These spatulas are used to gain greater control as the work progresses. You will find that, after practice, the plaster can be easily scooped from the bowl with the spatula and

Polystyrene (Styrofoam) image by Derek Howarth, who uses his skills to help other artists enlarge their work. Here, working on a sculpture for Allen Jones, the image is already sliced to receive the steel armature.

placed where it is most needed. The changing nature of the setting plaster stiffening makes this control possible. Build up the form carefully. *Do not* mix too much plaster at a time; try to keep it under control. *Do not* be tempted to continue using the plaster as it becomes crumbly in the bowl, or to add water to it in an effort to soften it.

When you add new plaster to old, make sure the old surface is thoroughly wet. If it is not soaked, moisture will be sucked from the fresh plaster causing it to flake off. Successive fresh applications can usually be made without soaking, except in very dry conditions. Scratch any smooth surface to provide a key for further build-up.

To avoid the problem of wetting down dry plaster while still achieving a secure bond, add a small percentage of polycellulose filler to a plaster mix. This can help overcome the messy conditions associated with building directly with plaster of Paris.

Textures will occur naturally as the material hardens and the work progresses. Some sculptors further exploit the rough, heavy texture easily made with plaster. A whole range of surface texture can be achieved by cutting and carving the plaster as it hardens and after it is a solid. Experiment with various tools to develop a personal approach. Try using axes, chisels, rasps, rifflers and knives, and don't forget that you can

RIGHT The polystyrene image has the steel armature inserted.

always add to the form, so any brash cutting or carving can be remedied.

Smooth surfaces on plaster are achieved in several different ways. On fresh plaster, after using rasps and rifflers, rub over with pieces of fine woven metal mesh. The mesh will clog up – just shake it out and continue.

Sandpaper is not satisfactory on fresh plaster as it will clog up quickly; however, it is extremely useful on dry plaster. You can use both wet and dry emery, but this can sometimes result in too much water being produced, making for unpleasant working conditions.

Almost any abrasive can be used on dry plaster but beware of power tools; they create too much dust for comfort, and are usually too fierce for this material. Experiment a little to find out for yourself.

DRESSED STONE

Blocks of stone from which any roughness resulting from quarrying has been removed. Such blocks are roughly rectangular for ease of transportation to the stone yard, and for ease of calculation of volume and subsequent cost.

DRILLING

In sculpture this is more than the simple act of making a hole. The tools used range from the simplest pointed rod to the modern electric and pneumatically powered versions.

The stone carver drills holes to split the stone, to place and secure lifting tackle, as well as in the actual carving process. By drilling to controlled depths, he can locate a surface in the block; this is a special feature of the enlarging and reproducing process. The drill is also used as a drawing aid for the carver, helping to achieve deeply defined shapes that enhance the play of light and dark, giving a certain drama to the form. Holes are, of course, also drilled for the conventional reasons of placing fixings, bolts, etc.

For the *woodcarver*, the drill is the means of providing a hole for all the conventional reasons; to secure a screw or bolt, to help make a joint and as an aid in piercing a block to create form or provide decoration. An auger, driven through the heart of a log, will help control the shrinkage as the wood seasons (*see Seasoning*). Auger bits are used to remove large areas of wood to prescribed depths.

To the *metalworker*, the drill, together with thread cutting, taps and dies, is part of the means of assembling components using bolts and rivets.

The power drill

With its various attachments this has a wide range of applications for the sculptor, from drilling holes and sanding surfaces to mixing paint (or any two-part resins), etc.

DRY MIX

When making particular concrete mixes it is best to mix the various ingredients dry. An even distribution of materials is essential and this is most easily judged when the materials are dry, and an even colour can be seen to indicate a thorough mixing. Such mixing is best carried out in a broad-based container. Polythene baths are now manufactured for use in the building trade, to mix and carry mortar, and these are ideal for studio use too. Cement mixers, powered or manually operated, are of course equally useful, especially if a large batch of material is being prepared.

Investment materials for metal casting are also best mixed dry, for the same reason – to achieve an even mix. Always try to mix enough material to complete the job in hand. This will help to ensure a consistency throughout the work, a matter of the utmost importance, no matter what the material being used.

EDITIONING

Making a number of castings from a master, either a cast or master mould, has been the practice since the Renaissance. It is a way of spreading costs over a production run of a limited edition. In some cases unlimited numbers were made; today it is usual to declare the edition to be made by numbering the work, e.g. 1/6, meaning number one in an edition of six castings. In the past the master cast was often destroyed or altered after use so that no more castings could be made from it.

Now some artists retain the master cast, but it should be clearly identified, as with Henry Moore's gift to the Ontario Museum of Fine Art, in Toronto. The gift is a collection of master copies, all of plaster. Some artists retain the right to make artist's copies, which should be clearly marked as such, i.e. A/C 1, etc. Long editions are not greatly favoured either by sculptors or collectors, although items are sometimes advertised as being of a limited edition of 1,000, for example. Whatever the edition, the collector needs to be assured that no more than the stated number will be made.

Of course, identifying editions by numbering is a twentieth-century phenomenon, of greatest value to compilers of a *catalogue raisonné*, gallery owners and collectors. It doesn't affect the true aesthetic value of a good piece. There are no edition numbers, for example, on the bronzes of Giambologna; they tend to pop up all over the world and are very highly prized.

The artist is expected to behave ethically, however, and so he should, subject of course to earning a living so as to survive to make the next work. Clearly identified editions are proof of the sculptor's ethics, and should be respected by all. A unique work can be numbered as 1/1 or inscribed as unique.

Forgery in art is a subject enjoyed by the popular press, and in sculpture particularly, cast metal works and modern foundry materials have made forgery a growing industry. It is relatively simple to make a flexible mould to work forgeries from. If the master cast is not used for this purpose, however, any clandestine casting will be volumetrically smaller than the legal copies. Some foundries will supply a certificate of authenticity clearly identifying the casting, giving its dimensions, etc., in an effort to foil the forger.

ENLARGING (*see* Scaling Up)

A procedure that concerns all working sculptors when making the transition from the maquette or sketch model to the large-scale work. The methods of calculation employed are more or less the same for all materials. The simplest is using proportional callipers, the most complex and the most accurate method is that using a pointing machine. This is a three-dimensional pantograph designed to make proportional calibrations by means of fixed points. Both systems use the mechanical multiplication of measurement. Sculptors devise personal variations on these themes but all depend on establishing fixed points of reference on the maquette that are then transferred to the larger-scale project. These fixed points must not be altered nor should the base on which the work stands be changed, as they provide the datum against which all measurements are taken.

A three-dimensional pantograph incorporating a cutting needle is used by some artisans to make exact reproductions of surface and texture, usually in plaster, clay or some other suitably soft material. The needle echoes the scanning pointer and cuts the image. In medal making and coinage, these pantographs are used to make very precise reductions. A blunt needle scans the pattern at one end of the machine and its movements are followed accurately by a sharp cutting needle, to make the proportional reproduction in a suitable metal making the die with which the medal or coin can be

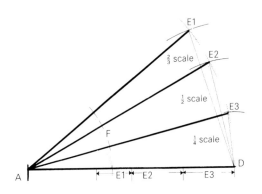

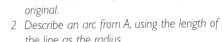

LEFT *Calculating the reduction of a measurement:*
1 *Draw a line A–D equal to the height of the original.*
2 *Describe an arc from A, using the length of the line as the radius.*
3 *Take another radius equal to a chosen proportion of the line A–D (say, ¹/₄) and describe an arc to cross the first at E.*
4 *Connect the point A–E.*
5 *To use this scale, make a measurement from the original and use this as a radium to make an arc from A to cross both line A–D and A–E.*
6 *The measurement required is the distance between the two lines at which the arc crosses F.*

OPPOSITE *An enlarging frame, made with callibrations in as many planes as possible.*
A and B *The elevations and plan, which show the kind of frame to be made proportionally around the maquette, or working model, and around the enlargement. If the copy is direct and actual size, the two frames should be the same size. Plumb lines ensure a true vertical.*
C *An adequate scaling system, suitable to give an approximation from the sketch model.*

BELOW *A pointing machine*
A *The pointing machine built up around a block of stone with pointers set to correspond to those identified on the original.*
B *The pointers are adjustable in all directions based upon the correct vertical of the frame and the fixed points, in this case shown as crosses at the base of the sculpture.*

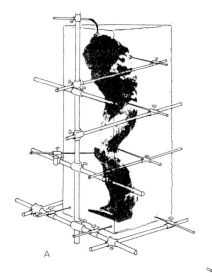

A

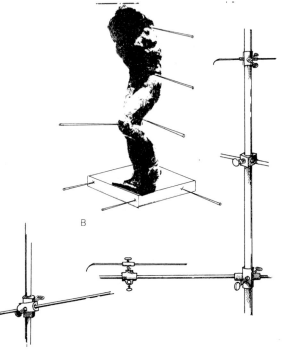

B

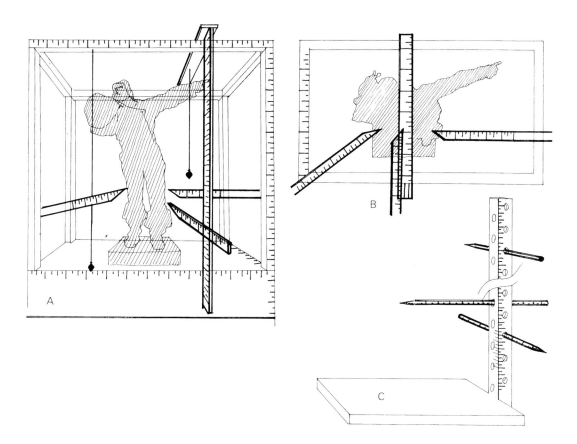

struck. Both the pattern and the reproduction slowly turn as the scanning and cutting are done.

I have provided diagrams of some of the enlarging methods, plus simple drawn scales that can be used with callipers. These aids can, of course, be used to make copies at actual size also.

A relatively simple but useful method of enlarging is achieved by making a series of templates. These are made from a definitive working model of the projected sculpture, the working model being larger than a sketch or maquette version. This working model needs to be made of a material that will allow the form to be cut or sawn, i.e. plaster of Paris or resin. The working model is cut or sawn through to make a number of profile-like slices. When placed together

the slices equal the original form but each individual slice provides an accurate section through the form, making in effect a template. Each template section can be proportionally enlarged and, when assembled together, provide an enlarged version of the original form and the basis for completing the larger work.

Any template can be enlarged, or reduced, by simply 'squaring up', that is, drawing a calibrated grid over it which is then related to a similar but larger, or smaller, calibrated grid that provides the aid to scaling up or down (see illustration above).

EPOXY RESINS (*see* **Plastics, Resins**)

When used in laminations, mostly with glass fibre, epoxy resins provide a much harder final product

than the laminate made with polyester resin. Epoxy is often the preferred material when the final sculpture is to be resin, as it has greater durability and better contact/impact resistance.

Variations of this resin are formulated to make very strong adhesives for a wide range of materials and can be found in most hardware stores.

EXOTHERMIC HEAT

This is the heat generated by a material as it changes from a liquid to a solid. It can be seen and felt easily if you make a strong mix of plaster of Paris: as this sets it steams gently and is warm to the touch. The same thing occurs when cement sets, and rapid-setting cements such as high aluminous cement can get quite hot to the touch. If you mix Portland and high alumina cement the exotherm creates a flash set, resulting in a very quick hardening of the mix. This can be useful but is not good practice.

The heat generated during the polymerization, thus molecular crosslinking, of various resins can be great enough to burn. An over-accelerated resin applied too thickly or poured as a solid will create great heat. This will cause the material to splinter and crack, sometimes dangerously, and so proportions should be judged carefully.

The heat generated by setting plaster poured into a mould made of wax, can become an aid. The heat will warm and soften the wax sufficiently to allow it to be carefully peeled from the plaster cast. This usually can be done when the plaster is hard enough to stand up to a certain degree of handling.

EXPLOSION CASTING

A technique devised for use in industry, where there is often a need to produce one-off, high-fidelity castings; there is a similar need in sculpture, but this solution is quite an expensive one. High explosives are placed on top of the chosen metal,

which in turn is placed on top of the mould (this can be made from plaster of Paris). The mould is cushioned in water, which will absorb the shock waves from the explosion. When the charge is detonated the metal is forced into the mould with great velocity, and the resulting casting reproduces accurately all features of the mould, both form and surface detail.

FABRICATION

Perhaps the most famous fabricated image of modern times is the *Statue of Liberty* designed by Bartoldi. Although there have always been jobbing artisans practising those crafts long associated with sculpture, it is not unusual today for artists to have their work fabricated; that is, to have a sculpture made *for* them, from drawings or small sketches, by craftsmen practising a wide range of industrial skills.

The metalworking skills typical of heavy industry, such as those associated with shipbuilding, contribute to the large-scale abstract works that are seen in public places. This phenomenon has grown out of the relatively modern techniques of sculptors' welding and has led to specialist sculpture-fabricating workshops, making available to the artist techniques and processes from the manufacturing industries.

FIBREGLASS (*see* GRP)

This has become a much-abused title, all too often used wrongly to describe items made of glass-reinforced polyester (GRP). The name actually covers only the material which is made up of strands or fibres of glass. These fibres have been made by forcing molten glass through minute holes to make strands of fine glass with sufficient flexibility to be woven into cloth. It is subsequently manufactured in a number of

William Tucker series A no 1 in fibreglass, 1968–69.

different forms, and those most commonly used by sculptors are as follows:

Chopped strand mat

This is a mat of random strands of glass 50mm (2in) long, which is used to give multidirectional strength to resins of all kinds and to concrete made with high alumina cement (*ciment fondu*/lumnite).

Fine strand mat (or tissue)

The finest grade of chopped strand mat, usually used as the first laminate of glass after the gel/surface coat of resin. Used only with resins.

Woven fibreglass

Takes the form of a cloth in the traditional warp and weft manner. It is used as the final lamination, after the chopped strand mat. In this way its two-directional strength is used as a back-up to the strength given by the random fibres.

Roving

A random assembly of long glass fibres, loosely bound together in the form of a thick rope. It is used to build reinforcing ribs to strengthen forms and when properly impregnated with resin is very strong indeed.

Fibreglass is dimensionally stable with a high degree of tensile strength, it is flexible and when used in combination with resin it has high impact strength also, which indicates its usefulness to sculptors. Fibreglass does not shrink or stretch and can withstand temperatures as high as 537°C.

Glass fibre products normally used by sculptors are those manufactured to include a wetting agent; this helps the vital impregnation of the fibre with

the resin. It is worth checking on this point with your supplier, as there are many variations of these materials made for specific purposes. If for instance you need to work in an atmosphere of low temperature or one of high humidity, make sure you are supplied with the correct fibre and resin to function in such conditions. Humidity and moisture can adversely affect the glass fibre and subsequent polymerization of a normal batch resin.

FILLERS

These are the inert materials used with resins. They were originally used to increase their bulk, but it was discovered that they could impart other properties as well. Fillers can give special colour and opacity and they can imitate other materials such as bronze, aluminium, brass, marble, etc. It is for their ability to imitate other materials that resins came to be extensively accepted into the art and design world. Many people deplore their use in this way but their value should nevertheless be acknowledged.

Sadly, one of the finest British stones, Hopton Wood, is now quarried only to make powder to be used as a filler for paints and resins.

Fillers are inert, having no chemical action of their own that might upset the polymerization and crosslinking of the resin or paint. Mostly they are powders with a mesh size as fine as 200, but small aggregates of up to 30 mesh are used with polyester and epoxy resins to give them greater bulk and weight, desirable in sculptures cast in GRP. Some of the fillers used are as follows:

• Talcum powder (French chalk)
• Stone and marble dust of all kinds
• Metal powders of all kinds, especially bronze, brass, copper and aluminium with an optimum mesh size of about 100 mesh
• Sand, mica, silica, kaolin and chalk

When using metal fillers it is best to use a thixotropic agent (pre-gel) in the resin to stop the metal particles settling to the bottom of the mixture. They should remain suspended evenly throughout the surface build, in the gel coat. Do not be tempted to pre-mix the metal and resin too far in advance of using it; it is possible for it to cause an already accelerated resin to set. Mix it in measured quantities as you use the resin. Abide by manufacturers' instructions, or make your own tests before embarking on a major casting or construction, to gain certain knowledge of the product you are using.

FINISHES

The surface treatment of a sculpture is largely a matter of personal preference; the range of surface effects is almost limitless. There are some factors that have an added bearing on choice, however, mostly to do with the final placing of the work. Atmospheric conditions must be taken into consideration if the sculpture is to be placed in the open air. Sulphur in the air will turn bronze black, salt in the air will turn it green. These two conditions have caused sculptors horror in the past; it is a shock to see a completely opposite colour to the one you applied appearing after only a short exposure. The correlation between the prevailing colour and texture of a building is a significant factor also, which affects the choice of materials and thence the colour and texture of the sculpture. The differing qualities inherent in various materials form part of the study and practice of sculpture, enabling the artist to exploit such qualities rather than imposing an alien finish that offends against the nature of the material used. Any finish to be applied to a work should be borne in mind during its making, to be sure of a complete integration of form, finish and environment.

The practical working sculptor will have a good

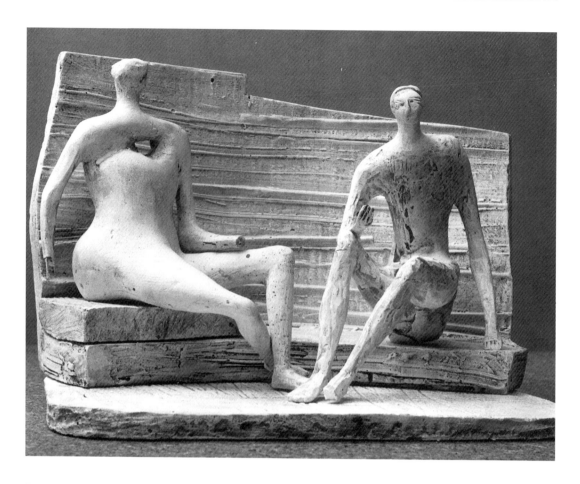

Two Seated Figures Against a Wall by Henry Moore, 1957. This is the plaster original, made in direct plaster.

knowledge of how to achieve many kinds of effect, based on both experience and observation, and a willingness to experiment sensibly with whatever is new to his repertoire. Some ground rules are as follows:

Stone

Stone is, of course, a material that is chosen for its inherent qualities of colour and texture. Whether or not it can be polished to exploit the most subtle colour, or whether it should be left rough cut or bush hammered are considerations arising from the nature of the stone. The ancients did, however, paint their carvings, and there is no reason today why this practice should be avoided. The only proviso is to select the right paint or resin for the kind of stone or marble that is to be used, bearing in mind its final placing. Most paint manufacturers now make paints specifically for stone; seek their advice. Polyester resins can be easily coloured and applied to stone and not only do they give a means of applying colour, but they enable the sculptor to make inlays, by filling suitably prepared recesses in the carving with resin which is later polished off according to the finishing process used. A technique worthy of experiment.

Wood

Wood is also normally selected for its inherent colour and grain, and as with stone such qualities should be exploited to their fullest. Finishes that enhance these inherent qualities are those that seem to follow naturally such as oiling, waxing and polishing either using wax or by burnishing. Such treatment explores the subtleties of colour and grain pattern.

Paint finishes on wood are, of course, as varied as the artist cares to make them; wood has been the basis for many a fine painting and so indicates an infinite range of possibilities. The current taste for limed oak offers an interesting finish. This is achieved by wire brushing the wood to reveal the grain, into which a wash of colour is made, and then rubbed from the surface. The colour remains in the hollows to give a shimmering quality to the surface, without losing sight of the grain.

Polychrome sculpture

Sculpture painted in many colours is again being used widely. Some people feel that colour should be applied to enhance the form and not disguise it but this attitude seems now to be out of favour. Some sculptors now say the form exists no matter what colour you apply or how. This may be true but it seems to me almost a contradiction of modelling or carving to achieve fine form if it is then camouflaged. The example of George Segal's *Three People on a Bench* is another case for caution, I think. He has attempted to make bronze resemble plaster of Paris by painting the surface white. This illustrates the range of possibility but it is also a strange use of material.

Metal

False patina

Non-ferrous metals are the materials most commonly given a false patina. Acids and alkalis are employed to oxidize the surface of the metal to create colours: they are the result of the corrosive action of these chemicals on the metal. It artificially produces a fine film of corrosion, similar to that resulting from exposure to polluted atmospheric conditions. The art of making the false patina is a specialized one and should be tackled with caution. For a start, no two persons using the same chemicals will achieve the same colour; there are too many dependent factors.

The metal should be clean and free from grease, the chemicals used should be as pure as possible, or consistent in the batch being used. The utensils employed, namely brushes, cloths, containers, etc., should preferably not be of metal as this will adversely affect the chemicals. Check the formula of the metal: metals with a high copper content will react differently to those low in copper and with another alloy such as iron, giving different colour. If all these factors are controlled the act of applying a patina on bronze can be exciting (see Patination).

Polished metal

It is quite common nowadays to see highly polished metal sculptures of all kinds. Those most favoured are bronze, copper, aluminium, stainless steel and to some degree mild steel. The art of polishing is not a complex one: it just requires time, care and patience. There are many powered polishing machines on the market to aid the sculptor, and used with the correct buffing and polishing mops they can take the hard work out of most jobs. Polishing compounds are manufactured for use with particular metals, and you should seek the advice of your local supplier to ascertain the nature of the products available and their use on the respective metals.

Bronze, copper, brass, silver and gold

Finish the surface by hand as finely as possible after using grinding tools. Use emery cloth or a wet and dry abrasive paper down to the finest grade.

Archer by Henry Moore, 1965. This casting is beautifully sited in front
of the city hall in Toronto, Canada.

Use a fine emery compound on a buffing wheel or cloth to polish out any fine scratch marks left by the abrasive cloth or paper. This can be done with a machine or by hand. Wash off any emery deposits using ammonia or white spirit.

Using a clean buffing mop or cloth and Tripoli compound (or whatever is advised by your supplier according to the metal), polish the surface further, cleaning off any deposit when you have finished.

Repeat this polishing by machine or by hand twice more using White Diamond compound, and then rouge (or whatever else is advised). Make sure you use clean and separate buffing mops or cloths for each compound.

Finally, polish the surface with a soft yellow duster.

Aluminium

This can be polished simply by using wet and dry abrasive paper in varying grades, then by rubbing the surface with a liquid metal polish (any proprietary make will do) using pieces of cardboard, preferably the sort used to make ordinary boxes. The aluminium will gain a fine, burnished appearance. There are also special compounds made for polishing aluminium with machines or by hand; ask for information from your supplier.

The biggest problem related to polished surfaces is preventing the subsequent and inevitable tarnishing. Regular polishing is the simple answer, but for those works that do not allow this, the surface can be lacquered or given a coating of specially prepared surface-coating resin. There are proprietary products of both resins and lacquers available now, and once again you should always seek advice from manufacturers of resins. Some local hardware stores will be able to supply you with lacquers for spraying on to polished metal.

Electroplating

Another process for making a fine finish in which a fine layer of one metal is deposited evenly on to the surface of another. Small electroplating units can be made in the studio but this technique is best left to industry, where the technology and know-how are immense. It is a process involving toxic chemicals, in large quantity, and electric current, albeit in low voltage, but still it is a combination not to be played with. When the technique is handled expertly, items electroplated with gold, silver, bronze, cadmium, nickel or chromium can be very beautiful. Such plating can be polished or left with the eggshell sheen it will have straight from the acid bath. Protect a polished surface in the same way as any other polished metal. Some resins can be plated if the filler used will enable an electric current to be passed through the body of the work; it is a technique worth discussing with a good plating works.

Anodizing

An electrochemical process for giving a protective coating to the surface of aluminium. This process converts the surface of the aluminium to an oxide and prevents corrosion. A limited range of colours is available, black being among the most effective. The anodizing process is not one you can easily set up in the studio.

Metal spraying

This is another industrial surface-coating process that can be applied to a completed form. The equipment used is fairly sophisticated, and for the results to be effective it needs to be carried out expertly and in the presence of the

Walking man by Alberto Giacometti, modelled in direct plaster and cast in bronze, 1969.

necessary safety measures, so seek an industrial company specializing in metal spraying.

Surface coating

This relatively new process uses plastics of various kinds to coat metal objects. The metal is first cleaned by sand-blasting then heated to a predetermined temperature, and then plunged into an airbath of thermoplastic resin powder. On contact with the heated metal, resin melts and adheres to its surface. The thickness of coating is controlled by the temperature of the metal and the length of time the object is held in the airbath.

Sand-blasting

Can be used to give a finish to the surface of most materials. The process involves blowing, or blasting, sand or grit through an airgun on to the surface of the sculpture. The pressure of the air can be controlled and the size and nature of the sand or grit can be varied to suit the material. The surface that results is of an even, granular texture. On glass, the surface will become opaque. On stone or terracotta, the surface will have a dusty appearance, and sand-blasting will make the grain of the wood stand proud. If glass beads are used instead of sand they will have a polishing effect. As the particles are smooth, not sharp and faceted as in sand or grit, they do not cut the surface but burnish it.

FIRING FOR CERAMIC SHELL

This firing differs in that the completed mould is subjected to an immediate temperature of 1000°C. The strength of the mould material is such that it will easily withstand this thermal shock. If the mould has not been previously de-waxed, this high temperature will cause the wax in the mould to melt from its outer layers, thus making room for

the bulk of the wax to expand, before it liquifies to run out. If this does not happen, the mould walls are liable to crack as the bulk of wax expands.

Once the mould has reached the bright red heat of 1000°C it is baked and ready to receive the molten metal. Ceramic shell moulds thus prepared can, if required, be stored for subsequent treatment. Any flaws in the mould can be repaired, patched with fire cement (kiln mortar) and then poured, or if necessary stored in a dry place. Heat stored moulds to make sure no moisture is present when this metal is poured.

FIRING FOR METAL CASTING

The art of lost wax (*cire perdue*) metal casting includes the crucial procedure of baking the mould to remove the wax pattern, leaving a cavity into which molten metal is poured, replacing the wax to make the final casting. This process is also known as investment casting, and all forms of lost wax investment casting must undergo firing of some kind.

Completed refractory moulds are stacked in the kiln. With the exception of ceramic shell, refractory moulds should be as fresh as possible. Wet moulds help create steam during firing, thus preventing wax, as it melts, being absorbed into the walls of the mould. If it is not possible to fire them fresh, pour water over dry moulds to aid this generation of steam and the complete evacuation of wax. Stack the moulds with their pouring cup downwards to ensure the wax will run out as the mould is heated, and make sure also that the flow path for the molten metal is clear. Large moulds that cannot be inverted will require a drain: a rod of wax included in the spruing, and protruding from the mould suitably low down, will allow the wax to run out from the mould. (Plug this drain hole when the mould is loaded into the pouring pit, before the molten

metal can be poured.) No matter what kiln you use, stand the inverted moulds on stilts, bricks or refractory blocks, so that the heat can circulate freely around the whole mould. If your kiln includes a drain to allow wax to run out to be reclaimed, this will probably need to be plugged, or shut off to prevent heat loss. It is safe to stack moulds one above the other.

When the kiln is loaded, closed and sealed, apply a low heat, to reach about 300°C in about ten hours. The temperature can then be increased quickly to reach 600°C, at which heat any carbon deposited by the disappearing wax will ignite. Allow this to burn completely as an indication that 600°C has been maintained long enough to burn off any carbon. If there is an inner mould (core) it is a wise precaution to allow the mould a little longer, after the carbon burning, at 600°C to make sure the core is baked sufficiently. The time involved will vary according to the size of the kiln load or the mould volume from about 18 hours to 36 hours. A single small mould, however, can be quickly baked, even in the furnace, reaching red heat and ignition in a few hours. The kiln is opened (cracked) after a further few hours; the moulds will benefit from soaking in the kiln as its temperature falls. Inspect the mouth (pouring cup) of the mould; it should be quite clean and free from any carbon deposits. If there is heavy carbon visible it is risky to pour the metal, and wise to refire the moulds. Once you are satisfied with the firing, you are ready to pour.

FIRING FOR TERRACOTTA

It is normal for terracotta sculpture to be unglazed, of either earthenware or stoneware. Glazed ceramic sculpture is a rather rare commodity, and requires two firings at least, possibly more according to the complexity of the image, colour, texture, etc. To fire in a kiln an unglazed sculpture to a temperature that will give a hard, durable result is not difficult, but all firing carries a certain element of risk and the unknown. You can never be certain what precisely will happen when fire and high temperatures are involved. To some artists this is an ingredient essential to the act of creativity. Cracks, warping and even explosions can be expected to a greater or lesser degree, but when all goes well the bonuses are high; results can be stunning.

The atmosphere in the chamber of the kiln is important: the colour of the fired clay depends upon whether or not oxygen is present. Plenty of oxygen (an oxidizing atmosphere) makes the fuel burn cleanly thus burning off any carbon present to give a clean colour. Reducing the amount of oxygen (a reducing atmosphere) during the firing causes smoke and carbon monoxide to remain in the kiln chamber; these react to any oxides present in the clay, changing their chemical make-up and consequently the colour of the fired clay. Such oxides may be naturally present in the clay or introduced to the body of the clay or to its surface. Some sculptors prefer the effects made possible by reduction firing.

The exclusion of oxygen is fairly easily achieved in gas-fired kilns by closing vents and dampers and maybe introducing some wood or sawdust to help burn up any lingering traces of oxygen. In a solid-fuel kiln the atmosphere is a reducing one anyway, enhanced by closing dampers and vents. Electric kilns present greater problems in creating a reducing atmosphere as carbon coating the wire elements causes very quick deterioration, and consequent expense. The high-priced carbon rod electric kilns will survive such reduction firing and can safely be used to fire moulds for lost wax metal casting. It is, however, generally necessary in

Femme Se Coiffant by Pablo Picasso, bronze, 1905. The Hanover
Gallery, London.

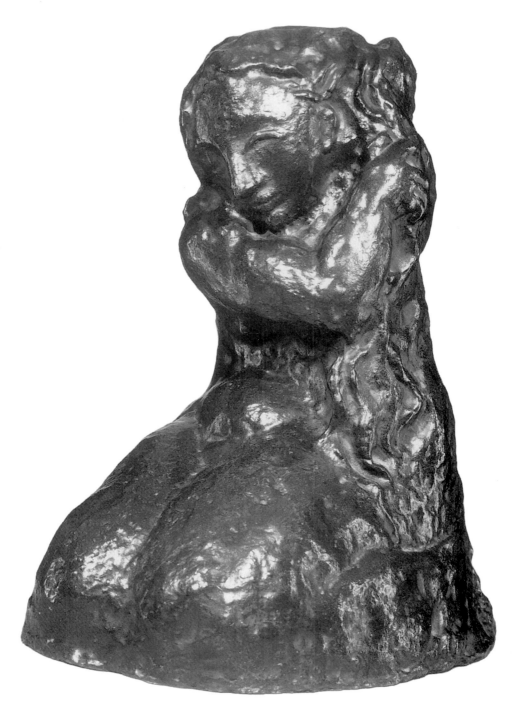

an electric kiln to place the material that will ignite to burn off any oxygen (wood, straw, etc.) in a container. If you introduce such combustibles into the electric kiln chamber without a container, it might affect all subsequent firing, even causing some damage to terracotta items. Kiln atmosphere of course will affect glaze firings as well.

Biscuit firing

The two firings are known as the biscuit (bisque) firing, and the glaze firing. The biscuit firing is the first. Place the dried clay object in the kiln, close and seal it, and slowly raise the temperature to mature the clay and make a hard durable material, safe to handle, aiming for a temperature range from 850–1020°C, according to the clay body being used. Earthenware fires at low temperatures. Stoneware fires at higher temperatures. All clays can be fired satisfactorily for sculpture in one firing; add colour by mixing oxides into the body of the clay or by painting them on to the surface.

Glaze firing

This fires the glaze on to the biscuit (bisque) body. Glazes are vitreous, impervious coatings made up of silicates in combination with such things as lead, potassium, sodium, zinc and various other oxides. Formulas of these combinations are devised to give particular character and colour to the glazes. Applied as liquid to the surface of the biscuit body, by dipping, painting or spraying, and allowed to dry, the whole object is then placed again in the kiln. Heat causes the glaze to vitrify and adhere to the clay, but the temperature must be less than that for the biscuit firing. Many glaze firings may be necessary to achieve a particular result, each of these being at a progressively lower temperature. Seek advice from ceramicists and experiment before embarking on a very important project.

FIXINGS

The security of a piece of sculpture is of paramount importance, therefore the means by which a sculpture is attached to its base or wall, or installed in a public place, is a matter of prime consideration. Simple fixings for small pieces have a certain logic, using any of a number of proprietary devices such as screws and nuts and bolts. Here are one or two pointers, however, that will help in all cases, large or small.

Make a template of the base of a sculpture so you can locate correctly any proposed fixing (see Template). If you don't use a template, threaded studs sharpened to a point and inserted into tapped (threaded) holes underneath the sculpture will provide a simple means of location. When you lower the sculpture thus equipped on to the prepared base, the points will accurately mark the centres for drilling any clearance holes to make the fixing. On a wooden base, the points can be pushed down hard to locate all centres in one action. When the base is harder – stone, marble, metal, etc. – then one hole becomes the pilot. The pilot hole is drilled out and a long bolt fitted to the base of the sculpture, corresponding to that hole, and shorter pointed studs fitted to any remaining fixing points. Then, by carefully lowering the long bolt through the pilot hole, orientating the sculpture correctly, the shorter studs will locate the centres of the remaining clearance holes. The points can be made to leave a mark using pressure, or a thin layer of clay can be placed first and the point pressed into this. Once the clearance holes have been drilled it is usual practice to turn the base over the drill or cut any countersinking to recess the nuts, bolt or screw head.

Charles I by Hubert Le Seur, bronze, 1660. Situated in Whitehall,
London.

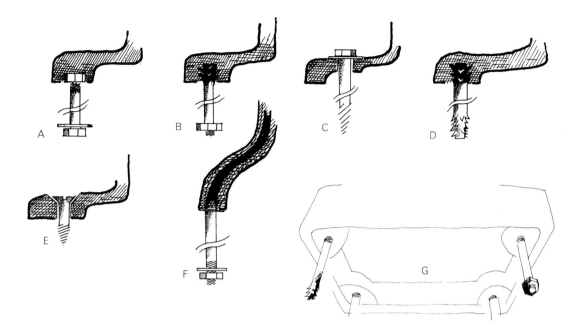

ABOVE

Some methods of fixing sculptures. A, B, D and F show the fixing placed into the thickness of the casting, which can be GRP, concrete or plaster.

A *Bolt screwed into an inset nut.*

B *Rag bolt with a threaded end to take a nut and washer.*

C *Coach screw passed through a clearance hole in the sculpture, which will make a secure but removable fixing.*

D *Double ended rag bolt, the free end to be set into concrete.*

E *Ordinary countersunk woodscrew, passed through a countersunk clearance hole in the work.*

F *End of a long reinforcing bar cast into the work with a threaded free end to take a nut and washer.*

G *Bolts of various kinds can be screwed into threaded holes in metal sculpture.*

If the sculpture is mounted on a single point, the fixing has to be designed to prevent the sculpture twisting freely on its base. If space allows, a blind hole drilled in the base to take a peg that is fixed adjacent to the main bolt or fixing, will prevent the piece from pivoting haphazardly. Failing this, you can secure the main fixing in the sculpture by means of welding, brazing, concreting or resin bonding, according to the nature of the materials being used. The fixing can then be securely tied into the base. If it is a bolt, then the nut can be secured from below by pinning through it. If the fixing is simply a bar of metal, this will need to be ragged, that is, keyed so that if it is glued or cemented in place, it will not twist. The diagrams above illustrate a number of methods that have proved successful.

On large sculptures and pieces where the fixing device is included in the casting, a template is essential for accurately locating any fixing points. Accurate templates are often included as part of a contractual requirement for a commissioned sculpture, especially when the site preparation and erection of the sculpture is being done by another party.

ABOVE *Crouching Male Figure*, bronze, by Giacomo Manzu, 1968. Situated at Wayne State University, Detroit. The flashing can be seen on the surface of the sculpture.

LEFT A bronze by John W Mills being lowered and fixed into place. Stainless steel rods protrude from the base and will be located through the concrete into corresponding holes drilled in the plinth with the aid of a template.

There is on the market an enormous range of fixing devices, made to accommodate almost any industrial requirement. The manufacturers of these items usually have a department willing to give specialist advice regarding their product and its use. Take advantage of such information and gain peace of mind regarding the security of the sculpture. Civil engineers will of course also advise, under proper consultation, on the correct fixing for a sculpture relative to its site, taking into consideration the strength of prevailing winds,

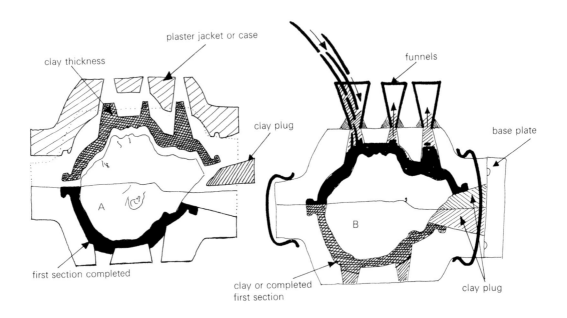

first section completed

plaster jacket or case

clay thickness

clay plug

funnels

base plate

A

B

clay or completed
first section

clay plug

The process of making a flexible mould:

A The plaster jacket made over the clay thickness. Its removal permits the clay to be taken away to leave the space for the flexible compound. The first section has been completed already.

B The plaster jacket clamped in place, with funnels fixed over the pouring and venting holes. The clay plugs or the base plate are fixed in place, according to which method is used. The compound is then poured to fill the space left by the removal of clay.

atmospheric condition, pollutants if there are any, etc. These factors are important when placing a work in a public place. The artist's third party liability under UK law is for seven years. If you employ a civil engineer to design the fixing and reinforcing of the sculpture, providing his instructions are strictly adhered to, the engineer or his company is liable in perpetuity.

I have illustrated some typical methods of fixing (see page 93), but, of course, special needs require

special consideration. Pay particular attention to the way in which your piece is mounted and fixed; it is an important factor in the presentation of a work (as important as the frame to a painting). On large work it is vital to the safe installation as well as the presentation and comprehension of the sculpture.

Vandalism is sadly a factor that must be taken into account today. My sculpture known as *Jorrocks* is installed on a site through which there is a public right of way. Eight adult males were therefore invited to clamber over it, to check for any signs of weakness, before it was finally put in place, its one-ton load was spread over a wide base, and all the internal reinforcing and the fixing on site was carried out to a specific brief drawn up by a civil engineer (see Reinforcing).

FLASHING

Cracks in a mould will result in fine fins or 'flashings' on the cast surface. This excess material is usually removed – cut or ground off – and the surface chased and made good. The Italian sculptor

Giacomo Manzu, however, often retains the flashing on his bronze castings, preferring these fine blemishes to any chasing work done on the bronze that may spoil his finely modelled surface. He does enjoy some of the finest of Italian bronze casting and any flashing is kept to a minimum. For the same reason he often leaves the core pins hole visible in the casting.

FLEXIBLE MOULDS

These are designed to allow a number of impressions to be made, but undercut forms and textures are also easily catered for by the flexible nature of the material used. The mould consists of a layer of flexible material that allows the reproduction of volume and detail, and is held together correctly by a rigid jacket, usually made of plaster of Paris. The materials used to make the flexible layer range from simple gelatine through various natural and chemical compounds, such as latex, polyvinyl chloride, silicone compounds, polysulphide and polyurethane plastics.

FLEXIBLE MOULD MAKING

The traditional method for making flexible moulds takes advantage of the natural characteristics of gelatine: a hot liquid is poured over a pattern, held in place as it cools by a suitable container, to produce an accurate negative reproduction of the original. Cold-curing flexible materials can be used employing the traditional process but they have also allowed other methods to be devised. I will describe those most commonly used to demonstrate the basic technique.

I have illustrated (see diagram opposite) the most basic version of the traditional process, that of simply standing the original in a container and pouring the gelatine to cover the sculpture and fill the container. From this basis, techniques have evolved capable of moulding almost any form, no

matter what the degree of complexity. The aim is to achieve an even distribution of flexible compound around the original form, keeping this in perfect register by means of a case or jacket (most usually made of plaster of Paris). The jacket is designed to be removed easily to allow the flexible material to be peeled away from the pattern and subsequent castings.

Prepare the original pattern. If it is porous material it should be treated with a suitable sealer. Clay requires no sealant, just a dusting with French chalk (talc) to prevent any new clay used from sticking to the surface. Synthetic clay will not stand hot poured compounds, so choose the correct material to suit from the RTV compounds available. Metal surfaces will require a parting agent from some RTV materials (see Release/Parting Agents).

Lay the prepared original on to a large board. Decide on the main parting line and mark this on the original. Now build a band of clay up to this line, all round the sculpture, about 75mm (3in) wide, leaving a small gap between it and the surface of the original. Make the surface of this band as smooth as possible. If the castings to be made from the mould are to be of a pourable material such as plaster, wax or resin, make allowance for access to pour the material into the mould. Make half-cones across the clay band to enter at the base of the form (see diagram opposite). These will be repeated on the second half of the mould to provide a pouring funnel.

Looking down on the form, identify any undercuts. These need to be plugged to prevent a locking shape occurring that will prevent the case being drawn easily from the mould. French chalk (talc) dusted on the surface of the original and on to the back of the plug will make sure it does not stick to the pattern or to the clay layer that is built over it. Cover the entire surface of the sculpture with a layer of clay. Some sculptors make this by

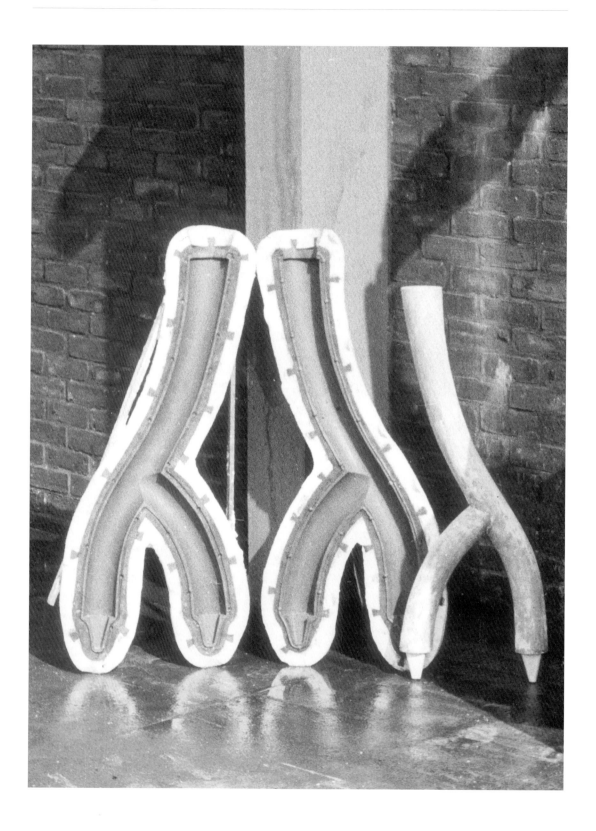

rolling the clay out to a suitable thickness and laying it down over the surface. Others roll out strips of clay and gradually build these up to make an even layer about 12mm (½in) thick.

Constantly check that the case will draw, by looking down on the job, fill any undercut and ensure the whole shape tapers. Make the surface of the clay as smooth as you can with a clean connection where the clay layer meets the clay band. Around this joining of the two surfaces make a clay lip with semi-circular cut-outs. This will form the register at the edge of the plaster case that will prevent the flexible compound collapsing. Try to make the whole job as tidy as possible; the eventual castings will benefit from time spent now.

Now make devices to allow the compound to be poured by placing truncated cones of clay at strategic places on the clay layer. Place the largest at the highest point (the pourer), and other smaller cones (vents) on other higher points. The number of cones will vary according to the area to be covered. The size of the cones will be determined by the kind of compound being used. Hot melt materials require large apertures to gain access quickly. Cold curing compounds can be accommodated by much smaller pourers, and the vents can sometimes be simple drill holes.

The whole assembly now needs to be covered with a layer of plaster of Paris, reinforced if necessary with scrim (hemp). Shape the plaster so that a flat surface or combination of flats is made to ensure that the case will stand securely when turned over.

When the plaster has hardened, do any trimming necessary to make a good case, with strong edges and stable, flat surfaces. Then turn the

whole assembly over. Take away the clay that formed the band and you should now be left with a stable plaster case, the clay layer revealed at the join and the back of the sculpture showing. Cut registration keys in the plaster seam and apply a release agent (see Release/Parting Agents).

Now repeat the process of making an even clay layer with the locating lip, the truncated cones (pourers and risers) and the plaster jacket complete with flat surfaces to stand securely (see diagram on page 96). If the original sculpture is a standing form, a third section of jacket is needed. Invert the whole assembly so that the base of the sculpture is revealed together with the edges of the case and the clay layer. Smooth the clay layers in such a way that the sculpture base and edges of the plaster case are left projecting. Cut register keys in the sculpture and the case, apply a release agent and cover the whole area with plaster. The plate thus made seals the case and allows location within the plaster jacket of the original should other moulds need to be made from it, a necessity obviated by the long shelf life of RTVs, but nevertheless an important point to understand. Completely open-ended forms must be packed with paper or some such packing before this end plate can be made, but the principle is the same.

The case, when trimmed and tidied up, is now complete. The next task is to replace the clay layer with the flexible compound. Prise off the base plate, and carefully remove the plaster case from that part of the mould containing the greater volume of sculpture. Some of the clay layer will pull away with the case, but carefully remove all of this clay and any plugs filling undercuts. The seam of the plaster case and clay is now revealed. This has to be cleaned and modelled to make a smooth, flat surface touching the surface of the original sculpture, with as fine a joint as it is possible to make. This marks the precise division between

Flexible mould and casting by Richard Rome.

sections of the mould. Registration keys are made in this refined clay seam. Clean the sculpture surface, ensuring that you use just the correct amount of release agent, if required. Do not put on too much as this will only blur the details.

Clean the plaster case of clay, trim to remove roughness and fill any holes in its surface. When the case is dry, apply a suitable sealing material; most commonly this is shellac (white polish) but in some cases a dusting of French chalk (talc) is all that is required. You may need to experiment to determine the best seal for the material you are planning to use.

When the whole clean-up of original pattern, seam and case is complete, carefully put the case back in place over the original. If the job has a base plate replace this also. The logic of the method can now be appreciated: the space between the plaster case and the original pattern is now obvious and ready to be filled with whatever flexible compound is being used. Clamp the case together at the seams!

Place funnels over the holes made as pourers and risers, sealing them in place with clay. These funnels can be made of any handy material – clay is the most adaptable but whatever you use try to make them the same height above the case. Pour the flexible material through the main pourer and watch it rise up all the funnels; when the level of material is equal in each of these the space is filled. Pour steadily, using only one access point. Air in the space will be pushed up the risers to be followed by the flexible material. Pour hot compounds quickly before they cool. Cold curing compounds can be poured slowly at a speed dictated by their curing rate, which is often adjustable.

When the compound has set and cured, turn the whole job over and repeat the process to make the second section. Remove the plaster case, clean both it and the original sculpture, and put on

any sealing material required. Paint a release agent on the first rubber seam if necessary, replace the case, clamp it (base as well if there is one), position the funnels and, finally, pour the compound. Proceed in the same way, section by section on complex moulds (see RTV).

FOUNDRY

The workshop or series of workshops where the craft of metal casting is carried out. The furnace is the heart of the foundry providing the molten metal that makes sense of all the preparatory processes that combine to make the final casting.

FOUNTAINS

The use of water in sculpture is not new, and there are many wondrous fountains around the world illustrating that this art form has fascinated for centuries. The demand for water features is growing. Application and incorporation of water within sculpture is a technique that requires experimentation, and sculptors need to consider the following factors:

- The source of the water:
 - Mains supply.
 - A water storage tank or cistern.
 - The natural supply i.e. river, naturally occurring cascade, self-draining ponds, etc.

- The waterproofing of any tank or container built into the work to retain the water, so as to

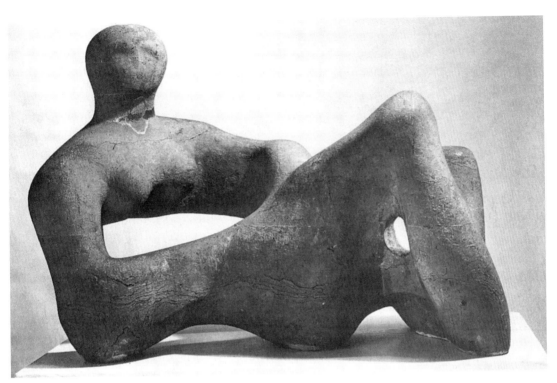

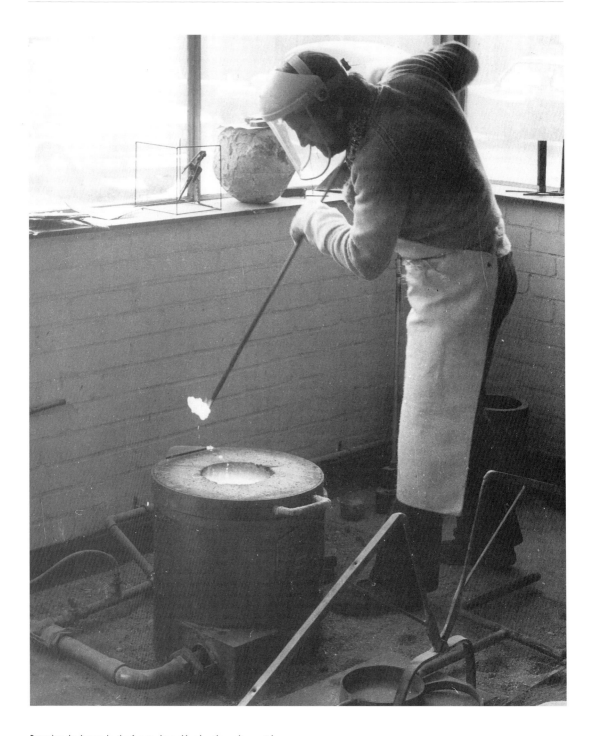

Preparing the bronze in the furnace, here skimming the molten metal.

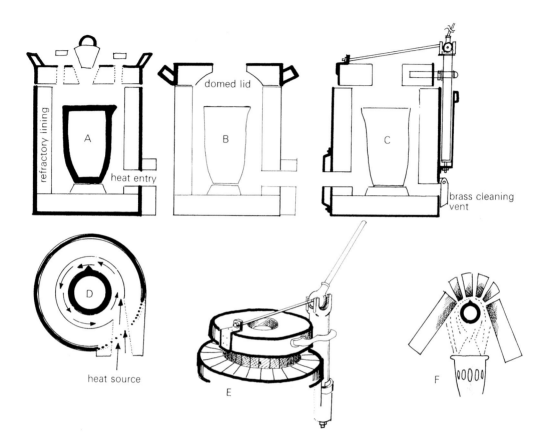

Different furnaces for melting metal of various kinds:

A *A furnace made from an oil drum or some such metal container, lined with refractory bricks, refractory cement or ceramic fibre.*

B *Another studio-made furnace, with a domed lid used without a stopper, which helps to achieve good combustion.*

C *A section through a typical manufactured furnace, with a swing/lift lid to facilitate charging and removal of the crucible, also shown in E.*

D *The entry and passage of the flame around the crucible within the furnace. The flame does not strike the crucible directly.*

F *A temporary furnace using fire brick on edge suitable for melting a small amount of metal for patching, etc.*

feed the water to the sculpture by gravity or by means of a pump. This may become a maintenance liability if it is not installed well.

• The action and flow of water over weirs that may have a hard or curved edge. In each case the flow of water will differ. The curvature of a weir will also affect the water; experimentation is the key to good design.

• The most suitable type of water pump, either submersible or circulating. A submersible pump needs to be submerged, and pumps water directly to the work from wherever it is contained. A circulating pump draws and supplies water via pipes and is usually situated above the water; this

kind of pump is typically used in swimming pools. Both types of pump are available in a large range of sizes. Seek expert advice on the latest technical information.

Unless you are experienced and confident, the 'plumbing in' of pipes and stopcocks, etc., is best carried out in consultation with a plumber or a hydrodynamicist, a specialist who studies water and its viability in different situations, and can even make water appear to be stable, for example when incorporated into a cruise liner's décor.

FURNACES

One of the most important items to the sculptor who intends to make his own metal castings is the basic equipment. It is all very well to be told 'how', but 'what' is of equal importance. I would emphasize that the foundry business, at whatever level, is not one to be entered into light-heartedly. It involves handling large quantities of heavy molten metal, a dangerous commodity that requires certain care and confidence. The degree of concentration on what is an arduous, hot and dusty task must be high to achieve results worthy of the time spent. If this is asking more than an individual's temperament permits, it is best left to others.

The heat sources for furnaces can be oil, natural gas or bottled gas. Oil and gas will require a blower to give sufficient power for the heat generated to reach the high temperatures required to melt metal. Bottled gas stored under pressure can be used directly.

The furnace itself is of metal, lined with a refractory material, with enough space within to house the crucible in which the metal is made molten and which is placed in the middle. The refractory lining helps maintain heat of sufficient intensity and longevity to melt the required amount of metal; the heat is directed into the

furnace from its source through an opening in the side of the furnace wall.

The flame enters at an angle to the centre of the furnace, the object being to circulate the heat around the furnace to avoid a direct blast on to the crucible. The furnace has a lid with a system of vents to control the heat within the furnace, to feed the metal to the crucible, and to allow the melting and molten metal to be stirred, fluxed or de-gassed as required (see diagram page 103).

It is relatively simple to make this kind of furnace, provided the project is well planned and carefully carried out. The metal container can be welded and made from mild steel or made from a large oil drum, or other cylindrical metal container, preferably of 70 litres (5 gallons) capacity. A larger-capacity container can also be adapted. Cut an opening into the side of the container to allow the flame to enter and make a refractory lining inside it to a thickness of 37mm (1½in) or 75mm (3in). The refractory lining can be made from fire bricks, fire clay, refractory cement or stoneware clay. The most favoured today, however, is ceramic fibre (see Ceramic Fibre). A blanket of this fibre stuck to the drum sides makes a very effective furnace lining.

Cut and shape fire bricks to fit the container, and cement in position with a fireproof cement. Refractory cements can be used to build up the lining, one side of the container at a time, doing the second side when the first has set and hardened. Make the lining all round the sides (with an opening) and over the bottom surface, which should include a pedestal for the crucible to stand on. Trim the edges of the lining around the top of the container. The lid can be made separately to fit on to the main part of the furnace, and should also have the necessary openings. To make a good fit between the lid and the edges of the lining, cast the lid against the top edges of the main furnace lining, using newspaper or tallow as a separator

between the cements. An extension ring can be made to fit between the main body of the furnace and the lid; in this way it is possible to accommodate various sizes of crucible. It must be a complete ring, however, for safety's sake.

Another method of making a furnace is to model the refractory lining with a very coarse alumina fire clay which fires at a temperature higher than the melting point of most metals, i.e. 1300°C. This coarse fire clay can withstand the thermal shock of the flame. The lining can be coiled or slab built to provide the necessary features of the furnace – the crucible pedestal, openings for the flame, and the lid. The whole thing can then be fired in a kiln to become matured stoneware. With some of the coarser fire clay you can fire the lining in the open air by building a wood fire around and inside it; light this and maintain the heat by stoking. This will reach a sufficiently high temperature to make the body hard and durable and able to withstand the thermal shock of the furnace flame but it will not reach a maturing temperature. This latter stage will be achieved when the furnace is used to heat a crucible.

Stoneware bodies can be used to line a metal container, and in this case it is advisable to pack an insulator, such as vermiculite or kieselguhr between the lining and the container. Stoneware can also be used in an earth pit, in which case use an insulator mixed with sand to make the lining firm and effective.

The simplest way of making a furnace is to dig a pit and channel and line the pit with fire bricks to make the chamber to contain the crucible. The opening through which the flame will heat the furnace is provided in the lining opposite the channel. Hold the fire bricks firmly by packing earth or sand around them, and make a lid by simply placing larger refractory panels, kiln shelves for instance, over the top, leaving spaces as air vents. The capacity of the firing chamber

can be adjusted in order to accommodate any size of crucible.

GELATINE

The oldest flexible material used in sculpture that requires heating to make it liquid enough to pour, and flow around a master pattern. It is an organic material made from a bone matrix rendered down by boiling. It is brittle when dry and usually sold in sheets that can be broken and softened by soaking in water and then boiled; a double pot (porringer or *bain marie*) is used for this to prevent the gelatine from burning. When the gelatine is melted (make it as thick as possible) stir it well and leave it to cool. A skin will form on the surface but do not disturb this until you are ready to pour the gelatine. When the mixture is cool enough to pour test the temperature; it should be tolerable to touch with the inside of the wrist. (This is a tried and true test that is more accurate than any thermometer.) Break the skin on the surface and pour the gelatine into the prepared plaster case (see Flexible Moulds). Gelatine moulds are suitable only for plaster of Paris or wax casting. The shelf life of the mould is very short; it is only a matter of days before this organic material shrinks, dries and cracks. It is useful material but probably superseded by the various plastic compounds now available.

GEL COAT
(*see* **Mixing Polyester Resin – Surface Detail**)

GLASS

Artists are increasingly using glass, as a cast, modelled or carved material, or in combination with other materials, to provide interesting qualitative contrasts between them.

Glass is a fragile but hard material which is fairly permanent and has been used for thousands of years (it is possible that it was discovered by

chance as the result of cooking fires used on sandy soil). Sand in combination with substances such as silica or calcium oxide and subjected to heat creates a liquid that hardens on cooling to become glass. Examples of glassware can be found in such ancient cultures as those of Mesopotamia and Egypt. It is an amorphous material having no unique crystal structure with no definite melting and cooling points; the temperature at which it melts or cools is dependent on the glass formula, of which there are many.

Formulas containing sodium carbonate or calcium carbonate and sand produce soft 'soda'glass', whilst formulas containing potassium oxide or sodium oxide produce hard glass. Those containing lead oxide are harder, and those using boric oxide are among the hardest heat-resisting substances.

Lead glass, i.e. where the formula contains a high lead content, is the most favoured by artists/craftsmen as it has the best degree of softness and is more fusible than glass made with potassium or boric oxides.

Coloured glass is achieved by adding various metal oxides to the formula. The colours achieved often have an intensity rarely matched by any other.

Brittle glass offers high compressive strength and with careful design can provide high tensile strength.

Modern glassmakers supply glass of various qualities for a wide range of constructional purposes. The majority also provide a consultation service and are usually pleased to help artists who bring new ideas for the use of their products.

Casting glass is carried out by pouring the molten material into a mould. Plaster moulds can be used; however, the glass has a tendency to stick, combining with the silica in the plaster; a wash of clay on the mould surface, where this is possible, will help prevent this. Molten glass is a sluggish material and industrial casting is in iron moulds, forcing in the glass with a plunger. In the studio, a large cup and feed is required so that the weight of the material and gravity forces the glass into the mould detail; the mould must be hot to aid such casting. The lost wax process may be used; however, the method for feeding the molten material into the mould must take into account the sluggish nature of the molten glass. Molten copper has the same difficulties of spruing, size of feeds, etc.

Temperatures range between 815°C, the normal (glowing red) working temperature for glass, whether modelling or blowing, and 1370°C, the temperature for fusing the formula ingredients.

At the glowing-red heat stage, glass can be shaped as it cools and reheated to be fused with another form, or to build up newly melted material. Glass items can be fused together when both are at the same temperature and in a viscous condition.

Surface decoration can be achieved by sandblasting, etching, engraving and grinding, perhaps using fine grit stones, pumice and putty powder. However, modern grinding tools and compounds such as diamond chips, grits and dust have eased this work considerably.

GLOWING RED
(*see* **Cherry Red**)

The colour of material that requires super heating to be used, i.e. molten metal at the best pouring temperature.

RIGHT The completed pouring gate, and the first layers of investment mould.

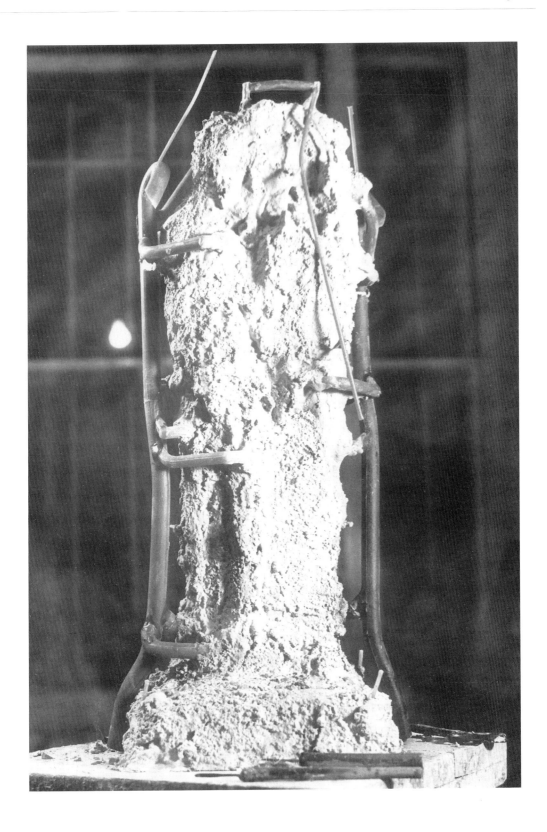

GLUE
(*see* Adhesives)

GOO

The word coined in the 1950s by sculptors who worked on the development of high alumina cement as a useful studio castable. Goo is the mix of fine aggregate and cement, made to a heavy cream consistency and applied to the surface of the mould as the first coat, that layer of material that gives the fine detail reproduction. Neat cement used in the same way is now also referred to as goo.

GRP

GRP is the common reference for 'glass reinforced plastic (polyester)'. Referring to sculpture as being cast in 'fibreglass' is incorrect because glass fibres are loose and need a bonding agent (usually a resin) to become a viable solid material. The glass fibres provide tensile strength to the mixture or laminate. The resin, though strong, is otherwise very brittle.

HYDRATION

The process of compounding with water, which is the action that cements and plasters undergo, changing from powder mixed with water to become a liquid and then a solid. The retention of water in the setting, hardening and cure of cements (concretes) is of great importance.

HYDRODYNAMICIST

A specialist in the use of water and the behaviour of objects in water, particularly in a marine design and engineering application.

INDUSTRIAL INFLUENCE

There is a vast range of industrial materials available today from which sculptures can be made. Indeed so great is the variety produced that no matter what your needs, a suitable material is probably manufactured. Industry should therefore be regarded as an added resource for sculptors. Experimenting with formulas to ancient recipes should be confined to those substances truly not available but vitally necessary. This vast range of industrial products and the willingness of manufacturers to give the aid of their laboratories and staff obviates the need for time-wasting experiments, so take advantage of all the facilities offered. In this way the sculptor can spend more time developing personal imagery, all his efforts being concentrated on gaining the greatest control over the material to create work bearing the individual mark of the sculptor and the studio.

However, in the main, industry is concerned with tonnage sales and the production of long runs of identical objects, so industrial methods are often initially expensive. Machine design and development costs thousands and is usually geared to produce cheap items in an endless number. The artist may be better off if he investigates the material in question and its industrial application, and then devises a method of his own which will best suit his needs. You need to know the rules to be able to break them.

IN SITU

This term is derived from the Latin, meaning 'in place', or 'on site', and refers to the siting of an object; its actual location. This is important when placing a sculpture so that the geological and/or urban features of the terrain are included in any planning. The orientation of the site and the consequent effect of natural light, etc., should always be taken into consideration.

INVESTING (*see* Investment)

The art of making an investment mould in preparation for metal casting. Normally made over a prepared wax pattern, the investment

can, of course, be built up over any material that burns out at a lower temperature than 600°C.

The investment can be built up using a brush for the first layer, and then with metal spatulas as a direct plaster working or it can be poured around a wax fixed in a container/flask or the wax can be dipped into a container/flask already filled with investment, and held in suspension whilst the investment sets. A combination of both building up and pouring is favoured by some sculptors, but it really is a case of choosing the correct method for the particular job in hand.

*The first fine facing coat of investment is of the greatest importance. It is from this that the bronze takes its form. It is normally applied with a brush. It should be about 6mm (¼in) thick and every effort should be made to exclude air bubbles.**

The fine investment is mixed with water to a creamy consistency. The thicker it is, the stronger it will be, but the more air is likely to be trapped. Where little bubbles of air touch the wax there will be little bobbles of bronze. These are easy to remove from a smooth surface but difficult to remove from a texture without removing the texture as well, except by tedious individual attention.

Jewellers subject the mix to a vacuum to remove all air before pouring it into casting flasks. Sculptors must manage by tapping the bowl to bring the bubbles to the top and skimming them off, and by careful handling with the brush. Larger bubbles are formed by failure to get investment into crevices in the wax. An assistant with bellows or an air line to blow the investment in is an improvement on merely taking care!

It is vital that the various coats which may be necessary to build up the required 6mm (¼in)

*This description for building an investment is taken from *Studio Bronze Casting* by John W Mills and Michael Gillespie, published in 1969.

adhere to each other. If one coat is left smooth and allowed to harden before the next is applied, scabbing may result. This occurs when the first coat cracks and separates from the second during baking. Bronze runs into the crack. The result is a depression in the surface with a scab of bronze lying in it. Start applying each coat before the previous one has fully set, and keep the surface as rough as possible. Ready-made investments may be particularly liable to this trouble. They are really designed for pouring into flasks. It is worth adding about one-fifth of fine sharp grog and plaster to help adhesion. Scabbing is most likely where the wax is concave, and consequently the mould is convex.

After the first coat is complete, clean the protruding stubs of the runners and riser and complete the systems, including the runner cup. (This pertains to Gillespie's method of spruing, by placing studs of wax indicating the pouring gate, which is then completed over the first 6mm (¼in) layer of investment.) The invested wax may be held in position by a dollop of the coarser grog and plaster used for the main mould.

When this is done, finish the mould by building up the main thickness. The only problem here is to control the thickness; it is usually done by building the mould up from the bottom in successive rings of the full thickness. Alternatively, ribs of the proper thickness may be laid vertically up the form, and the spaces between them then filled up to the same level.

The mixture (two parts ludo, one part fresh grog and one part plaster) should be mixed with water to the consistency of thin porridge. Splash it against the first coat and force it into the crevices with a knife or spatula when quite liquid. As it thickens, the thickness is built out. Any scrapings that are nearly set can be used to build up an outer wall, so that the next ring may be started by pouring the liquid mix inside it. The main mould may also be made by pouring grog and plaster into shuttering placed

round the completed wax, with the facing coat and pouring gate in place – you can use lino, sheet metal, or chicken wire with polythene. This can be quicker than building up but uses more material.

The thickness of the mould will depend on a number of factors such as the method of baking. If temperature control is good, the mould may be thinner; if the heat fluctuates and may be excessive at times, a thicker mould is necessary. The outer layer may become crumbly, but it will protect the inside provided the excessive heat is of short duration. The mould must also be thicker where a good sand packing is not employed. With good temperature control 37mm (1½in) over the facing coat is sufficient for smallish work, e.g. a life-size head. At least 12mm (½in) is necessary over the runners. Such a mould would need sand packing. Larger moulds may be 75–125mm (3–5in) thick and reinforced with chicken wire. The shape must also be considered. A small section can be quite close to the surface. Small projections may almost reach it. A wide area, such as a relief panel, will require greater thickness. The pressure of the liquid bronze increases with the height of the mould. It is at the bottom that the strength is needed.

Build up the grog and plaster level with the top of the runner cup, and at least 37mm (1½in) thick round it. The mould will normally stand on this during baking so it should be finished off firm and level. Leave the ends of the riser system sticking out until the mould is finished, then cut off flush. When complete, the mould should show a dense surface, with no crevices or narrow projections, otherwise the fire may overheat parts and make them crumbly. If the runner cup is of waxed paper, it should be removed before baking. It would eventually burn away, but before this occurred it would obstruct the escape of the wax.

An air line obviates the need for an assistant with bellows, but blowing the first coat does help to reproduce all detail accurately.

Pouring an investment involves the wax, complete with its pouring gate, being fixed down to a smooth surface, by its runner cup. Use molten wax and a hot metal tool or soldering iron to make the wax stick. The wax rods that form the vents/risers are extended to stick to this surface also. Then around this assembly, leaving at least 50–75mm (2–3in) of space all round, make a container/flask (see diagram page 43).

The container can be made from sheet material, such as heavy-duty tarred paper, linoleum, PVC or thin-gauge metal. Cut and roll these materials to make containers adjustable to fit particular pieces. Containers/flasks can also be made from cans, drums or suitable tubing but such flasks are rigid and not easily adapted. They do, however, have the virtue of remaining in place throughout the whole baking and pouring metal operations.

Tie the rolled container around the outside using strong wire or cord and a simple knot or twist. Inside, make a lining of 12mm (½in) mesh chicken wire, to fit snug around the sides. Place the lined container in position and fix with a thick mix of investment (see diagram for method on page 43). When this has set, mix enough investment to fill the flask. Estimate the volume required, then to half that volume of water add the same amount of investment. Some sculptors pre-mix the ingredients of investment, others simply add them individually to the water. One method may be more accurate than the other, but both work.

When the investment is mixed, tap the mixing vessel to make any air rise and escape from the mix. Pour the investment into the container, directing the flow to the side of the wax, not over it. As the container fills, the investment rises around the wax (which should be coated with a wetting agent), driving any air ahead of it. Fill the container

to the top and allow the investment to set.

As it hardens, draw any identification necessary into the surface, and release the wire or cord binding the outside. This will prevent the investment cracking as it expands on hardening; the container will simply be forced open. When it has fully hardened remove the container/flask, pull the mould from the flat surface and place it, runner cup down, in the kiln.

This process suits items ranging in size from just a few centimetres to a metre. Large investments, however, are best built up, thus allowing the sculptor to make an even coverage of the wax, and to reinforce the whole mould as it is built.

Dipping wax patterns into flasks already filled with investment is another method often used, when speed is of the essence or there are a large number of items to be cast. Carefully lower the wax, coated with a wetting agent to prevent air bubbles forming on the surface as it is dipped, into the investment, which has been suitably mixed and poured. The wax can be dipped and raised once or twice to check for good coverage, but remember the investment is setting. Once you are satisfied, hold the wax in place with the investment level with the top of the runner cup, for a few minutes, until the setting investment holds it tight. The wax has a tendency to float, so place a suitable weight on the runner cup to hold it in position as the investment sets, so you can get on with another mould if necessary. As the investment hardens, crack the container by releasing the wire or cord, then remove it completely when the investment has hardened, and place the mould in the kiln, runner cup down.

If you are using a fixed flask, a can, metal tube or drum that will remain around the mould, make sure the bottom is cut out, after the investment has hardened, or drill some holes, to release steam generated in the mould as it is baked in the kiln. If this is not given the means of escape, it will cause an explosion in the kiln, damaging the mould and any others in the immediate vicinity.

INVESTMENT

The refractory moulding material applied to the surface of the pattern. Some formulas for such investments follow:

INVESTMENT CASTING

The term given to metal casting processes other than sand moulding.

Grog (ground ceramic material)	1 part
Plaster	1 part
Silica flour	1 part
Grog	3 parts
Plaster	1 part
Ludo (reconstituted plaster/ investment material)	3 parts
Plaster	1 part
Plaster	1 part
High alumina cement (ciment fondu or lumnite)	2 parts
Sand	6 parts
Proprietary refractory cement	10 parts
Plaster	1 part

In all of these formulas the plaster is the binder. When used with cement of any kind the plaster holds the investment in place whilst the cement hydration takes place.

Proprietary jewellery investments can be used, and are manufactured in a wide range of formulas, but they are usually expensive.

For ceramic shell investment materials, see Ceramic Shell Casting.

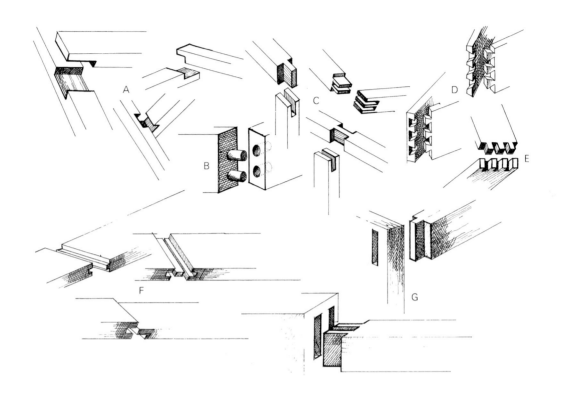

Some of the common carpentry joints useful for woodworkers, all of which can be carried out on large timbers:

- A *Halving joint*
- B *Dowelled joint*
- C *Tenon joint*
- D *Dovetail joint*
- E *Combing joint*
- F *Housing joint*
- G *Mortise and tenon joint*

IRON

The title Iron Age recalls the discovery under a very hot fire, after copper, of another shiny, hot liquid, that became even harder than copper when cool and was equally abundant. Iron has had a long history in its use by sculptors and artisans, but it wasn't until the Industrial Revolution in England, and the development of the great smelters and foundries at Coalbrookdale, installed by Darby, that the full range of iron was exploited, and its influence felt worldwide. Although it can be cast to produce items of very fine detail, it is most commonly used by sculptors today as a medium for constructing sculptures by welding and brazing.

Indeed, wrought and welded sculptures are almost a twentieth-century phenomenon. Brittle when cast, iron becomes malleable to a degree when red hot and can be shaped. This characteristic, coupled with the advance in welding technology, has led to its prominence in sculpture today. However, it has poor resistance to

Torso of the Monument to Blanqui by Aristide Maillol, in lead, 1905.

Scarf joints

atmospheric corrosion and therefore requires maintenance, such as regular coats of paint, when placed in the open. There is a new steel, marketed under one brand name as Core Ten, which has the developed advantage of a surface that, once oxidized, is resistant to further deterioration and can be used safely on large constructions.

JOINTS

The devices made to attach items one to another, usually of wood. Most are self-explanatory when seen in relation to a diagram, and some basic joints are illustrated on page 112 and above.

KILN DRYING

The modern industrial equivalent of the natural seasoning of timber, making a wide range available to the various timber trades very quickly. It provides useful wood for construction but such force-dried timber is never entirely satisfactory for the sculptor.

KILNS

The kiln is, for the sculptor, a vital piece of equipment used to make terracotta sculptures and in the process of metal casting (lost wax). Kilns used in firing clay have become sophisticated machines, developed over the years to provide for all the needs of ceramicists and the wide range of ceramic bodies they use. At a more primitive level

there is an overlap where kilns (usually studio built) can be made to accommodate the needs of both metal caster and terracotta maker.

Kilns for firing clay have been much discussed and written about; to try and deal with that complex field in this book is quite pointless. The bibliography lists some reference books that will cover the subject in greater detail.

The most basic means of firing clay is simply to pile combustible materials around the dry clay image, so that it is completely covered, and then to set fire to it. Close compaction of the fuel causes it to burn slowly and achieve a temperature suitable for low fired earthenware. This method does involve some risk to the image but is still used in India to fire large votive clay horses, and is a useful technique to use in emergencies, or in study workshops where there is a minimum of sophisticated equipment available. It is also a satisfactory way of introducing the basic nature of firing clay, leading to an understanding of kilns and their function.

The most primitive kiln is a form of updraught kiln. This is simply a chamber built over a fire box, with a hole at the top of the chamber to create a hot draught from the fire through the space so that the fire will burn with some degree of control. Control is achieved by adjusting openings under the fire box, the walls of the kiln chamber being constructed of mud bricks, or clay and shards of

broken pottery or a mixture of both. This kind of kiln is still used in some country potteries around the world, and for metal casting. Even in more sophisticated foundries such hand-built kilns are favoured. I have seen them in Milan, New York and London in recent years.

Modifications to the traditional kiln are too numerous to cover here as I have already stated, but the invention of ceramic fibre has probably caused the biggest rethink in recent kiln technology. This material is marketed under various proprietary names, but is basically blends of alumina and silica (alumino-silicate) blown into fine fibres that have unique refractory properties, great strength at high temperatures, and are lightweight. These characteristics have made it possible to construct kilns that are less bulky, capable of high temperatures and relatively easy to build and maintain. I have illustrated some variations of kilns using both ceramic fibre and refractory bricks and cements. Sculptors tend to make up equipment to suit specific requirements, thus making it impossible to cover all innovations. Suffice it to say that there is always a way to fire a terracotta, or to achieve a metal casting, of almost anything you care to make once you understand the basics.

Controlling the temperature of a kiln is probably the greatest problem because it is critical to achieve a temperature at a controlled speed, and to reach the required temperature for the particular material. Some people trust their eye and assess kiln temperature by colour, viewing the kiln interior through spy holes. The same spy holes can be used to view pyrometric cones. These are made of heat-resistant clay that softens and bends at specific temperatures. Numbers inscribed on the cones correspond to the temperature and the time taken to make the cone bend, thus giving an accurate account of the firing, enabling the sculptor to judge the maturity of the firing according to the kiln's contents.

LAMINATING

The gluing together of materials, usually in sheet form, to make a solid stronger than any of its single components. GRP (glass-reinforced plastic/polyester), plywood and papier mâché are common examples of such laminating. When carried out on a large scale laminated timber beams and buttresses can be made to span very wide areas. Large sculptures can be made utilizing such processes of laminating, offering at the same time wider possibilities of daring than can be easily achieved carving from natural-grown timber. The early days of flying and subsequent developments in making wooden aircraft have supplied us with adhesives and methods of laminating that, on the whole, are almost taken for granted today.

LATEX

A natural cold-curing rubber, latex dries on contact with air, forming a fairly elastic skin. This unprocessed rubber can be built up over an object in layers; the addition of a little gauze in the build-up will inhibit some of the shrinking it is liable to. It will require a plaster jacket to hold it in place.

LAYING UP

The term given to making the laminations of resin and fibre, as in glass-reinforced polyester/plastic (GRP). Under ideal conditions a complete GRP lay-up should be as follows: gel coat resin (surface), resin and glass fibre tissue, followed by a *3oz* glass fibre chopped strand mat, followed by a *3oz* woven glass fibre cloth. Each layer of fibre, be it glass fibre or terylene or some other material, must be fully impregnated with resin. The fibre provides the tensile strength the brittle resins require to make a strong solid. The laminations I have described are the basis for lay-ups used in

industry for car bodies, boats, canoes, etc., needing the strongest possible thin section. Sculptors usually use only the chopped strand mat. Sculptures usually are of greater bulk than other items made of GRP and so can dispense with the finer lay-up, but it is wise to gain the knowledge and skill for a full lay-up so as to be prepared.

LEAD

This metal is an attractive medium for sculpture: it has a high resistance to atmospheric corrosion and is a pleasant colour. It has a low melting point, about 327°C, and is easily cast in the studio. In sheet form it can be fashioned simply, requiring little or no annealing. If worked too thin, however, it is liable to break. Its soft appearance and resistance to corrosion was responsible for the Victorian fashion of casting copies from classical sculptures, to adorn grand gardens. Majestic lions are typical examples of such statuary.

The ease with which lead can be worked can cause some carelessness and severe studio accidents can result. I would caution against relaxing any safety measures when using lead: treat it with the same respect you would show metals of a much higher melting point.

Plaster of Paris moulds are sufficient for casting lead, but adding refractory materials such as brick dust or grog will make safer moulds. Of course, if you are using the lost wax process to prepare the mould these are essential, otherwise plaster moulds are quite adequate. The mould should be thoroughly dry, with no free water. It should therefore be heated, preferably baked at a temperature of about 250°C, and maintained at this heat for about 24 hours if the volume is large. Domestic ovens can be used or kilns built in the studio. If you try to pour lead into a plaster mould that has not been dried by heating, free water in the plaster will immediately vaporize

and cause the metal to be blasted from the mould. This is the cause of most studio accidents, and burns result in lead poisoning, so treat the metal with care. The rewards can be interesting.

Foundry sand can be used to make open moulds for lead. Clay, too, can be used for this purpose, but only for shallow castings. The clay must be leather-hard and the metal layer thin so as to chill before any moisture in the clay has time to vaporize. Be careful.

To melt lead, use a steel crucible, available from hardware stores or plumbers' suppliers. Iron ladles can be similarly purchased. Once the lead is molten, skim the fine film of scum from its surface and pour the metal. Place the prepared mould, packed in dry sand, near the crucible and pour an even flow of metal. When pouring lead in any quantity try to be two-handed – have a helper and pour using two ladles. This will ensure a continuous flow of molten metal, maintained at the correct temperature. Of course, if you have a two-man shank and ring, the pour can be achieved in one move, but this means keeping a crucible for the exclusive use of lead, which may not be a viable proposition. Crucibles are expensive, and the traditional steel crucible is the best for lead in the long run.

Pure lead is seldom used for casting. It is difficult to work. Being very soft, it tends to clog rasps and files. An alloy of lead and antimony is favoured. This casts with the same ease but the resulting metal is harder and more easily chased. Up to 10 per cent of antimony, by weight, is used in this alloy and the resulting metal is brighter than pure lead. The antimony imparts a certain brittleness to the metal that makes it harder and better to work; printers' typeface is cast with a lead/antimony alloy, and can often be a source of supply.

Lead with antimony does not, however, lend itself to direct working, being too stiff and brittle to hammer, shape and bend. For this purpose you require roofing grade lead, which is almost pure and is sold in sheet form in various thicknesses.

LEATHER-HARD

This is the condition reached in the drying of clay, when further work can be done, mainly for terracotta. It is early in this stage that the work can be cut and hollowed. At the later leather-hard stage, when the clay is too hard to cut through, it can be burnished. This is done using a bone or wooden tool, and rubbing the surface until it becomes shiny and smooth to the touch. Burnishing consolidates the surface of the clay, and if well done can help to make a vessel able to hold water without substantial loss. The fine hard, dense surface achieved by burnishing is particularly interesting, and if the burnishing tool used is of silver the colour of the fired clay will take on a particular grey shade. At the leather-hard stage the clay can be carved and surfaces defined more precisely; undercut shapes can be made to take inlays, etc. Experience will enable you to judge the precise degree of hard/dryness you require for particular additional processes.

On ordinary modelling clay (clay that is not suitable for firing) the leather-hard stage enables the artist to make very precise hard forms that can be balanced against softer shapes and surfaces. It is almost impossible to model a hard, tight curve satisfactorily using soft clay. French sculptor Auguste Rodin made a practice of keeping clay at varying degrees of hardness, to use according to the form he was modelling. Leaving some clay to become leather-hard was a common practice of his.

LIGHTING SCULPTURE

It has become common practice to include lighting when designing sculpture for public spaces. In the past this feature was often an afterthought and consequently resulted in lighting the work from below. However, this is not the most effective use of light; in nine out of ten cases the sculpture is made in a studio, foundry, carving yard or workshop with a prevailing top light. Top (natural) lighting helps to clarify the form, whilst lighting from below contradicts a natural illumination and obscures a true perception of the sculpture.

Whenever possible, light sculptures from above, unless the scheme demands more elaborate and dramatic effect. Determine the availability of adjacent structures – buildings, trees, lamp-posts or pylons – that will enable the work to be lit from above. Putting the light source above and in front of the work at three-quarter views provides a good basic artificial light.

Seek advice from a lighting consultant who can provide information regarding:

- Light intensity and the danger of ambient light pollution.
- Colour (this needs to be chosen with care but can add spectacular effects and drama).
- Lighting hardware such as floodlights or spotlights, both available in a wide range of models. Spotlights allow precise focusing and, using templates, special features on the sculpture can be highlighted.
- The running costs of various lighting hardware – clients often ask for information on these costs, and it is always helpful if the artist can show that they have been factored into the total costing.

LOST PATTERN PROCESS

Forming hollow castings in metal, using the sand moulding process, has always been of particular concern to sculptors. The problem of making an original form, complete and hollow, to be simply covered with sand without making complex pieces is an intriguing one. The possibilities inherent in the coarser material are interesting and, with the advent of foamed polymers, the exploitation of the lost pattern process offers a wide range of qualities.

The commercial development of lightweight expanded plastic foams – up to 98 per cent air – has provided the means for evolving the 'lost pattern' process. In many ways this is similar to that of the lost wax process. The original can be made of expanded polystyrene or of rigid polyurethane foam. The metal thickness may be determined during this time, and the form can, of course, be solid or hollow, according to size. The effort and time involved in making a small form hollow may be better spent, however, in controlling the juxtaposition of volumes, and the overall shrinkage of the metal upon cooling. When it is encased in a sand mould, molten metal is poured straight on to the original which instantly burns out, to be replaced by the metal. In this way many tedious moulding processes are eliminated.

The technique for using these cellular polymers is fairly straightforward. The original or pattern can be made by cutting, shaping, gluing and generally using an amalgam of additive and subtractive techniques. Rigid polyurethane foams can be obtained in various densities, expressed in so many pounds per cubic foot; the greater the poundage the greater the density. Because of this density and their fine cellular structure these foams can be worked to a much finer tolerance than expanded polystyrene. Once the original form has been made from one of these materials, it has then to be prepared for casting.

The original is first fitted with a pouring gate which can be made from strips of the parent material and built up on the master form by gluing. The pouring gate is similar in principle to the lost wax system. A series of runners and risers is also necessary to permit the metal to run and the gases to escape.

The completed original, with its pouring gate, is then embedded in foundry sand which should be firmly compacted about it. CO_2 sand is commonly used for this purpose because it can easily be hardened by applying CO_2 gas, *in situ*; the mould does not require heating to make it rigid. Green sand (natural bonded) can also be used as it too requires no heating, which is an important factor in view of the nature of the plastic.

Molten metal is then poured directly on to the original. The foamed polymer will volatize and disappear, to be instantly replaced by the metal. When cool, the mould can be broken off and the metal casting trimmed and chased to its final state.

It is possible to embed a polystyrene object in dry sand, vibrating the sand so that it packs around the form completely. Then the molten metal is again poured directly on to the pattern, feeding it from the bottom. Venting must be well planned so that the foam is immediately replaced by the metal, otherwise hot gases may erode the pattern in advance of the metal flow.

LOST WAX

The art of casting where the positive form is, at one stage in the process, made of wax. The wax is then prepared according to the material to be cast, i.e. metal or glass, and covered with a refractory moulding material commonly referred to as the investment. The completed refractory mould (investment) still containing the wax is baked at a temperature of 600°C, causing the wax to run out leaving a cavity which can be filled with the molten casting material to make the casting.

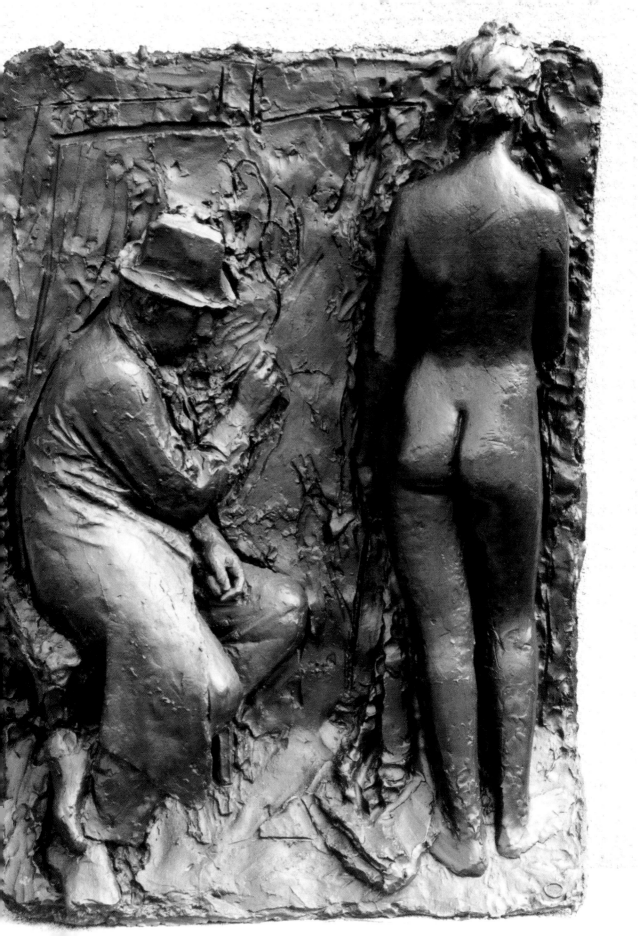

TOP AND RIGHT *Ammonites* by
Anthony Hawken, Grinshill stone, 1999.
Cheltenham, England. Top illustration
shows the maquette from which it was
scaled up.

PREVIOUS PAGE *Self Portrait with
Model*, Giacomo Manzu, bronze, 1958.
Washington.

John Mills and Derek Howarth at work on an enlargement of *Aurora Water Carriers* for the cruise ship *Aurora*. This is part of the scaling-up process, working from the maquette on which the scaling grid is drawn.

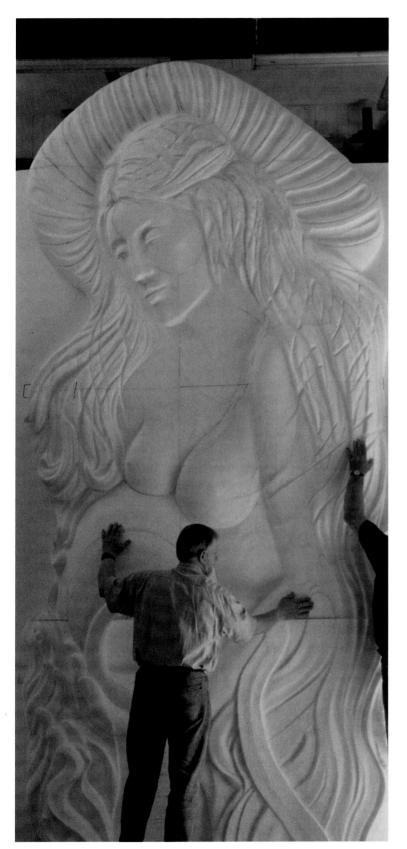

TOP AND RIGHT *Caractacus* by
Anthony Hawken,
Richement Stone, 1999.

OPPOSITE PAGE: *Group of Bears* by
Paul Manship, bronze, 1952.
Central Park,
New York.

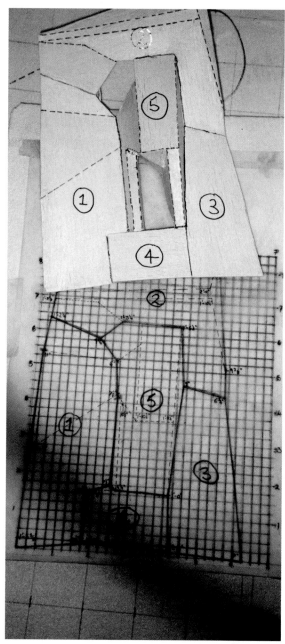

TOP LEFT Derek Haworth discussing the enlarging task for *Head of the Stairs* with the sculptor Ivor Abrahams.

BELOW LEFT Various profiles have been marked out on a sheet of polystyrene (Styrofoam).

ABOVE Each profile is numbered and then overlaid with a calibration grid to aid enlargement.

RIGHT ABOVE and BELOW The enlarged profiles are then assembled to create the large version of the sculpture.

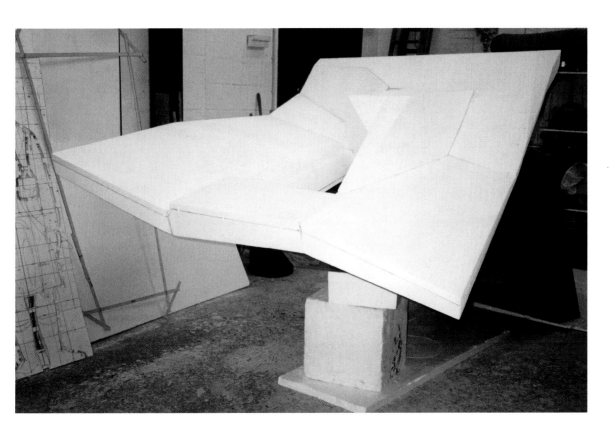

TOP LEFT The polystyrene (Styrofoam) enlargement is given a durable surface with GRP sheets, and the surface is sealed.

RIGHT The finished sculpture in poly-chromed bonded glass by Ivor Abrahams, 2001.

LEFT *Geometry and Stone* by Michael Kenny, Kilkenny Limestone, 1998, Northampton, United Kingdom.

BELOW *Quadriga Fountain* by John W Mills, bronze, granite and water, 2000. Charleston, South Carolina.

LEFT *L'Homme passant la Porte* by Ipousteguy, bronze, 1964. ABOVE *The Procession* by John Pappas, bronze, 1978. Detroit.

ABOVE *The Great Horse* by Antoine Bourdelle, bronze. Yorkshire Sculpture Park.

RIGHT *Begob* by Alexander Lieberman, red-painted steel, 1996. University of Michigan.

ABOVE Royal Artillery Memorial by
Sargeant Jagger, bronze and Portland stone,
1921–25. Hyde Park Corner, London.

OPPOSITE PAGE: John Mills working on
the sculpture *Time*, using direct plaster.

ABOVE Drummer by Michael Sandle, bronze. New Orleans.

Young Girl in a Chair, Giacomo Manzu, bronze, 1955. Washington.

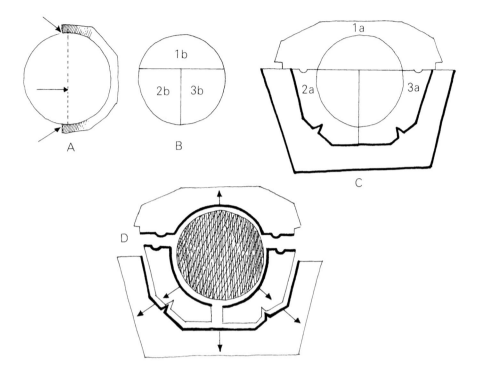

The principle of piece moulding:

A *Although in theory two pieces will be sufficient to make a piece mould of a sphere, if the division is not accurate the mould section is in danger of locking on.*

B *It is safer to divide the mould into three sections.*

C *The completed mould showing the mould section 2a and 3a contained in the case.*

D *Removal of the mould and case from the original and subsequent castings.*

MAIN CASE OR MOTHER MOULD

That section of a piece mould that contains all the actual mould sections, holding them in their correct position, ready to prepare and to make the cast (see diagram above). Each mould piece is given a register to locate it exactly in the main case.

MAINTENANCE

Sculpture maintenance is very important in the long-term wellbeing of a work, especially those on public sites and subjected to the vicissitudes of the elements. Finishing materials such as wax, oil, or any of the proprietary treatments now on the market (used with care and consultation) have a limited life, and therefore a maintenance regime is necessary (unless the natural degrading or enhancing effect of weathering is desired). Repeating the final finish (of wax or oil) at regular intervals is usually sufficient, but never apply a heavy coating. For sculptures in a clean environment, simply washing down with a mild detergent, with a final good rinse in clean soft water, is usually all that is required. Clients should also be made aware of the maintenance regime so that any later work on the sculpture is carried out according to these instructions.

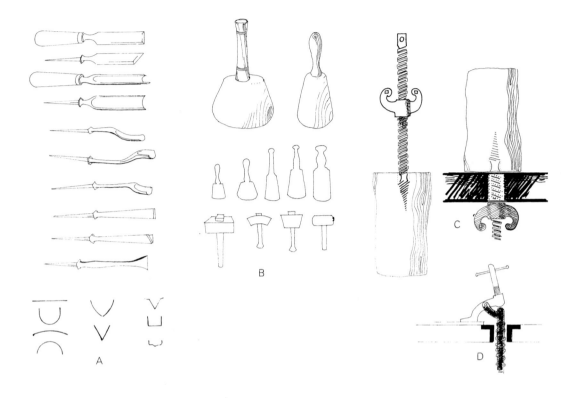

ABOVE
A Various wood-carving chisels and gouges with some of the profiles that they make.
B Carvers, mallets and possible variations.
C A bench pin that is screwed into a log then passed through a clearance hole on a carving bench and secured by means of the wing nut to facilitate carving.
D A bench clamp, also used to secure items to a workbench.

In some cities (particularly London) public statues/sculptures are regularly painted with a thick layer of corrosion-resistant mixture. After many layers of this over a number of years the modelling is obscured and all detail covered over, spoiling any perception and appreciation of the work.

One of the simplest treatments for a bronze maintenance is to apply a light, clear, good-quality polish (*not* beeswax) on a hot summer day when the bronze is warm; polish it in the evening when the sculpture cools and allows the coating to be buffed up.

MALLET

Like the hammer, the mallet is the means by which energy is transmitted to the cutting edge of a tool, and is as important to the carver as the hammer. Wood-carving chisels and gouges are struck only with a mallet as are round-headed stone-carving tools. The mallet takes on various forms; for instance, a joiner's mallet, made mostly as a general-purpose tool for tapping joints as well as for striking the chisel, is usually of an angular or square configuration. Those used for carving are round but of various shapes. The best mallets are made from lignum vitae, but other close-grained woods such as beech are used; however, they do

Stone-carving tools of Peter Nicholas, including hammer and mallets, mallet- and hammer-headed chisels and claws, rifflers and rasp.

MASTER CAST OR MASTER COPY

The definitive pattern from which a metal casting is made or from which a copy in wood or stone is carved. The master copy determines precisely, for the artisan, not only the pose, volume, size and disposition of a form, but all the detail. The foundry, when accepting the commission to cast, is obligated to make an accurate reproduction of the 'master', precise in all its features. The master should be present at all stages in the casting process to ensure accuracy. The sculptor should insist that this is so whenever he inspects the work at various consulting appointments. There was at one time a pride among art bronze foundrymen that the master cast would not be damaged, and that both it and the casting would be presented

tend to wear away more easily. The carver's tool kit will contain a number of mallets of different weight and size, necessary to carry out any scale of work.

Chipping-out mallets are usually old carving tools that have served their time. Chipping away plaster moulds is very wearing and doesn't require perfect tools.

Mallets with textures cut into their striking faces are used in clay modelling to help consolidate the clay to give texture to the surface, and to help break up the play of light over the clay surface.

together for the final approval of and acceptance by the sculptor, a practice sadly lacking today.

Recently there has arisen the practice of using a 'master mould', this usually being a flexible mould of one of the newer compounds, from which all waxes are made for casting. Mould materials such as polysulphide are fairly stable and so can be stored, and it is the advent of such compounds that has given rise to this use of a master mould. The bronze chaser needs to have the original or a copy to hand as he works, so the master remains essential for his work. Of course, casting can be taken from the master mould for this use, but I do think the disregard for the master cast has been brought about by the use of such stable rubber moulds.

MAQUETTE
(*see* **Bozzetto, Sketch Model**)

The sketch model made by sculptors is always referred to as the maquette, a word derived from the French for model. By progressing from drawing, a two-dimensional activity, to working in three dimensions, the sculptor gains a better understanding of the work he is planning. The maquette is not usually a definitive statement of an image, but represents a kind of thinking in the round. This is the means by which a sculptor establishes proportion, balance and gesture. He can explore alternative solutions to a given idea; he can work out the carveability of a form or combination of forms to best exploit the wood or stone. The kind of support that will be required to develop a full scale sculpture can be worked out using the maquette. In short, this sketch model is the proving ground for an idea or image that will be exploited fully as the work progresses through its various stages. A final maquette is often used to communicate an idea to a client.

Sculptors have differing ideas regarding the nature of the maquette, whether or not it should

be made in a material compatible with that of the final product. Should a sketch for a carving be of similarly carveable material? A study of the working methods of Michelangelo would make this appear unnecessary, in his case at least. Should an assemblage be designed by assembling items on a smaller scale? This is a matter for personal choice, and providing your knowledge of the final material is sound it probably doesn't matter too much. If it is not, for whatever reasons – perhaps the material presents a new challenge – then it would be sensible to explore an image via a similar process.

The maquette is not a working model. This is usually the next stage in the making of a large work. In the working model, forms and surfaces are worked out in greater detail so that the sculptor can build up to the large scale. This is of vital importance if the work is to be carried out by assistants or other artisans.

MATERIALS FOR SCULPTURE

Methods can be devised to make sculpture from almost any solid. Our view of what materials are suitable for the manufacture of sculpture has largely been conditioned by art history. Only those images that have withstood the ravages of time have survived for us to study. So, regardless of the image evoked, the materials have been assessed according to their durability. In descending order of resistance to the elements, we have stone, non-ferrous metals, ferrous metals, followed by fired clay and then wood. Other substances that survived were considered to have been used only as vehicles, intermediaries used to make things that would later be reproduced in one of the durables.

We now know, of course, that this is a false

Enlarged sculpture of *The Thrower* by John W Mills, 1959. Note the maquette for another sculpture in the background on the left.

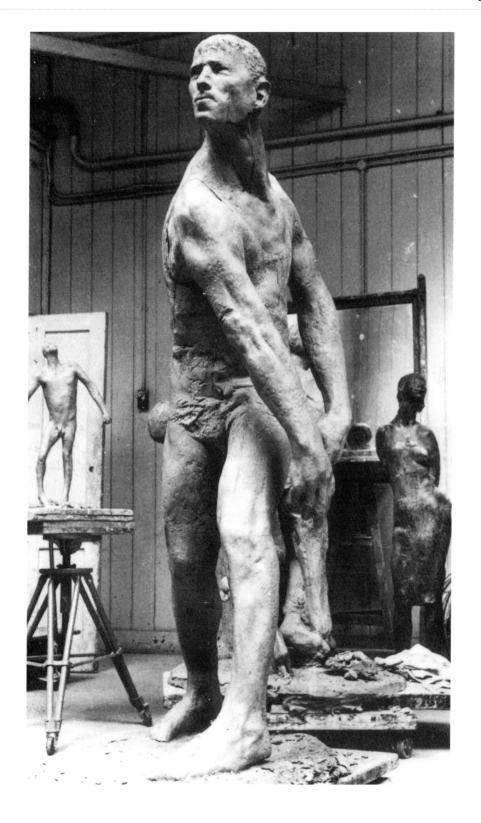

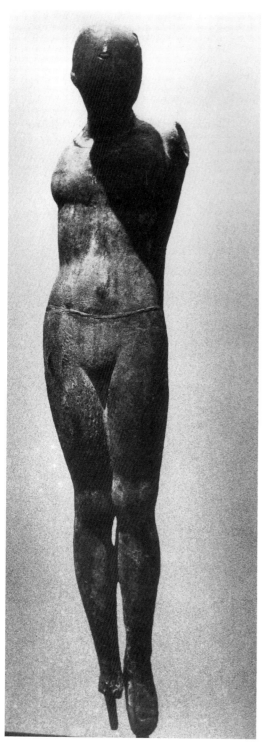

view, and that three-dimensional images were made from every conceivable material. The sculptor or craftsman selected the medium according to various criteria, materials available, material best suited to the image or symbol, the material required by the sect, society or client, the cost, the important factor being the image expressed and its relation to the society for which it was made. This undoubtedly was the overriding stimulus experienced by artists at the turn of the century, seeing with fresh eyes the images and artefacts from so-called 'primitive' cultures, and recognizing the complete unity of image and material they represented. Their fault was in being too influenced by the nature of the image only, and not by its relevance to the society it belonged to.

Archaeologists and anthropologists have revealed figures made from a very wide variety of stuffs, including feathers, leaves, tree bark, paper, etc. This custom among tribal societies continues, and we can see the response to modern ephemera in the adaptation of Coca-Cola tins and plastic spoons in the hands and faces of natives of Borneo for instance. Since the turn of the century and that first impact of tribal art on the artists gathered in Paris and London, we have seen a proliferation of works made similarly from non-durable materials. Often, works made as transient things have been enshrined as high art, thus placing great emphasis on conservation techniques. Ephemeral works such as 'firework happenings' are now made more durable by filming, endorsing the concern today for art conservation, and the related technological research necessary to preserve works of an ephemeral nature. Art history is changing in its regard for the image according to society and not just in terms of classical materials.

ABOVE *Juggler* by Marino Marini, bronze. Chicago Institute of Fine Art.

RIGHT *Horse* by Marino Marini, bronze, 1951. Toledo Art Gallery.

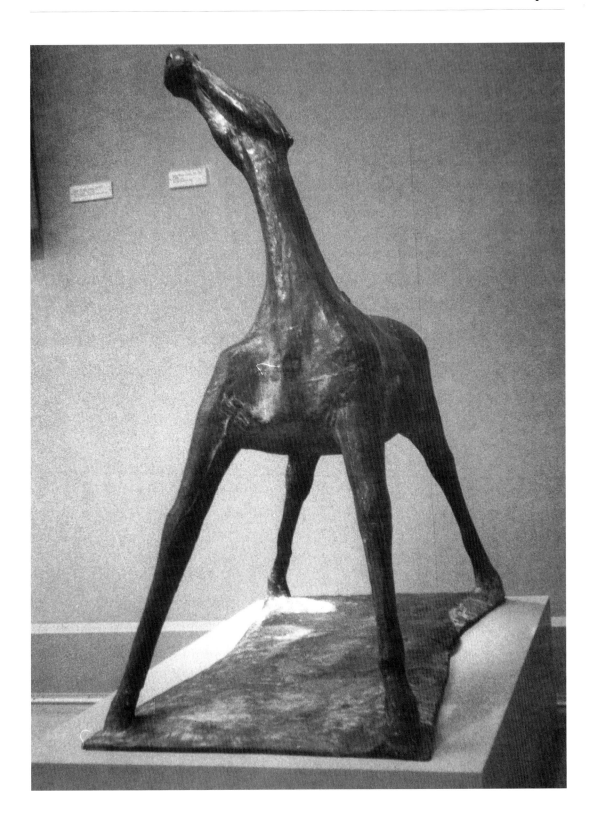

ABOVE and TOP RIGHT Henry Moore working plaster in his studio.
Henry Moore preferred to work directly in plaster to make his
maquettes — modelling and carving, thus maintaining a link with his
stone-carving background.

BELOW RIGHT *Mother and Child* by Henry Moore, bronze, 1987.
Yorkshire Sculpture Park.

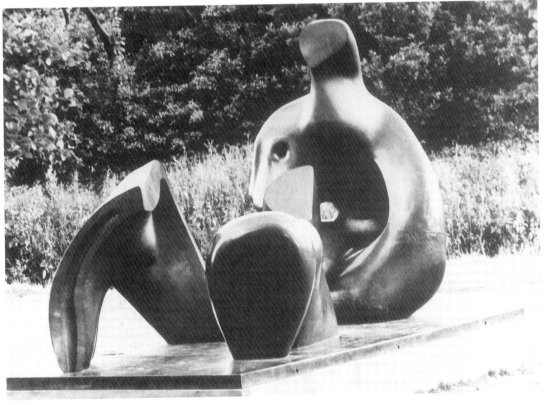

To the traditional big five of sculpture materials, modern industry has contributed new durable and semi-durable substances. There are now available various kinds of cements. Resins of all kinds are made and grouped together under the generic heading, plastics. There are new metal alloys extending the range of non-ferrous metals, and there is now treatment for erstwhile corrodible, erodible and decayable substances, such as wood and ferrous metals, extending the range of application of those materials now commonly used to make sculpture.

There have been two continuing dichotomies in the understanding of sculpture and its related materials. The first is the distinction still made in some quarters between sculpture and statues; the second is the attitude taken towards new materials. The length of time taken to absorb new materials into the vocabulary of sculpture is often due to the fact that they are assessed according to their resemblance to traditional materials. We have, for instance, a kind of concrete known as 'pre-cast stone', which is not stone nor can stone be pre-cast. We also have a substance known as 'cold cast bronze'. This is not bronze, and certainly not cast bronze. It is resin casting with powdered bronze used as an inert filler. The resulting sculpture can indeed be made to resemble bronze, but the true qualities of resins are much wider and more various than this, a fact slowly being appreciated.

Similarly 'holographics' are being offered as sculptures, but the items shown are often only reproductions of sculptures. The attractive qualities of this medium are undisputed, but so far have not been exploited as a unique quality. It is now not unusual to see sculptures made of rolls of linoleum or foodstuffs, so perhaps the need to assess a new material according to its potential as a facsimile medium for traditional, and more expensive, materials is passing. We should regard a material's worth according to its inherent qualities when seen in relation to the overall definition of sculpture, as three-dimensional form in the round or in the relief.

The attitude still expressed today, that sculpture is carved and statues are cast, is a surprising hangover from the Victorian era. It is an attitude based on the misunderstanding of the Renaissance, a view expressed relating to the work of Michelangelo and his dislike of bronze, and echoed recently in the criticisms of the work of Jacob Epstein. It is an undeniable fact that, no matter what their training, some people are by nature best suited to carving (a subtractive process), and others to modelling (an additive process). Whether this is due to the individual's initial exposure to sculpture it is difficult to say. Of course, the two are not mutually exclusive, and modellers carve as much as carvers model, but an illustration of the dominance of one predilection over the other occurs in the work of Marino Marini. His modelled and cast work is of very fine quality, and was a major influence on a great number of sculptors in Europe and America in the 1940s, 1950s and 1960s. Towards the end of his life, however, he produced a number of large stone carvings which clearly indicate his unease with the material and methods of carving. The work of Henry Moore, on the other hand, represents almost the complete opposite. All his sculpture deals with form according to his acute understanding of weight, mass and compression. The monolith is the guiding force in his work and is indicative of the mind of the carver. Both men, of course, were sculptors and both men made sculpture.

All naturally occurring materials, from the hardest to the softest, have been used by man to make images and demonstrate his powers of invention and ingenuity.

The Arm by Pablo Picasso, bronze, 1959, modelled in direct plaster.

The useful headings used by historians, the Stone Age, the Bronze Age and the Iron Age, aid a historic overview of materials: stone, bronze and iron, together with clay and wood, are the five basic substances used by sculptors through the ages. These headings also help in understanding techniques. By studying technical changes from one period to another it is easier to comprehend the formal changes that occur in the images themselves, such as the abraded forms typical of Archaic Cyclades, developing into the exuberant freedom of Hellenistic Greek sculpture resulting from the devising of tempered iron carving tools. Such an example illustrates how overcoming the limitations imposed by known materials and techniques often leads to an excessive use of the new freedom. The big five can be broken down in terms of technique, as malleable, castable, carveable and constructional materials. New materials introduced into sculpture invariably fit into one of these categories.

Stone, wood, clay, bone and ivory are natural materials, of course, occurring in most parts of the world in great abundance, but not everywhere. Their variety and availability is conditioned by geological and geographical patterns. The works of some cultures are affected by their lack of certain materials. Wood is a rare and valuable commodity to the Eskimo, so images made from wood are often given great ceremonial importance. A similar shortage on Easter Island has had the same effect.

Equally, where there is an abundance of a substance the output of the culture is affected, as it expresses itself in that material; the stone of the Aztecs, or the clay of any culture living in a fertile plain or estuary, for instance. The quality of the material, its hardness, how easy it is to work, affects the forms used to express cultural activity. In southern India soft, easily carved sandstone has led to temples being covered

Detail of *Choristers* by Lucca della Robbia, marble, 14th century. Museo di S Maria del Fiore, Florence.

Head by Henry Moore, concrete, 1926.

with a fine tracery of carved figures and forms.

Today, this easily identifiable cultural difference is obscured, to a degree, by the export and import of raw materials around the world. Their wider availability has obviated cultural geographical peculiarities. The exploitation of form and image is now more dependent upon the knowledge and skill of the individual. There is little or no continuation of craftsmanship from one generation to another and so certain skills,

and the related materials, are falling into neglect. Stone is comparatively little used today. Wood is used more but it is not a widely chosen material, although there is a small renaissance of both wood and stone carving. Clay, other than in ceramics, is most often used as an intermediary medium, to make images to be cast in more durable substances. Fired clay, terracotta, is used but not often as a final material, when compared to the overwhelming use of cast metals of all

Mlle Pogany by Constantin Brancusi, polished bronze, 1913.

after casting. Texture and surface need to be restored when any repair work has been done, for instance where saw and grinding marks are left after the removal of the pouring gate and welding over core pin holes. The careful use of matting tools allows the skilled chaser to work the surface so that such spots are virtually undetectable. Such a craftsman is worth his weight in gold to an art bronze foundry, as castings are more often judged on their final surface than on their light weight.

The matting tools are usually made to suit personal requirements for the sculptor or craftsman. They can be made to suit particular shapes and to cater for textures of all kinds. Good-quality tool steel is needed to make the best matting tools and chisels, forged, filed and ground to give the chosen shape and then tempered to harden the striking face. This face can be textured by hammering it against a suitable texture at the dull red stage of tempering, when the metal is soft. Textured surfaces such as rifflers, bastard files, etc., can be used; alternatively, textures can be made by filing and sawing.

It is possible to purchase matting tools but I have never found one that really fitted the bill; it is best to make your own.

MELTING AND POURING METAL

There is always an air of anticipation and excitement whenever a furnace is lit and a melt begins, but it is never a procedure to undertake lightly.

The metal is melted in a crucible, 'the pot', heated in a furnace. Some sculptors pre-heat the crucible before charging it with metal, waiting until it is red hot; others place metal in the cold crucible and allow the whole thing to heat up together. The danger in the latter method is that there is a difference in the expansion rates of the crucible and the metal, so that if the metal is packed too tightly it may expand more quickly than the pot and crack it. The former is the safer method, paying

kinds. New foundries have sprung up in recent years all over the world, particularly in the USA.

MATTING TOOLS

Specially prepared punches with patterned striking faces, used to blend (matt) metal surfaces, usually

due respect to the crucible, the vital part it plays in the process and its high cost. Although capable of withstanding thermal shock, the crucible, charged or not, should be gently heated for the first ten minutes or so, to make sure any free water is driven from both pot and metal before the heat is turned up seriously. Harsh treatment of the crucible can cause it to become thin and fragile, presenting a serious hazard, liable to break when being lifted from the furnace with a full load of molten metal.

The crucible should not stick to the floor of the furnace, and a small podium cast into the floor of the kiln will raise the pot above any metal that might be spilt and allow the heat to circulate better around the crucible. If cardboard is placed under the crucible it will carbonize during the melt and help prevent the pot sticking. The crucible adhering to the furnace or to any stilt placed freely in the furnace is another cause of its deterioration.

Place small pieces of metal in the bottom of the crucible to melt first and aid a quicker melt. Initially, heat reaches the metal by radiation from the crucible walls so the quicker a puddle of molten metal can be made the better. As the metal melts add more ingot or scrap until the desired quantity is arrived at. Try to keep the metal well consolidated as it melts so that the maximum advantage is taken of the heat generated. All metal must be pre-heated to drive out any free water, always present in cold metal, before adding it to the charge. Cold metal must never be added; the free water will immediately vaporize and blow molten metal all over the studio. Pre-heat the metal around the top of the furnace on the lid. If you make your own furnace allow for this in the design (see page 103). It goes without saying that any metal tools used in the preparation of the metal – stirring rods, skimmers, de-gassing plungers, ladles, etc. – must also be pre-heated before use.

A pyrolance is the tool used to measure the temperature of the metal, and is in effect a thermal couple mounted on a lance, connected to a gauge that accurately records the temperature of anything the lance touches. It is an expensive piece of equipment, however, and although it is essential where solid experience is lacking, it is an item soon discarded by the regular practitioner. Practice and familiarity with melting alloys of various kinds will make you a good judge of your metal, gauged according to its colour and consistency in the pot. Some old-timers say that if a cigarette paper thrown in ignites immediately the metal is ready! In another test, if a dry, warm, mild steel rod is dipped into bronze, held there for a few seconds and then withdrawn, the state of the metal can be judged by whether or not a crust of bronze is sticking to the rod. If the rod is clean the metal is ready to be poured, being somewhere in its upper optimum melting temperature range.

It is wise to buy good ingot from a reliable supplier to be certain of the alloy and, if the metal is unknown to you, to learn from them the metal's characteristics, for example what is the optimum temperature for pouring? The upper and lower limits? Does the metal require de-gassing, and what with? What cover flux is required, if any? etc. The upper limit pouring temperature is the superheated stage and for thin-walled castings this is usually the temperature at which you pour. For all other thicker casting, pour on a descending temperature scale, but within the lower limit. The cooler within the optimum range the better the metal in the casting. Do not 'overheat'. This will cause a change in the composition of the alloy; the white metals, particularly zinc, will be lost through oxidization. Although some elements can be adjusted, zinc can be added, de-gassing can be carried out, deoxidizing fluxes can be included in the melt, it is wisest not to 'overcook' the metal. Fluxes cut down zinc loss by providing surface

Bronze casting: preparing bronze prior to pouring.

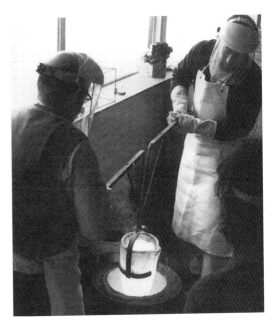

Lifting the crucible.

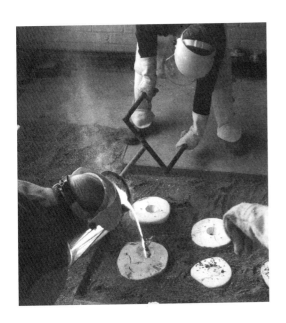

Pouring molten bronze into each prepared mould.

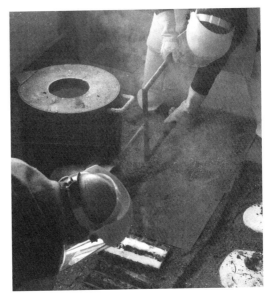

Pouring excess bronze into ingot moulds.

Making a plaster waste mould: applying the first coat of plaster of Paris.

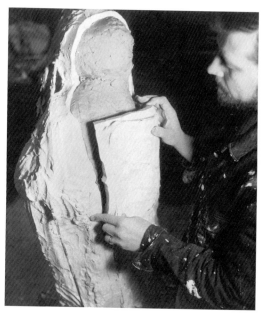

Removing the caps.

Removing and examining the caps.

Examining the caps for flaws and removing the burr made by the shim.

cover, and your supplier should be able to give you information regarding fluxes plus any de-gassing ingredients necessary. Aluminium always needs de-gassing, most copper alloys do also, but silicon bronze does not need a flux or de-gassing, which is one of the reasons for its popularity among sculptors who cast their own bronze.

In preparation for the pour remove baked moulds from the kiln and pack ready to receive the metal. A pouring pit made in the floor of the foundry is the safest place to pour. This is a pit deep enough to take the largest planned moulds, with their runner cup just above floor level. Pack the moulds in damp (not wet) sand. Builders' sharp sand is adequate but foundry sand is better because it retains its natural binder and consolidates well. The sand must be well packed down around the moulds right to the top. Cover the runner cup and vents during this packing operation. The compacted sand will counter-balance the pressure of the metal flowing quickly through the mould. The pouring pit is the best ergonomically as the pot is lowered to pour and not held up, causing a strain on the pourer's arm. (Lifting tackle, either electric or manual, will obviate this, of course.) Containers can be acquired or made to do a similar job, but remember that molten metal must always be contained. The moulds must be well packed down, no matter what device you use.

When the metal has reached the desired pouring temperature, it may need tempering according to the alloy, de-gassing or deoxidizing or both, but it will need to be skimmed to remove any surface dross. These operations are carried out in the furnace, with the flame off, so as to retain as much heat as possible for long enough to see that the metal is satisfactorily prepared.

Crucible tongs are used to lift the pot from the furnace, the size of the crucible determining the

kind used. With under 20kg (50lb) of metal, one person can safely handle the pour, but for 20kg (50lb) and more it is wise to use a helper and a two-person shank and ring. The principle of the latter is a long bar (shank) with the ring to hold the crucible at the centre. One end of the shank has two handles, the other no handle at all. The person pouring uses the handles to tilt the crucible whilst the bearer at the other end simply takes the weight, maintaining a level pot. Only the pourer steers the crucible (see diagrams, page 70 and illustrations, page 133).

Lift the crucible from the furnace to stand on a pad of sand in the centre of the ring of the shank. If the shank and ring are elevated enough the crucible can be placed directly into the ring. Carry out further skimming at this point if necessary; remember the metal is now cooling and the object of the exercise is to pour at the optimum temperature. Draw the ring up around the crucible, tapping the shank to seat the pot correctly, lock it in place and carry to the moulds. Place the crucible as close to the lip of the runner cup as possible, to prevent undue splashing and any oxidizing of the metal as it flows, and 'pour'. Fill the runner cup and keep it full with a fast but even pour. The sight of the metal flowing up the vents and a full runner cup indicates that the mould is full and the pour complete. If there is more than one mould to be poured, make sure any assistant knows the order in which the moulds are to be filled. This assessment should be made well ahead of the melt so that the correct amount of metal is melted to fill all the moulds, and so that those with the thinnest section are poured first whilst the metal is hottest, proceeding to thicker sections and finally to solid pieces. Any excess metal should be poured into pre-heated ingots moulds, ready for future use.

Once the pot is empty and the pouring session over, the inner surfaces of the crucible should be

scraped to remove any residues, flux or dross, etc. Do this immediately. The life of the pot will be extended in this way and it is a job best done whilst the crucible is red hot. If you try to clean the pot cold you are likely to chip away its surface and do it more harm than good.

Damp sand should be available at all times during the melt and pour, to cover quickly any splashes of metal: place it ready in advance if any are expected. Keep water well away from the foundry area but available in case of fire. Wear protective clothing when dealing with molten metal of any kind.

MESH SIZE

This refers to the size of holes in a sieve used to separate aggregate, powdered or granular, expressed by the number of holes per square inch (24mm sq). Therefore 120 mesh is smaller granular material than 30 mesh. Fine grog, brick dust or sand used in concrete or metal casting is usually of the order of 120 mesh.

MIXING POLYESTER RESIN

The method employed in casting with polyester resins, which are probably the most widely used synthetic resins in sculpture, is similar to that for most other materials. Differences do, however, arise from the peculiarity of the material that demand some understanding of the various chemical changes which take place during the cure.

The mould must offer maximum access to the mould surface. The state of the mould to be prepared must be dry. The release agent is of great importance since it has the difficult task of releasing an extremely persistent adhesive material (see Release/Parting Agents). Resin is a complex chemical substance whilst being fairly simple to use. It is usually made up by mixing three proprietary liquids: 1) the basic resin to which a

chosen filler may be added: 2) the promoter or accelerator which controls the curing speed of the basic resin, and is added to hasten the chemical change from a liquid to a solid; 3) the catalyst, which is the chemical that, when added to the basic resin, causes the chemical change, resulting in a hard, insoluble material. The resin, accelerator and catalyst are usually sold under these headings. Resin suppliers will advise on the appropriate materials, and additives of all kinds, compatible with their products. Be certain to ask what accelerator and catalyst to use with particular resins. Do not rely on samples from other manufacturers. These additives do vary according to the nature and origin of the raw material from which the resin is made.

It is important to use these materials in the order in which I have mentioned them. This corresponds to the order of mixing:

- Filler into resin
- Accelerator to resin
- Add catalyst as and when required to harden the resin.

Mix the total quantity of resin and filler needed for the work in hand, to maintain consistent colour and cure. It is possible to add the accelerator to the whole resin mix, to attain a constant rate of curing throughout the work. Do not add accelerator to catalyst; such a mixture can react violently, even explosively. It is wise to make a test to determine the length of time the pre-mixed resin-accelerator takes to harden, after adding the catalyst. Then add the catalyst to make sufficient resin only to complete an area of application easily, allowing time to clean brushes and other tools before the resin gels and hardens. Clean tools diligently after each fresh mix. Wash the implements in warm water and detergent or in an appropriate solvent for the particular resin used.

Mixing the resin in a large amount, and taking smaller quantities from that to work with, saves time and energy, which would otherwise be spent on making smaller amounts often. It also ensures an even rate of cure throughout the work. Difficult areas can easily be dealt with by adding extra accelerator to a small mix, to speed up the gelation and cure. This method is often employed to secure reinforcement, or to fill a tricky overhanging surface.

The proportions in which the components are used is important; ask for the manufacturer's advice when you buy the resin. Generally, the percentage of accelerator should not exceed 4 per cent. More than this proportion may, with some resins, act as a retardant. The amount of catalyst should not exceed 3 per cent. More than this does not increase the speed of cure, and is therefore a waste of material.

Surface detail
(*see* Gel Coat)

The fine detail reproduction required from a casting medium is achieved by painting on the surface of the mould a layer of resin known as the gel coat, whose job it is to reproduce detail faithfully. Apply this gel coat with care and as evenly as possible. Any colouring or filler used in the resin should be well mixed and dense, especially for the gel coat. This is particularly important when using a metal filler. Uneven mixing will possibly lead to a patchy, uneven colour on the final surface, as indeed will an unevenly applied gel coat.

Glass fibre reinforcement
(*see* GRP)

Resin, when hard, is fairly brittle and therefore requires some form of reinforcement. To achieve a strong material, laminates of resin and glass fibre are built to make the required thickness. This allows an efficient tensile strength. A mat of glass fibre is stippled on to the hardened gel coat with resin. Stippling ensures that the fibres of the material are properly impregnated.

It also helps to drive the fibre into the finest forms, to make sure they are strong. This process of lamination is called laying up. It is important to make every fibre bond well to ensure a good dense, consistent thickness. Tools of various and curious shapes are made to assist in placing the fibres where they are most needed, to force them into difficult forms and help an even lay-up. Other kinds of reinforcement may be included in the laminates to give greater rigidity and strength to a casting, such as mild steel, high tensile aluminium, wood, and nylon rope, in fact almost anything inert. It must be included in the lay-up, and be covered completely with resin and glass fibre, which will provide proper protection from any corrosive attack.

When the three components – resin, accelerator and catalyst – are mixed, there begins the process of polymerization. Visible changes take place, and the resin changes from a syrupy liquid to a jelly-like solid, which in turn becomes very hard when cured. Resins will slowly polymerize without the addition of accelerator, or catalyst, and this factor largely determines the pot life, or shelf life, of a particular resin. It may take place over a period of years, but if you store resin in glass jars and expose it to sunlight its shelf life will be drastically reduced, sometimes down to a matter of days. Keep resin in a cool, dark place.

This very general explanation is meant to give an idea of the medium and what is going on inside the mould when the casting is being made. There are, of course, things which can go wrong, and it is useful to have some idea of what should be happening so that you can recognize, and if possible overcome or avoid, any problems.

Problems

A large contributory factor in the efficient cure of a resin is heat. Exothermic heat is produced during polymerization of a resin, and this heat enables the resin to cure. The temperature of the studio in which the resin is being used is important, too. Resins are generally made to cure in a controlled temperature of about 15–150°C, and if the working temperature is below 15°C there is a risk that the resin will not cure. A low temperature retards the cure drastically, with the serious effect of causing the monomer to evaporate, spoiling the crosslinking polymerization, resulting in a sticky jam-like surface. To avoid this, use a resin that will cure at a low working temperature – resin manufacturers will advise on this. Currents of air will also cause the styrene monomer to evaporate, even if it is warm air. If you want to further accelerate a cure, apply external heat. Industrial infrared heater units are useful in this respect; they will also help to raise the working temperature in the area of the mould.

Exothermic heat can be very damaging and may catch the unwary sculptor off guard. Solid casting, if done with resin, will create great exothermic heat, which will cause the material to expand and contract violently, resulting in large cracks. For instance, a general-purpose resin poured into a cubic container, and allowed to cure at around 15°C, will generate a temperature of up to 160°C during gelation and hardening. The thicker the casting, the greater the heat. The use of lamination, and the introduction of fibres and fillers of various kinds, helps to avoid this hazard of excessive exothermic heat.

Fillers

Fillers are used in polyesters for a variety of reasons. They are added to reduce exotherm, i.e. heat. They are also added to achieve particular colours and effects, and to reduce cost by increasing volume (fillers are less expensive than resin in most cases).

Fillers are also added to provide compressive strength; fibrous fillers give additional tensile strength. Polyester resins are usually of pale, transparent colours which in themselves are very beautiful. This transparency can be avoided by the addition of fillers or pigments. It is wise to experiment with any intended filler, however, because some can prove to be efficient retarding agents, and can even inhibit the resin cure by reducing exotherm. (Or they may increase exotherm, accelerating gelation and cure.)

A filler can be useful in assisting a lay-up, by making the resin thixotropic, and therefore making it less likely to drain away from an inclined or vertical surface. The limitation on the amount of filler that can be added is determined by the ease with which a mixture can be used. Fillers frequently used in resins include the following:

Alumina	Slate powder
Asbestos	Whitening
Calcined clays	Wood flour
China clays	Talcum powder
Metal powders	Asbestos fibre
Mica powders	Glass fibre

Aerosil (to gain thixotropic properties)
Pre-gel (to gain thixotropic properties)

These fillers are added as powders or fibres; they must be evenly mixed and the fibres well impregnated with resin.

Pigments

Pigments are used to colour the resins and are supplied in the form of a thick paste. This is the easiest way of adding colour. Powdered pigment can be used but should be thoroughly mixed to a paste with a small amount of resin, prior to mixing into the larger quantity. This ensures the best distribution of colour.

Use the pigments recommended by the manufacturers. Pigments used in other industries may not be compatible with polyester resins, and may inhibit gelation and cure. Experiment carefully with any new powder.

MODELLING

An additive process opposite to that of carving. Techniques develop according to personality, physical attributes, preference for heavy texture or

Profiles of metal and wooden modelling tools:
A *Some of the typical metal spatulas manufactured for use in sculpture and all the plastering trades.*
B *Wooden spatulas used with clay and some soft waxes.*
C *Some of the range of loop tools, made from non-ferrous metal and fixed to a handle; they can have serrated edges.*

smooth surfaces, etc. The quality of the material used affects the nature of the image to be made and vice versa – both factors control or affect the aesthetic content of the work.

There are some pointers to the techniques of modelling that can help in the acquisition of a personal approach. Get used to using your fundamental modelling tools, your hands and fingers. Become skilled in manipulating the clay with these God-given tools, practise for as long as possible before being tempted to pick up any other kind of aid. Modelling is a sensual, tactile procedure and by pushing, squeezing, pounding and prodding the clay with the hands and fingers, a degree of sensuality will be retained in the work. This is the distinguishing element that makes clay unique in the repertoire of sculpture.

Regard all modelling tools as aids to hands and fingers (see illustration below). I have illustrated

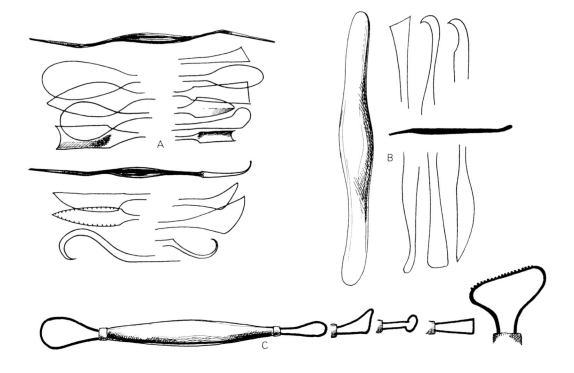

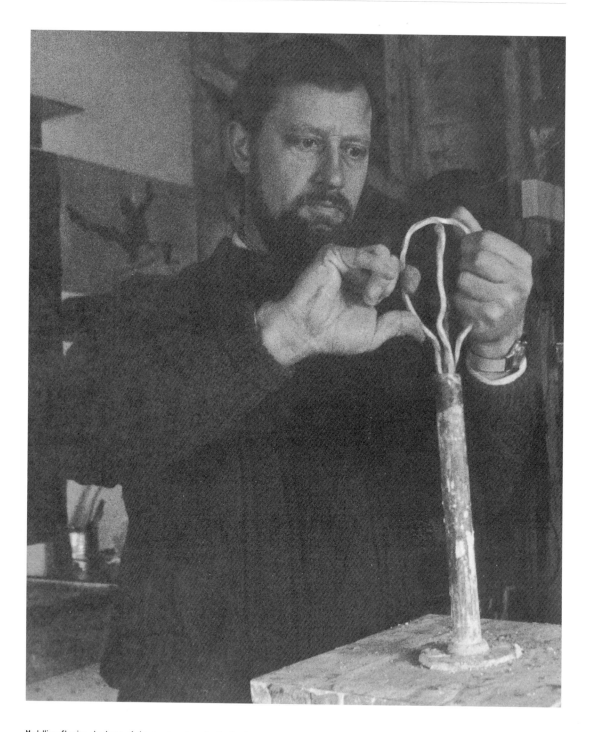

Modelling: Shaping the loops of the armature to make the head peg.

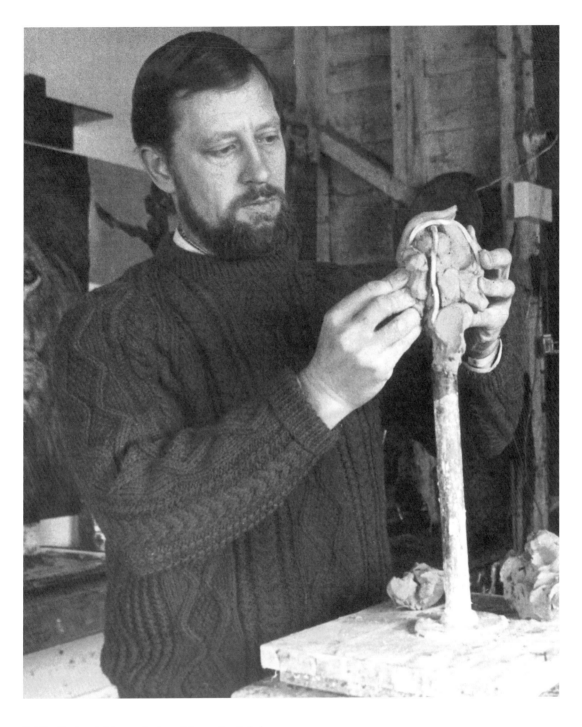

Modelling: Clay is packed between the loops of the armature to begin
the build up.

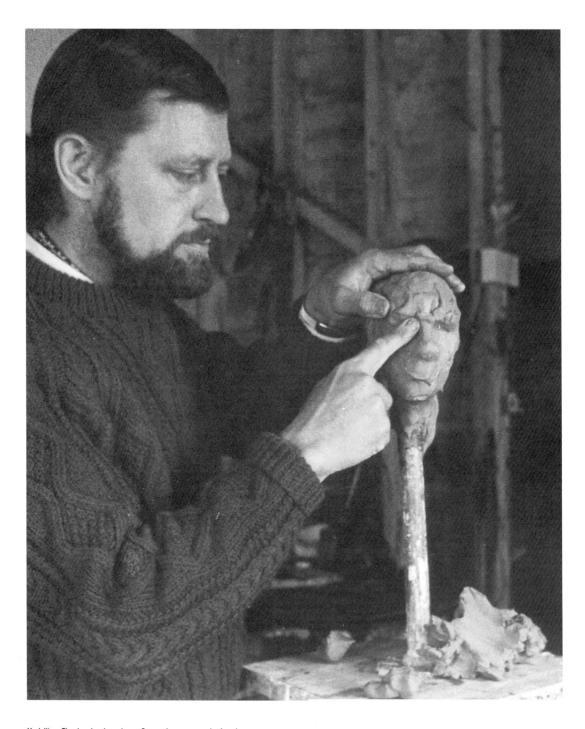

Modelling: The head takes shape. Depressions are made for the eye
sockets. The character of the sculpture should be established as soon as
possible.

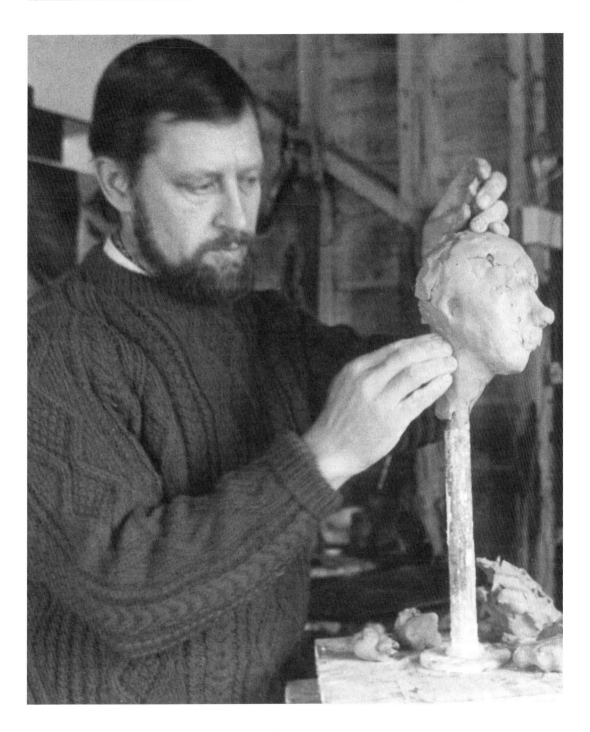

Modelling: Profile and silhouette are emphasised. The thrust of the neck
livens the character.

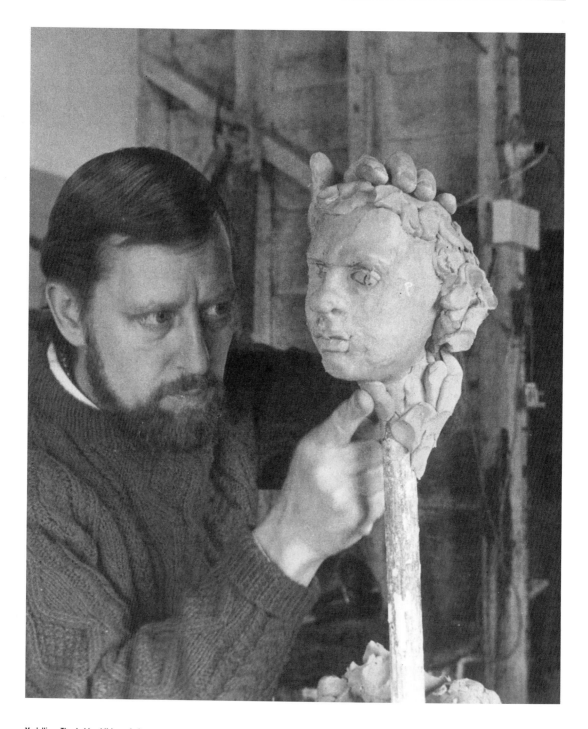

Modelling: The bold addition of clay.

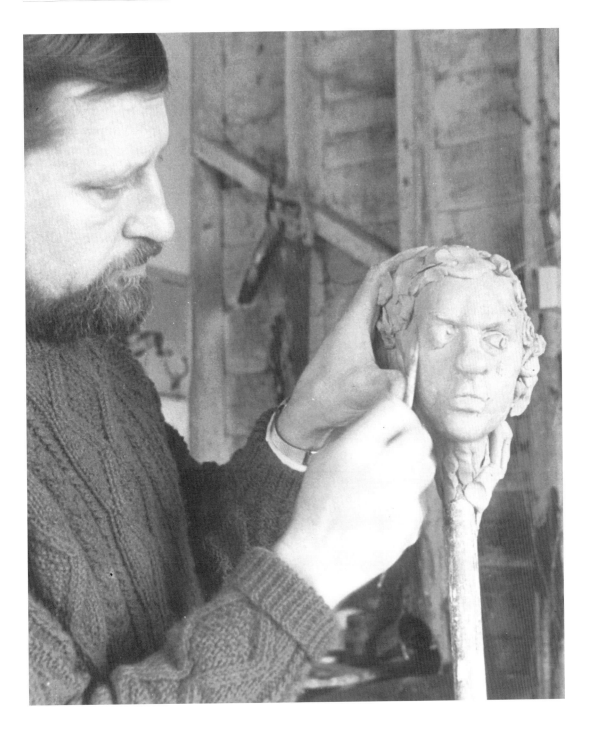

Modelling: Modelling tools are used to draw form and features more clearly.

those most commonly used and indicated their common usage in the captions. Cleaning these tools is a matter of some concern: wooden tools should be scraped and oiled, not washed with water which will make the wood swell and deteriorate quickly. Clean metal tools (water can be used on these) and then oil them for storage. Tools used for synthetic non-hardening clay pick up some oil, but should be scraped to remove any small deposits which do harden after being left for a long time.

Modelling tools are available in a wide range of sizes. The metal and wooden varieties need to be elegant in form and comfortable in use for you to gain the most benefit. Some wooden tools in particular can be clumsy, and you will need to tailor them to your own individual requirements. The best tools tend to be those made in Italy.

Whether building the clay over an armature or not, remember to keep the volume of the object being made smaller than its final form, thus allowing for the additive process of building up to the required volume. Clay can, of course, be cut and carved, especially in its leather-hard state, but such techniques often result in poor surface quality and poor realization of form in modelling terms. Of course, it is possible to employ a combination of cutting and adding clay according to the form to be expressed. Most intuitive modellers will cut out a bad section to enable the whole piece to be modelled again to retain the surface quality. Purist attitudes should be avoided, however. There are no absolute rules. As with any creative process, 'A successful end justifies the means'.

Clay can be added in great handfuls using the power of the whole arm, hand and fist. If the clay is kept wet, effective gestural marks can be enjoyed and exploited. You can use wooden mallets to consolidate the clay and if the striking faces are textured they will impart surface pattern that will help comprehension of the form being made, by breaking up the light on the surface. This part of the procedure can be very pleasurable when putting up a large work, acting almost like a therapy – enjoy it!

As you approach the final surface of a sculpture you may have to take more care in your application of clay; one way of doing this is to add the clay in pellets of varying size. Make these at random, rolling the clay between your fingers to the desired size and quality and pressing it to the surface. Such applications can be left as a texture or smoothed over to make a tight surface. Very wet clay gives a particularly soft texture to a surface and is often used to meld a transition between harder shapes. It has the opposite effect to that achieved by burnishing a leather-hard surface; this can be taken to a tight polish, enabling the form to be clearly defined. Auguste Rodin used a combination of these effects, exploiting the range of possibilities between the extremes to create a quality equivalent to living form. Experimentation is the key. It is best to try as many different methods and effects as you can think of; do not be too hasty to develop a personal style. This can all too easily lead to mannered effects.

When selecting the modelling medium to suit the image to be made, consider the subsequent stages in the completion of the sculpture. In most cases the pleasure of modelling is followed by the painstaking processes of moulding and casting, and maybe more than once, according to the final material. These various stages all offer a range of additional effects, presenting further possibilities affecting the final quality of the sculpture, all of which should be considered and experienced. Rodin, for instance, retained the seam lines of piece moulds; and Marini carried on working in bronze, with chipping and cutting continuing the direct working process.

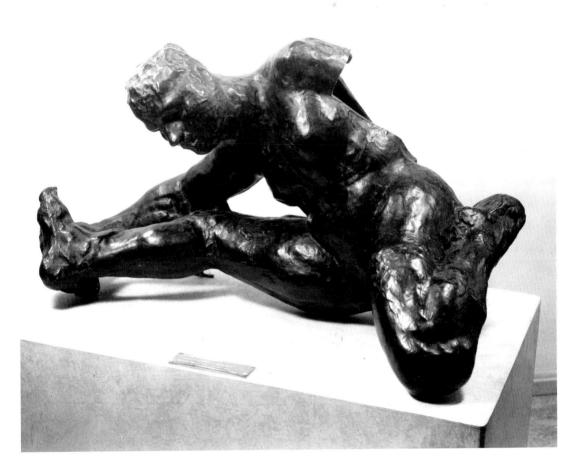

Figure of a Woman by Auguste Rodin, 1891. It clearly shows Rodin's vigorous use of clay during the modelling process.

Modelling clay for terracotta

In all its forms the one modelling technique that retains the fresh direct touch of the sculptor on the final surface is fired clay. It is possible to make terracotta forms and surfaces which are unique, having been subjected only to the continuing process of modelling then firing.

Clay in all its forms is the most malleable material; it has no inherent structural quality such as you experience with wood or stone. It will just sit there as a lump; the sculptor must impress his will on it. If this is achieved, its potential as a means of personal expression is enormous.

Clay to be fired to make terracotta is best made up into hollow forms. Bricks and small objects are made, of course, and indicate possible techniques using similar coarse brick clay and slow firing, but this is an abnormal practice. Hollow forms extend the clay, impart some structural strength, and make larger sculptures possible. If you make a fairly uniform wall thickness throughout the sculpture, the clay will shrink evenly as it dries, and during the firing.

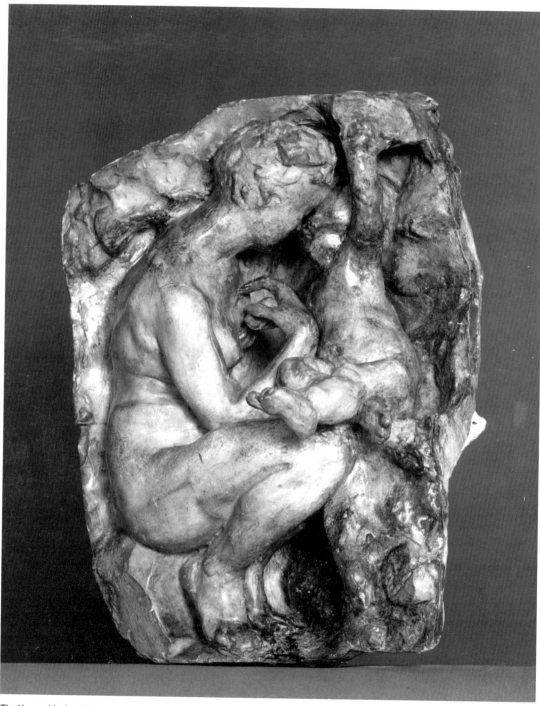

The Young Mother by Auguste Rodin, plaster, 1891.

Series of terracotta sculptures by John Mason, 1963.

John Mason's clay sculpture, 1961.

Hollow forms

These can be made as follows: Shape the clay solid, either over a simple armature or without support. Take the modelling close to a final surface and then allow the clay to harden until almost leather-hard. Stand the clay on sand, vermiculite or newspaper to dry off, to prevent cracking as it shrinks. When hard, cut the form with a wire into appropriate sections. Hollow out the centres of each section using wire loop tools, leaving an even wall thickness of about 6–12mm (¼–½in). Keep each section damp, don't allow it to dry any harder, then make a mix of clay and water to make a slurry or slip. Paint this slip to the edges of each section and firmly press it to its planned partner. Assemble all the sections of the sculpture in this way; the joins can be consolidated by tooling and the final surfaces made. The sculpture can be kept workable by judicious dampening for as long as necessary. Cover the sculpture with a newspaper when it is complete, to allow it to dry slowly and evenly. Remember to stand it, again, on a material that will allow it to shrink safely.

Clay slab building

Place the clay on a cloth, plaster or marble bat, and roll or pound it to an even thickness. Make as large a slab as possible – try to make enough to complete the work in hand. From this slab you then cut the components to be assembled to make your (hollow) sculpture. Uniform-thick slabs can be made using a kind of tile cutter. This is a number of parallel wires on a frame which, when pulled through a lump of wedged clay, cuts a number of slabs at a time. Another way is to make shallow moulds into which clay can be pressed to make the parts to be assembled. Such moulds can increase the range of shapes to be constructed.

Assemble your clay shapes, using slip as the adhesive. Build up the form, taking care to keep the clay in a suitable state of dampness: don't allow it to become too dry. If you score the surface to be stuck, the slip adhesive will become part of the parent clay body, resulting in a solid structure. Its adhesive quality can be enhanced by the addition of a little acetic acid or sodium silicate.

Clay coiling

Another ancient method of working clay which is still with us. The title is self-explanatory. Lengths of clay are coiled over each other to build a wall

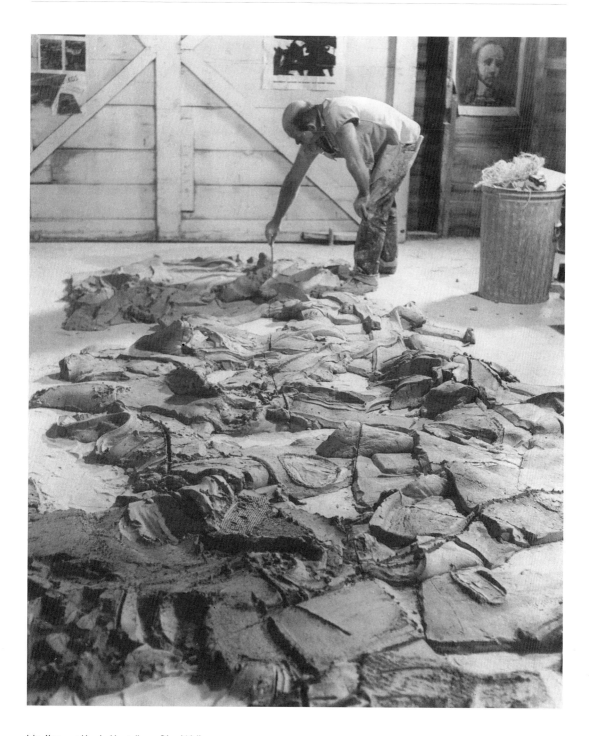

John Mason working in his studio on *Blue Wall*.

thickness. On a porous surface (plaster, wood or marble), clay can be rolled into long lengths, or cut from long slabs. These lengths of clay are then laid one upon the other to build up a hollow form. The shape of the form under construction can be adjusted by cutting and squeezing the clay. Practice is required to gain experience in judging the changing strength of the clay as it dries, to enable shape to be exploited. Slip applied to the strips of clay as they are pressed together helps to consolidate the clay as it is built up, but don't use too much. The coils can be blended as they are applied to make a homogeneous clay wall and to achieve particular surfaces. This can be done with the fingers, with modelling tools of various kinds, with lightweight wooden paddles or with combinations of these. Add textures by pressing items into the surface. The possibilities are endless.

Combinations of clay can be used. For instance, if you paint a slip of pale clay over a dark body (or vice versa) the resulting surface can be modified by modelling or scratching through to reveal the underbody (graffiti). Successive layers and varying colours can be used to great effect. Inlays of clay can be made in this way: fill incisions made in the clay with a slip of a different colour; when the two clays have hardened scrape the surface to reveal the inlay. Known as engobe decoration, this was much used by Victorian designers of architectural decoration. Take care that the various applications of clay dry out evenly, to equalize any shrinkage.

Slab building or coiling clay over soft materials can help in the manufacture of large volumes, enabling large spans to be made with clay that could not otherwise be supported. Forms that have a large opening at the base will permit any support to be withdrawn before firing, as the clay reaches the leather-hard condition. If the form is enclosed, any packing should be soft enough to allow the clay to shrink safely, and it must be burnable at a low temperature so that it will burn out during the firing of the terracotta. A vent will be necessary, made through the clay wall, to allow the release of any pressure that might build up, otherwise the sculpture will break as the packing burns during the firing. Traditional packing support includes bunches of straw or leaves, newspaper, rope or string. Soft foam plastics of various kinds can also be used but these plastics require kiln venting to evacuate noxious gases.

Casting using slip or press moulds allows hollow forms to be made also (see Casting) and these techniques, together with wheel-thrown shapes, complete the number of methods available to the artist in the exploitation of terracotta.

Any combination of the methods described can be used to make an image, and ceramic forms can be used in combination with almost any other material. Slip adhesive can be used on wet clay; epoxy resins can be used to assemble fired clay units, as can cement mortar. Metal fixing can be used also, and such supports as stainless steel rods and bolts can be included in the ceramic body during firing, or rebates made to house such supports and fixings. By designing the work sensibly, with due consideration to the properties inherent in the materials you are working with, endless combinations are possible leading to an ever-widening means of personal expression.

MOULD

This is the negative volume, void or vessel (often referred to as the female) from which a positive casting (male) is made.

MOULD MAKING

The act of producing a negative volume, or void, that exactly records the original pattern or image, so that a casting can be made from it.

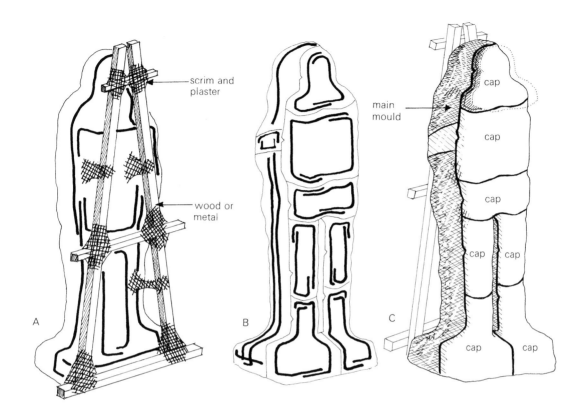

scrim and plaster

wood or metal

main mould

cap

cap

cap

cap

cap

cap

cap

A

B

C

Plaster waste mould:

A *The frame is attached to the main mould for ease of handling, ensuring that little or no strain is taken by the plaster; note the metal reinforcing to the main mould.*

B *The best method of reinforcing the mould and each of the caps; ensure that all reinforcing irons overlap.*

C *The division of the mould into the main mould, which is the part that contains the bulk of the form, and the caps.*

Knowledge of and experience in making moulds of various kinds are essential features in the repertoire of sculptors' skills, no matter what their speciality may be. There are three basic moulding processes to be learned – waste moulding, piece moulding and flexible moulding. The most simple mould is made in one piece, rather like a culinary jelly mould. Shapes in the round, however, require moulds of at least two sections and complex forms will need moulds of many sections. The guiding principle is the same for all moulds; the divisions are made to create a main section or main mould, designed to contain the bulk of the sculpture, and to give the mould stability. All other sections of mould are made to fit on to the main mould and are called caps. The caps are designed to permit the easy removal of the original material and its armature, if any, to gain access to clean and prepare the entire mould surface. Allowance has also to be made to

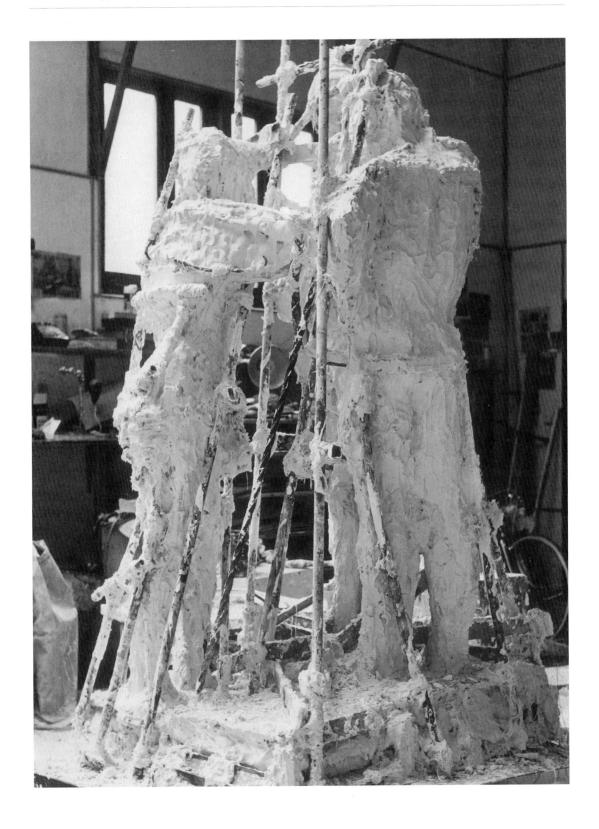

make the casting. The size and number of sections will be affected by whatever material is to be used to form the cast together with the volume and complexity of the sculpture. A useful datum when marking large moulds is to restrict the size of caps to the length of your forearm (braccia). This will ensure that you can reach all seams on the inside as the casting is made (see Waste Moulding, Piece Moulding, Flexible Mould Making).

NICKEL STEEL

This is a relatively new group of steels, developed for use in construction work, mainly in the USA. Exposed to the weather, nickel steel forms a protective patina which, once formed, prevents any further deterioration, making this a useful material for external use, where it can be left untreated. This characteristic has caused nickel steel to be widely used in sculpture, particularly in very large works, such as Clement Meadmore's at St Joseph's Hospital, Michigan.

These sculptures are mostly constructed by professional fabricators working to an artist's sketch model or drawing. When first exposed to the weather, nickel steel turns a bright rusty brown, gradually maturing to a deep purple. The surface when mature also provides a good key for painting, making it possible to achieve a very effective bond, extending the nature of the sculpture.

Nickel steel can be worked in much the same way as mild steel, responding to the same processes of cutting, shaping and welding. The biggest difference is cost.

LEFT Large plaster waste mould under construction, showing the reinforcing.

OXY-ACETYLENE WELDING AND BRAZING

The oxy-acetylene welding torch is becoming more and more widely used as a means of making metal sculptures, and can be used either to weld or braze metal together. A weld is the fusion of pieces of metal (parent metals) one to another in a molten state. The welded joint has the same characteristics as the parent metal, being simply the contact of the pieces of metal brought to a molten state, thus causing them to fuse at that point. Brazing differs from welding in that it is simply sticking two pieces of metal together by means of a third. The third metal is an alloy applied from a rod at a much lower temperature than the melting temperature of the parent metals. Adhesion is caused by the alloy filling the pores of the metal which have been opened by the heating of the two metals, thus becoming jointed. A brazed join is as strong as, and sometimes stronger than, the parent metals.

The equipment used is the same for both brazing and welding, and consists of the following items: two metal cylinders (bottles), one which is usually black in colour, containing oxygen, and the other, acetylene, which is always red. Pressure gauges are fitted to the top of the cylinders to indicate the amount of gas in the bottles, and the amount being let out to the welding torch. The pressure gauges include a diaphragm control which governs the flow of gas to the blow torch. Hosepipes carry the gases to the torch (red pipe for acetylene, black for oxygen). The torch itself is the mixture control for the gases. It contains two valves which allow control of the flow of gas to the nozzle. All threaded fittings are made to screw clockwise (right handed) for oxygen and anti-clockwise (left handed) for acetylene, to avoid accidents. The actual nozzle or outlet for the mixed gas can be varied in size, according to the metal gauge or thickness. Heavy-gauge metal will need a

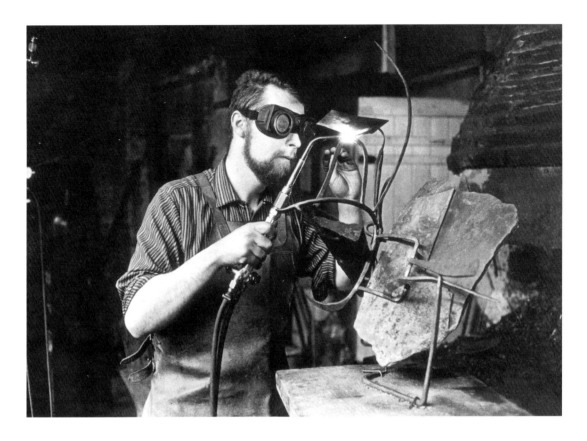

RIGHT Bryan Kneale oxy-acetylene welding to complete a sculpture that combines forged and welded steel and stone.

larger nozzle, and vice versa. The welding torch is simply a convenient mixture control. A welding and cutting torch has an extra control, a lever which allows the sudden release of oxygen through the centre of the flame to blow away molten metal, thus cutting the metal. Goggles or dark glasses must always be used to shield the eyes from the intense, bright light at the welding nozzle during the welding. Without such goggles serious damage can be done to the eyes. Goggles should also be worn when simply watching a welding operation for the same reason. A flint gun with which to make a spark to ignite the gas mixture is the most sensible means of ignition.

The beginner is well advised not to attempt to teach himself, but to get the advice and assistance of an experienced welder. Acetylene is a very combustible gas and if mishandled can be extremely dangerous. When taught properly, the basic technique can be quickly understood and practised. This has proved the undoing of a great many young sculptors who have been misled, by the ease with which pieces of metal can be joined, into believing there is nothing else to consider. The welder needs to understand the traditional crafts of sculpture and form in order to develop his own personality sculpturally, and not echo others by being trapped into just joining pieces of metal, which is a common fault.

RIGHT Testing the heated metal to check the colour and gauge the state of the steel for forging into shape.

Welding

Oxy-acetylene welding is done by igniting a mixture of oxygen and acetylene blown through a blow torch, to give a flame hot enough to melt the metal. This flame is directed at the metal to form a molten puddle. Mild steel, the metal most commonly used, becomes first red hot and then as it melts it glistens, and a puddle of yellow molten metal appears. The object is to move this molten puddle along the metal in front of the torch, adding to it by dipping into its centre rhythmically, a rod of the same metal. The torch is moved slowly in a circular motion or up and down across the puddle, and at the same time moved slowly forward. The metal rod is applied rhythmically, in relation to the movement of the torch, to the centre of the molten puddle. The torch and the rod are best held at angles of between 40° and 50° to the surface of the metal. By making a weld in this way a bead of metal will be formed, and will make a trail of progress across the parent metal.

Industrially, the welder must make his bead even and accurate, so that maximum strength results and even stress throughout the weld. Sculpturally this is not so vital, and although the artist should aim to work an even bead trail, it is not always essential to achieve this on a sculpture. The secure fixing of one piece of metal to another, giving the sculptor as much freedom to manipulate the torch and metal as possible, is ideal. This will help him to invent a personal torch calligraphy, making the welding individual.

Brazing

Brazing is comparatively simple compared with welding. The parent metals are cleaned and prepared for brazing; any dirt or oil or rust is removed. The parent metals are then heated to just about red heat, and to these metals, whilst they are red hot, a flux (basically borax) is applied. The flux is used to clean the metal, preparing it finally for the brazing alloy, and to cause this alloy to run quickly and freely over the heated parts of the parent metals. Only sufficient alloy to run over these heated areas is necessary. Adhesion is caused by the contraction of the pores of the parent metal upon cooling around the alloy, which has run freely into them. A brazed joint is as strong as the parent metals, but will, of course, become non-existent if the work is again heated up to the melting point of the alloy. A point to remember is that only these parts of the work which have been allowed to reach red heat will be brazed satisfactorily.

It is not necessary to have oxy-acetylene equipment to do simple brazing, as natural gas such as butane or coal gas may be used. A brazing nozzle can be purchased at a reasonable cost to work from an ordinary household gas supply, which will produce sufficient heat for brazing.

PAPER

During the past two decades paper has become a material with many applications other than just providing surfaces of various quality for two-dimensional expression. With re-awakened interest in papermaking, and the consequent production of 'pulp', paper has entered a new era. It is now possible to make paper castings, and to employ paper pulp in a wider constructional way than traditional paper construction allowed. Papier mâché, of course, has a long and distinguished history as a medium for the manufacture of three-dimensional images, particularly large, lightweight affairs. Other paper techniques can now be included in the repertoire of sculptural media.

John Mills at the Meridian Foundry in London, inspecting the welds on a bronze casting of the memorial to Jackie Milburn, 1995.

PAPER LAMINATING

Over a suitable structure or armature (see Armature) layers of paper sheets or strips soaked in a paste of glue and water are built up. The glue can be made from flour and water or it can be any of the water-soluble glues now on the market, particularly those used for hanging wallpaper. It is best to let each layer dry before adding the next, to avoid moisture build-up in the centre of the paper thickness. The paper and glue will tend to dry from the outside surface and if you are too quick to add another layer there is a distinct possibility that the centre of the mass will remain moist and therefore be liable to rot. As any paper can be used to laminate, the technique will allow for a certain element of collage, utilizing other materials, photographic images, printed matter, cloth, etc. This is a medium that can be exciting to use because of the casual nature of items that can be included.

Once the paper has dried thoroughly it can be painted or varnished. Left untreated the paper will not deteriorate if the glue in the mixture holds stable – the sculpture depends on good glue.

PAPIER MÂCHÉ

In most applications of this material common today this term is misused. *Papier mâché*, from the French, means 'masticated paper', paper reduced to a pulp, and this was how the material was originally devised. It was made from existing paper and not from the raw fibrous flax. More often nowadays papier mâché refers to a lamination of sheets of paper and glue (see Paper Laminating). As a material for making sculpture, however, true papier mâché has a long history, particularly in the Orient, and can be used as a casting medium, as well as for modelling.

To prepare paper for casting or modelling (any paper can be used), first soak it to make it soft and dough-like. Boiling will speed up the process, but not fierce boiling. Add a preservative to the mix – a modern fungicide will do in place of the traditional salicylic or carbolic acid, or formaldehyde. A water-soluble glue is then included to become the binding agent. Inert fillers can be added to the mass to vary the nature and consistency of the dough, fillers such as pumice powder, French chalk, sawdust or even plaster of Paris. The latter, if used in any quantity, will tend to set up and harden more quickly, thus affecting the workability of the mâché. Experiment to find the mix best suited to your purpose. The resulting dough is a paper-pulp-glue-putty. This can be pressed into a plaster mould or built up by modelling, usually over a structure already covered with a laminate of sheet paper and glue.

The plaster mould must be suitably prepared (see Release/Parting Agents) and dry. The dough is then pressed against the mould surface and built up evenly, high points being given particular attention. If the sculpture is large the thickness can be reinforced with galvanized chicken wire and laminations of paper and glue – allow each application to dry before adding to it. Large volumes can be cast providing allowance is made to build up and join each section from the inside, as the mould is assembled (see diagram page 153).

Once the mould has been filled it must be allowed to dry and harden naturally. According to the volume of the piece anything up to 48 hours might be needed for this. Applying a gentle heat will help to speed up the drying time, but too great a heat will cause the casting to shrink unevenly and be damaged. This drying process will be affected by studio conditions, the type of glue used, the bulk of the dough, and the nature of any fillers used in addition to the paper. When you are satisfied that the material is hard enough remove the mould. The papier mâché if properly

made will be tough enough to permit a waste mould to be chipped away with care (see Chipping Out). After chipping out, carry out any surface work necessary, using the same dough mixture to repair any faults in the casting, fill any cracks that might occur and generally prepare the casting for whatever final treatment it is destined to receive.

Matching master mould and core as used in industry in the manufacture of papier mâché goods can be used by sculptors, and plaster of Paris variants of these can be devised to produce high-quality casting and a dense, stable solid.

PAPER PULP CASTING

With the renewed interest in papermaking, and the associated techniques for making paper pulp with which to mould sheets of paper, has come the skill of casting sculpture using this pulp. It is a skill mostly associated with repeat casting in long editions, but it can, of course, be used to make one-off pieces.

The best rag pulp should be used for the most stable results. Wood pulp is given to becoming brittle in a short time, and also discolours quickly. Rag pulp is made using a beater and contains enough natural cellulose to bind the fibres together to form a stable mat. There is no need to add glue of any kind.

The beater is an essential piece of equipment to papermaking. It is in effect a mill, that beats and crushes the fibres of the raw material, breaking them down to make a smooth slurry. Natural linen or flax is used to make good rag pulp, retaining the cellulose inherent in the natural fibre. Good-quality woven organic cloth can be beaten to make a good pulp, too. It might take a little longer to break down but it can be done. I have seen a good pulp made from blue denim. Only enough water is used to make a very thick

slurry for casting purposes. Beaters are expensive items of equipment, however, and not readily available, so heavy-duty kitchen blenders or processors can be used to make your own pulp in small quantities. Failing this, pulp can be purchased in most countries from paper mills which manufacture for the paper industry. If there is an enthusiastic studio paper-maker in your vicinity seek him out and ask for advice. Such artists are always interested in wider applications of their materials. They often make more pulp than they can use, and will be familiar with conditions locally that might affect the techniques required, such as high humidity and any atmospheric disadvantages.

Casting with pulp is a more pure use of paper for making sculpture than papier mâché, simply because the basic material is at best a pure product and the results can reflect this fact.

A simple plaster mould is all that is required to make a casting and the mould should be dry. Pack the pulp into the mould by carefully pressing it against the surface in much the same way as you would clay. Build up a good even thickness, paying attention to all the high points in the mould and making sure they do not get too thin a layer. When the desired thickness has been built up, cover the mould with moist cloths and allow the whole thing to dry slowly, controlled by the moist cloth drying out, too. The paper will shrink a little as it dries, pulling away from the mould as it does so. Of course, any undercut shapes will present problems so these have to be kept to a minimum if not entirely eliminated. Design the sculpture according to the process and its limitations.

The technique is more suited to one-piece moulds and relief sculptures, but, of course, works in the round can be made if the mould has a large enough opening to get your hand in to add pulp to the seams, to consolidate the casting. Paper

cannot be cast solid; the centre of the mass will remain moist for too long and deteriorate.

Castings made in this way will have a rugged surface, which has a certain charm. If a finer, denser surface is required, then an inner mould or core should be made that can be clamped into the master, to squeeze the pulp and compress it. In industry, matching metal moulds, master and core, are used, making it possible to exert great pressure on the pulp to squeeze it until it is almost dry, and to achieve a thinner cast section. This provides the product with a dense, stable characteristic typical of much good-quality paper tableware.

PATINA

This is the surface colour and texture of a sculpture, usually used in reference to a naturally matured surface that shows the effects of ageing and the elements, such as those shown on ancient sculptures recovered from the ground or from the sea. Those taken from the water have gained a patina that is the result of prolonged exposure to salt water and to the working of various crustaceans. This patina is usually green and also of a crustaceous nature and its richness has influenced sculptors since the Renaissance, when archaeological discoveries first revealed such work, to initiate the art of false patination – that working of the sculpture surface to achieve effects similar to those revealed on the excavated ancient images.

Marble and stone mature also; those buried in the ground are affected by minerals present in the ground, whilst those exposed to the weather are stained and coloured by wind and rain, and harbour lichens on their surfaces, to create a patina that can only be gained by age.

Prior to such excavations and the qualities exposed to view, all sculpture, as far as we know, was coloured, indeed highly painted to resemble real life. Residual colour detectable on the surfaces of ancient sculptures also influenced the art of false patination, which became the norm, and is still the practice among most sculptors who use cast bronze.

The various surface treatments of images from so-called primitive societies has also had an influence on sculpture since the turn of this century when artists were made aware of the power of these works. Surfaces encrusted with coloured clay or mud, and worked over with earth colour and engraved with sticks, etc., have been copied on almost all the materials of sculpture, from terracotta to GRP.

False patinas are achieved using paint, of course, but also by applying acids to metals' surfaces and metal-filled resins (see Patination *and* Finishes).

PATINATION

The art of applying a false patina to a metal surface, usually associated with bronze casting. The techniques used to patinate or colour bronze are the same as for any other metal; similar chemicals and formulas can be used.

The oldest and simplest method of patination is to bury the bronze object in the ground or in a sand pit for a long period of time. The surface will oxidize according to its alloy and the acid or lime content of the soil or sand. The soil chemistry can be altered by mixing in animal manure, or by adding urine. Such a patina pit was a feature of some of the older art bronze foundries, and on the premises of some art forgers anxious to reproduce the effects of natural patination or archaeological antiques. Such lengthy processes using pits or long immersion in the sea are not very practical, hence the development of artificial

RIGHT *Burghers of Calais* by Auguste Rodin, bronze, 1884–86. The casting is in Philadelphia where the high levels of salt produce a heavier patina on the sculpture.

162

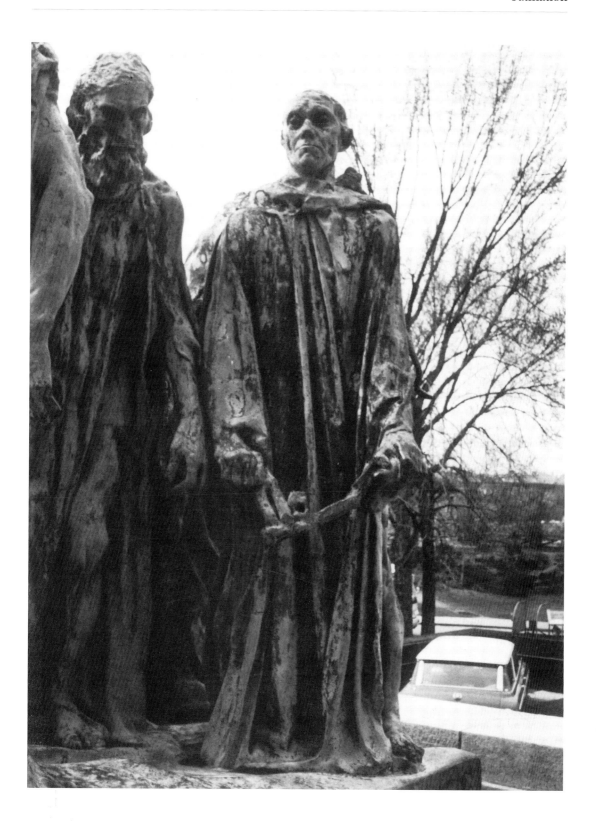

patinas using heat and a variety of chemicals.

There are basically three techniques: applying the chemicals to a heated surface; applying the chemicals to a cold metal which is then heated; placing the bronze in a chemically charged atmosphere.

The chemicals can be applied using a brush. One without a metal ferrule is essential when applying acids to make green patinas, and should preferably be used for all brush applications. The metal ferrule will contaminate the chemicals and alter their effect. A dabber made of absorbent material tied to a wooden or plastic rod is a safe alternative. A spray can be used also; a hand-pumped pressure spray is effective and for small items the careful use of a venturi mouth spray is effective (but don't breathe in through it).

When the chemicals are applied to the heated surface, the metal should be hot enough for the liquid to sizzle. Stipple the chemical on, to achieve an even surface. Periodically rinse the surface with clean water to prevent over-oxidizing, which will result in a thick build-up on the surface, liable to scale off and become patchy.

There is an old adage that says, 'A thick patina covers a poor casting'. Of course, the effects of texture and colour are matters of personal choice and taste. Chemicals can also be painted roughly over the surface, or dribbled on and allowed to run, or even splattered to make runs and blotches.

Applied to a cold surface the chemicals are more difficult to control, they need to be applied more sparingly, and then gently heated to speed up the oxidization on the bronze. Do not over-heat the metal when doing it this way, and allow the work to cool before adding more acid. This is the slowest method but some artists prefer it and maintain that the patina is more subtle.

If time permits, strong chemicals applied to a cold surface and allowed to oxidize slowly over a long period of time will help to make subtle patinas. One sculptor uses a spray to apply a fine mist to his prepared bronze once a day, over a period of months. The results are certainly beautiful but he does operate in a very warm, dry climate.

Placing the work in a chemically charged atmosphere is a technique that allows for the most even colour with no risk to the surface, and is usually a process reserved for small items placed in a mist cabinet. The bronze may be either hot or cold.

Preparation of the bronze for patination is important. The surface should be clean, free from grease and from any fire scale resulting from welding or brazing. Ammonia or methylated spirit (denatured alcohol) can be used for this. On some works, sandblasting can be used to clean the surface (a practice now much used to remove ceramic shell investment). Before sandblasting was introduced, an acid pickling bath was used to clean the bronze, inside and out. After such a bath, place the bronze in clean water to neutralize the acid before the patina is applied – make sure the inside is properly treated. Sandblasting or glass bead blasting can be used on large works. This is a very dusty, messy process and protective masks and clothing must be worn to do it. Glass beads will burnish the surface and give a certain translucence to some patinas, so choose which you use accordingly. There is on the market a number of emery-impregnated rotary brushes which are used for deburring processes in the engineering industry. They can be mounted on a spindle or on an arbor for use with electric drill or spindle grinders, and are a useful alternative to sandblasting. They can be used to clean the bronze surface and to burnish it ready for patination.

The patina will need to be fixed after the chemicals have done their work, and the bronze has been rinsed to neutralize any residual acid.

Greens: Cupic nitrite diluted 10 parts to 1 with water gives a basic green

Ammonia	113ml	4fl oz	
Sodium chloride	142g	5oz	Gives an apple green
Acetic acid	1136ml	1 quart	
Ammonium chloride	142g	5oz	
Copper sulphate	14g	½ oz	
Ammonium chloride	85g	3oz	Gives an antique green
Water	1136ml	1quart	

Brown: Ferric nitrate diluted 10 parts to 1 with water gives a basic brown

Potassium sulphide	7g	¼oz	
Barium sulphide	28g	1oz	Gives a deep brown
Ammonia	56ml	2fl oz	
Water	2273ml	3quarts	

Black:			
Ammonium sulphide	56g	2oz	
Water	1136ml	1quart	

Fixing is done by applying wax to the heated bronze, which is then polished when the whole work is cold and set. A good-quality polishing wax should be used; those with a beeswax or carnaubiar wax base are the most favoured. Regular shoe polish has a carnaubiar wax base and is very good. Silicone waxes are satisfactory but do not give the depth of sheen that the more natural wax preparations do. Some greens, particularly pale colours, will darken if fixed with wax, and in these cases a gentle but firm rubbing with French chalk/talc will stabilize the patina and give a very soft sheen. On some large works a thin coating of lubricating oil alone is needed.

The best method of heating the bronze to patinate it is by using a blowtorch of some kind, either one fuelled with oil or with bottled gas; the latter is the best. The equipment that comes with bottled gas has a greater range of nozzles and so offers more control. Oxy-acetylene welding equipment can be used but the heat is usually too intense and the patina, chemicals and wax are easily burned.

The above formulas give a general idea of chemicals and their effects. All the patinas described work on most leaded bronze, and on silicone bronze, but experiment on other alloys.

Ammonium chloride (sal ammoniac) when used on its own tends to leave too great a build-up of oxidization, very quickly. It should therefore be diluted with water or mixed with other chemicals to control its action. The two nitrates listed above are very useful basic patinating acids and can be easily made up in the studio.

Patina on aluminium

The only chemical patina that can be applied to aluminium in the studio is to a formula that will give a black only and is as follows:

Caustic soda	113g	4oz
Calcium chloride	28g	1oz
Water	1136ml	1quart

The aluminium should be immersed in this mixture, but proceed with care: caustic soda is a pernicious chemical. I much prefer to make painted patinas to aluminium.

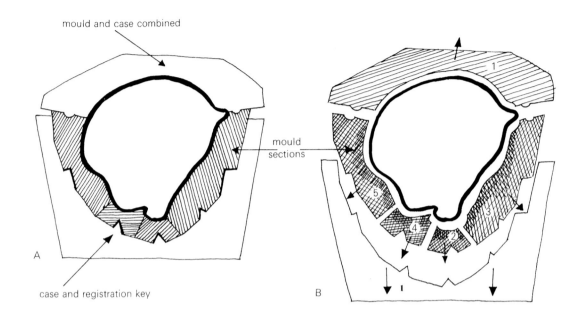

mould and case combined

mould sections

case and registration key

A

B

A *The principle of the piece mould, showing mould sections around a master cast contained within a plaster case, with registration keys to give proper location to the sections. The top section shows a combination of mould and case, which is usually the last section made.*

B *The exploded view shows that each section of the mould can be removed and relocated into the case in a predetermined order to make the perfect mould.*

Patina on mild steel

Natural oxidization will cause mild steel to rust, and rusted mild steel can often be very satisfactory – large sections can sometimes achieve remarkable effects of rust and scale. The rusting process can be hastened by using hydrochloric acid diluted 1 part to 50 with water.

It should be remembered that rusting on mild steel, unlike that on core ten, is indicative of

corrosion and deterioration, and mild steel sculpture if placed in the open air will need to be sealed to prevent further corrosion. This can be done using a surface coating lacquer or resin. Any surface treatment will need to be carried out regularly as part of the maintenance of the work, and should be allowed for when selecting this material for use on a commission.

PERSPEX

The trade name of acrylic plastic marketed in the UK by Imperial Chemical Industries (ICI). This is produced in sheet form but blocks can be made to order.

PIECE MOULDING

The technique practised to enable more than one impression to be made. The mould is composed of separate pieces like a three-dimensional jigsaw, each and every undercut requiring separate pieces. These pieces of mould are held together with a jacket into which each section of mould fits snugly and is held in its correct position relative to

volume and detail. The moulds are usually made from a hard-setting compound plaster, terracotta, glass-reinforced resin, sand, etc. – and taken from originals made of hard substances. The technique of sand-moulded metal casting depends vitally on skill and a fine knowledge of the piece moulding process.

A piece mould has to be made with more careful planning than a waste mould because each undercut shape or texture has to be catered for. It is usually a mould with a longer life, allowing more than one impression to be made and should be planned and constructed accordingly. This kind of mould can be made from clay, using either metal shim or clay walls to make the divisions, but the result will be a bit of a hit-and-miss affair because it is not possible to test each mould section as it is made. It must be possible to remove the sections easily from the pattern and from subsequent casts, so piece moulds are best taken from a hard positive.

To proceed, carefully examine the original pattern and plan the work. Decide where the main division is going to be made. Usually on a figure this is the dividing line between the front and back, favouring the front, but it can be any major division. Some sculptors draw these planned sections on the original at this stage. Carefully lie the sculpture down on a suitable surface, large enough to allow a 50–75mm (2–3in) ribbon of plaster, blocked up with clay or polystyrene (Styrofoam), to be made all round the main dividing line, leaving a 6mm (¼in) space between the ribbon and the master cast. This ribbon of plaster is made as smooth as possible, and the space then filled with clay to make a precise join with the master cast which will eventually define the main seam. This construction is called the bed. A release agent is now applied to the plaster surface in readiness for making the first section of mould (see Release/Parting Agents).

Using the clay wall system or simply by building with direct plaster, the first section of mould is made. Remember that piece moulds are made up of numbered pieces, made in sequence, fitted into the mould case in sequence and removed from the casting in sequence. Make sure that the first section tapers away from the plaster bed as a guide to the shape of all subsequent caps. This is planned to ensure easy removal from the mould case. When the plaster of the first cap has been shaped and has set and hardened, carefully remove it from the master to check that it can be removed, and also to trim it to a precise shape. This will ensure that the seam surfaces are smooth and as fine as possible. When you are satisfied with this piece replace it, number it and coat it with a release agent, and make its partner following the same careful procedure. Take care when you are removing and replacing pieces of mould that all surfaces are free of any foreign particles that might become trapped between the master cast and mould section and between sections of mould. Carry on with the careful making of mould pieces until the whole sculpture showing above the bed is covered. This can be done over a relatively long period.

Check that you have allowed for the easy removal of all pieces of mould in their correct sequence and that the assembly can be removed from its main case or mother mould. Give particular thought to deep hollows. These may require a number of smaller sections that have to be removed and assembled in a particular order (see diagram opposite).

To make the main case or mother mould, coat assembled mould sections now covering the sculpture with a parting agent. Then cover the whole thing with a layer of plaster and scrim, down to the plaster bed. The top of this covering must be made flat so as to provide a stable base when

it is turned over to make the other side of the mould. When this case has hardened and has been trimmed, turn the whole assembly over, keeping the original in the mould. Remove the bed and clean up the revealed edges of the mould, apply a release agent and repeat the whole process of making mould pieces and main case till the mould is completed.

To remove the mould, carefully lever off the case, then remove each section of mould, in its planned order, placing each piece in its correct position in the case. As each section has been tested for removal from the original and checked for taper to draw from the main case none should lock on.

If sections become large or are deep in hollow forms, handles and hooks are incorporated in the plaster section, but covered with clay during the manufacture of the main case. Such devices help in the removal from the master cast, and from the casting.

PIECE MOULD MAKING WITH POLYESTER RESINS

As a moulding medium polyesters have a particular application. They are used to make precise castings of polyester glass fibre laminates, particularly in the motor racing business. The kind of mould made with polyesters is a piece mould, the only diffference being in the way that the seam wall is made. Plasticine is used to determine the wall on the master form. This can be done with some precision. The master is treated with a sealer and parting agent. The pieces of mould are made by building a lamination consisting of: gel coat (fairly thick), resin and glass tissue, resin and glass fibre, plus any reinforcing required. The seams can be drilled and bolts provided to make the strongest possible closure of the mould.

When finally removed from the master cast the mould can be handled freely because of its strength: the surface can be worked on, polished and textured. A release agent is then applied to prepare the mould for casting.

The procedure for casting is as follows:
- Prepare the master cast, sealer and parting agent. Plan the sections of mould and draw the seams.
- With plasticine, make the precise wall surface to determine the first section of mould.
- Make the piece by means of the normal lay-up; gel coat, subsequent laminations with glass tissue, glass fibre reinforcing. Be certain to make the seam edges as in the diagram on page 36.
- Remove the plasticine, apply a release agent to the resin seam. Make the next section of mould.
- Repeat the laminating, plasticine wall and release agent processes until the master cast is covered with mould section.
- Drill at the seam shape to allow for the bolt as shown in the diagram on page 49. The bolts clamp the mould sections together, and these are held firmly in position because of the nature and breadth of the seam surfaces. No mould case is necessary.
- Remove the mould from the master case. Prepare the mould surface.

This description is brief, but if taken in conjunction with the section on piece moulding with plaster of Paris, and the section on casting with polyester resins, the principle, and subsequently the practice, of mould making with this material will be clear.

PLASTER OF PARIS

Plaster is a kind of common denominator in sculpture, being a workhorse equal to clay. Used mainly as an intermediary material, for mould making, and for making patterns by direct working suitable for casting from, it is not a durable material, although some artists today do choose to

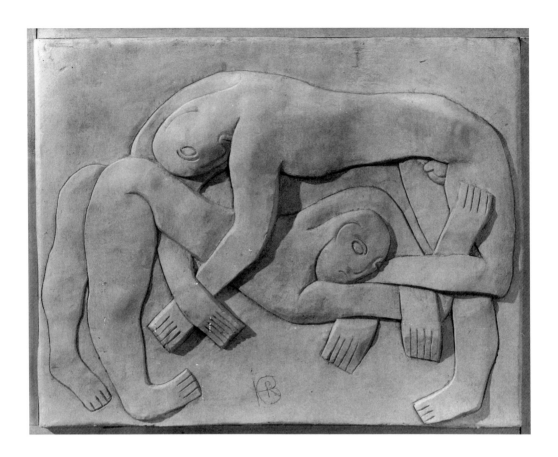

Wrestlers by Gaudier-Brzeska, plaster of Paris on stretched canvas, 1915.

use it as a final material. Because of its fragility and vulnerability, it requires treating to make it tougher and longer lasting indoors. For external use it can be treated to stand out for a couple of years only. The Henry Moore gift to the Ontario Museum of Fine Art in Toronto includes a large number of original plasters known as master casts that have been treated with white shellac. This hardens the plaster and gives it an appearance similar to ivory or bone.

The use of plaster in some form or another can be traced back to Ancient Egypt, though presumably it must have existed before then. It is made from gypsum, and the name plaster of Paris derives from the city of Paris where it was first produced commercially in large quantity, to a reliable standard. Gypsum is a crystalline solid which widely occurs naturally and which when heated and finely ground makes the powder we know. When this powder is mixed with water it re-crystallizes to make a solid, similar to its original natural state. During this setting, the material gives off heat (exotherm) almost equal to that used in its manufacture. Plaster today is a very varied substance, and is made in a range of formulas. It can be used to make hard and dense solids suitable for industrial foundry pattern-making, able to withstand the ramming of sand against its surface: or to make the pliable plaster used by dentists to take moulds from teeth. The setting time of the plaster can be adjusted, too, according

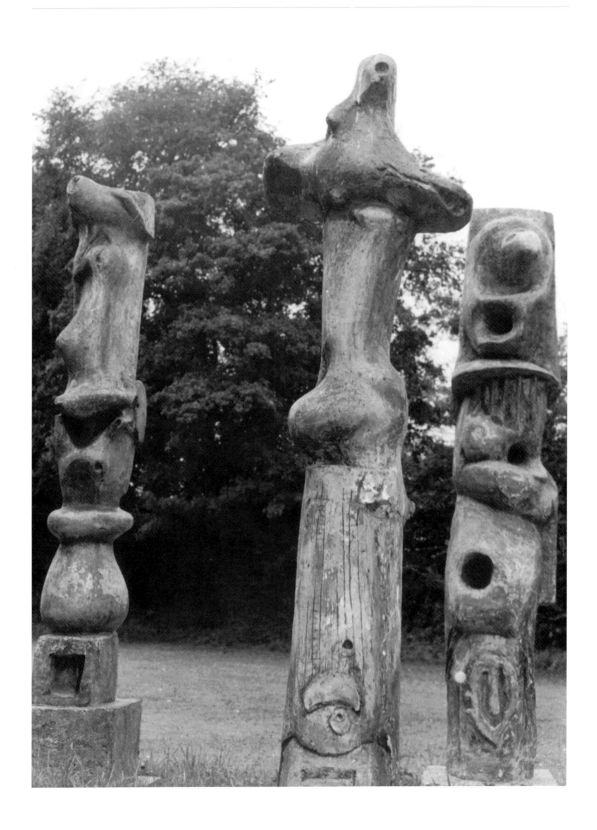

water level before
and after adding
plaster

A *The amount of plaster of Paris showing above the water level to make a satisfactory mix. The proportion should be equal parts (by volume) of plaster and water.*

B *The proper insertion of metal shim into clay to give a good suppport.*

C *The appearance of the metal shim after the plaster has been placed around it and scraped to reveal its top edge; note the substantial plaster thickness on either side of the shim.*

D *The metal shims should be tailored to fit the form with a small overlap.*

E *Shim folded to make a register key, which should only be used on vertical seams.*

to its particular application, to make it set fast or slowly. It can be made also to have zero expansion on setting, which is necessary when making precision patterns.

Upright Forms by Henry Moore, plaster (made by a direct plaster build-up).

Mixing

This is a basic skill, easily learned but requiring some practice. The normal proportion is equal parts by volume of water and plaster. This is usually a matter of judgment rather than measurement as there is some latitude possible in these proportions. Stir the plaster in its container prior to making a mix; this will allow air into the powder and aid a good mix. To a suitable quantity of clean water add the plaster. Do this by sprinkling it through the fingers so as to spread the powder and prevent lumps in the plaster. The powder will rise just to break the surface when enough has been added to the water (see diagram above). Allow this to stand for a minute or two. It is possible to let the mix stand at this stage for as long as ten minutes. Once the plaster has been stirred, however, it will set quickly. (This is a useful tip when working on large volumes.) After the mix has stood awhile, agitate and stir it till you have an evenly mixed liquid. It should show opaque on the hand.

Tools for working plaster:

A *Selection of rifflers, to be used on marble and wood; clean frequently with a wire brush to give good results on plaster of Paris.*

B *Plaster rasp, made on the cheese grater principle and available in a wide range of sizes.*

C *The widely used surform tool, also made using the cheese grater principle. This allows grindings or shavings to pass through the holes but differs from the plaster rasp in that the protrusions have sharp edges. These tools can be used on wood, plastics and the softer metals (lead and aluminium).*

D *A version of the surform that cuts by pulling, particularly useful for sculpture.*

The plaster mix can be adjusted to have a greater quantity of powder to water, which will make a harder final product, but do not add more water. Do not be tempted to make too thin a mix as this will probably result in killing the plaster which will not then make the chemical change to a satisfactory solid.

Do not be tempted to add plaster to an already mixed batch: the differing setting rates will give you a poor result. The setting time of plaster varies according to the type of plaster used but in general 15–20 minutes can be expected from a fresh plaster. Basic gypsum plaster of Paris is the workhorse of the studio, available in most places through building and sculpture suppliers in three common grades – potters' plaster (coarse casting), fine white casting, and surgical and dental plaster. The latter two are the finest and hardest of the basic grades and have a fast setting time, usually five to ten minutes, designed to cater for their medical application. All these plasters expand on setting.

Other specialist plasters are made for industrial purposes, usually to provide a very hard substance with little or no expansion. They are used in precision pattern-making and some proprietary brands are listed here:

Herculite

Hydrocal

Kaffir D

Ultracal

Hydrostone

Plaster setting times can be changed if needed to make it set faster or to slow it down (accelerate or retard it).

Plaster retarding

To achieve this add any of the following substances to the water:

Acetic or citric acid, about 5 per cent solution.

Urine in a 5 per cent solution with water (an ancient additive).

Most colourants affect the setting time, some may even kill the plaster, so always make a test of any colourant you plan to use.

Glue size (dextrine or potato starch) – a 5–10 per cent solution in water is normal, but a stronger solution will retard the plaster for longer and make the final solid much harder. Experiment to find the solution that suits your needs best. Very cold water will also retard the mix a little.

Plaster accelerating

To speed up setting, add to the water common salt, cement (either Portland or high alumina) or a 5 per cent solution of alum. Hot water will accelerate the plaster set, too, but it is sometimes too quick and in any case it might be simpler to use a harder grade of plaster.

Plaster rasp

A specifically designed perforated rasp, made for use on plaster of Paris. It can be used as soon as the plaster has set. The notched perforations act like a cheese grater allowing the waste to pass through the rasp and not clog. A wire brush is useful to have by you when you are working as there is usually some build-up eventually, especially when the plaster is very fresh. These rasps have made light work of the task of building sculpture in direct plaster. They are made in a number of sizes (see illustration page 172).

PLASTICS

The generic heading for synthetic materials produced using resins as a base. There is an enormous range of these plastics, confused by industrial terminology and trade names. There must be thousands worldwide.

Plastics fall into two main categories – thermoplastic and thermosetting plastic, their titles self-explanatory. Both groups require heat to effect changes in their structure to make them workable, and usually require complex and expensive equipment, vacuum-forming equipment for use with thermoplastics being the most easily managed by sculptors, but not on an elaborate scale.

Plastics can be clear, translucent or opaque. They can be made lightweight or dense, solid or hollow, flexible or rigid, flammable or flame resistant, elastic or not, porous or not. They are manufactured as foams, solids, liquids, sheets, ropes, films, adhesives, etc., and are commonly purchased in any of these forms. Apart from the two common castables – polyester and epoxy resins – those plastics that appear most regularly in sculptors' studios are acrylic resins, polyvinyl chloride, polysulphides and silicone rubbers, mainly in the form of flexible moulding compound, constructable solid block and sheet materials, adhesives and paints as well as in the usual studio furniture of plastic sheeting, bowls and pails, etc.

The wide range of plastics accounts for many of the phenomena that have masqueraded as sculpture in recent years. PVC sheet has been made into inflatables and has hovered in galleries around the world. Such sheeting has been used to wrap up parts of the Australian coastline and one of the bridges crossing the Seine in Paris. Polyurethane

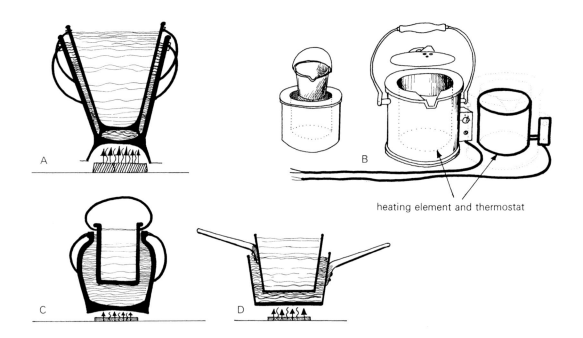

heating element and thermostat

Various vessels used to melt wax, glue, gelatine,
PVC or any material that needs to be shielded
from direct heat:
A A system devised using two pails (buckets),
with water boiled in the larger vessel.
B The cushioned heaters used to melt PVC,
made from aluminium with a shielded
electrical element controlled by means of a
thermostat.
C A glue porringer.
D An assembly of saucepans that act like a
porringer.

foam has been mixed and allowed to expand freely,
but I feel a question mark must be hung over these
entertaining happenings *vis-à-vis* sculpture.

Polycellulose

Polycellulose plaster fillers added to a plaster mix
will aid adhesion of fresh plaster to old, without the
soaking normally required (Polyfilla is a trade name).

Polyester resin

The nature of the material, of course, largely
determines the method and usability of that
substance. Any misunderstanding of what, in
general, is happening to the medium at a given
moment, can contribute to a misuse or a failure
in its use. Good handling and proper appreciation
of the use and suitability of form and method
come more readily when the nature of the
material is appreciated.

Polyester resins are unsaturated resins, which
means they are capable of becoming hard solids
under certain conditions. They are themosetting,
becoming hard and inflexible by the heat
(exotherm) generated during their cure, which is
brought about by adding the catalyst. The term
polyester is derived from polymerized esters.
Polymerization is a non-reversible chemical
reaction, and is employed to obtain polyesters by
reacting dibasic acids and glycols. At this stage the

molecular structure of the resin is in the form of a chain of identical molecules, simple repeating units. The polyesters are dissolved to form a solution in a reactive monomer. This monomer enables the chain of esters to crosslink, after the addition of a catalyst, to form a complex three-dimensional molecular structure. This is, in fact, a further polymerization resulting in gelation and cure of the resin, to become an inflexible and insoluble material. Some of the raw materials used in the manufacture of polyester resins are as follows:

Dibasic acids	Maleric
	Fumaric
Glycols	Ethylene glycol
	Diethylene glycol
	Triethylene glycol
Monomers	Styrene
	Methyl methacrylate
Catalyst	Benzol peroxide
	Methyl ethylketone peroxide (low temp:<15°C)
Accelerator	Cobalt naphthanate
	Di-methy aniline

PLEXIGLASS

The trade name for acrylic plastic that is marketed in the USA by Monsanto Chemical Co., usually in sheet form. Blocks of acrylic can be made to order.

POLYVINYL CHLORIDE (PVC)

A modern flexible thermoplastic that melts at temperatures ranging from 120–170°C, marketed and manufactured by Vinamould in the UK. This material requires special melting facilities for the best results. It can be prepared in a home-made double boiler using oil as the barrier between the two vessels, but specially made insulated boilers are manufactured to deal with this PVC and its high temperatures in safety. It is a very useful, tough, flexible compound, that is suitable for making

moulds to cast with plaster of Paris, cements, concrete, resins and wax. When used with a hot casting material such as wax, some oils from the PVC will transfer to the cast surface, but this can be washed off with a dilute detergent. If the mould surface is washed with detergent before the wax is cast, and the wax temperature is kept as cool as possible, the results can be very acceptable (see Flexible Mould Making).

PORRINGER

A double basin used to melt safely any flammable substance such as glue or wax. One basin is suspended in another which is partly filled with water. When placed over heat the water boils and melts the contents of the smaller vessel, thus no direct flame can come into contact with the glue, wax or gelatine.

PORTRAIT HEAD (see Bust)

A sculpture portrait that includes only the head and neck, and sometimes a suggestion of shoulder, is referred to as a 'portrait head', and is the most usual form of portrait.

POT

The familiar studio name for the crucible, used to melt metal for casting.

POURING GATE

The name given to the system of runners and risers designed to gain the most efficient delivery of molten metal to a mould cavity, with no turbulence and a simultaneous evacuation of gas and air, resulting in an accurate casting in sound metal (see Runners and Risers).

PRE-DETERMINED CORE

The self-explanatory title given to that form of metal cast sculpture where the core or inner

mould is made first and the layer of wax that determines the metal thickness and surface detail is applied over it. This predetermined core therefore establishes the form in all respects up to 6mm (¼in) or so of the surface. This is the method employed by Cellini and described by him so colourfully in his autobiography and treatise. The African bronze casters, particularly the Benin, used this method also. Up until very recent times some French casters preferred to make waxes for casting by first making a piece mould from the original and then casting from this in a chosen core material. This casting was then pared down by the thickness of the final metal casting, a tedious but exact procedure, and when it was completed the mould was re-assembled around this core, with supports of iron maintaining the space. Hot wax was then poured in to make the wax casting. Sand casting/moulding is still done using this pre-determined cast core method.

The technique of modelling the core in a suitable refractory material, however, to be subsequently covered with a layer of wax in preparation for metal casting, was used right up until the discovery of flexible moulding materials, commencing with gelatine.

PROTECTIVE CLOTHING

It may seem obvious, especially in societies that sport safety-at-work regulations, but sadly too many people neglect to protect themselves sensibly. Dusty conditions are always injurious to health, silicosis being an occupational hazard to all who work in such an atmosphere. Extraction fans should be installed whenever possible but they can be expensive items to install, so face masks should be worn to guard against dust and toxic fumes. Manufacturers of safety equipment cater to most needs, and should always be consulted as particular conditions present themselves. The same manufacturers will advise on

aprons, coveralls, gloves, leggings and footwear, as well as headgear and earguards.

Do not be tempted to use asbestos: besides its recently discovered carcinogenic properties, it was never an adequate shield against intense heat; leather offers better protection. The newer fire protecting clothing available for foundry work and other hot metal environments is by far the best kind of protection.

Never wear open sandals or soft shoes when working with heavy or hot materials; steel-capped boots are more suitable. Special foundry boots with quick-release buckles can be purchased and should be used in conjunction with the right kind of leggings or gaiters. Select gloves to suit particular uses; leather gauntlets cover most contingencies from hot metal to rough surfaces and are always necessary when handling fresh castings that are likely to have razor-sharp flashing. Goggles should also be selected according to the expected conditions and materials. Wearing them for welding seems obvious, but remember that those used for oxy-acetylene welding are not suitable for arc welding, nor are polaroids sufficient protection against any intense light of that kind. Toughened goggles made to specific safety standards should be worn when carving and for any metal grinding. Safety spectacles should be used generally when working with light machinery; these can, of course, be made to prescription. Everyday spectacles do not give adequate protection as they usually do not cover enough of the eye surround.

PYROMETERS

Meters for measuring temperature by means of thermal couples. These can be built into kilns as a permanent feature, with sophisticated controls making it possible to control the temperature

build-up, and adjust heat input to specific areas of the kiln. They can also be used in the form of a lance (pyrolance), useful in measuring the kiln temperature but designed to measure directly the heat of molten metal in the crucible.

QUARRYING

The quarrying of stone is a specialist activity, one seldom practised by sculptors. There is an account of Michelangelo, who was raised by a quarryman's wife, fetching his stone from the topmost point of the Apuan Mountains, where no quarry existed. He had to build the road down and prepare for the descent of the stone to the Arno, thence to Florence, but even he had to use the services of the quarrymen of Pietrasanta. The usual practice is for quarries to supply the stone yard, which in turn supplies the sculptor. Some quarries will help a sculptor directly, and most sculptors who carve stone have an understanding of quarrying processes sufficient to enable them to choose good stone (see Stone).

RASPS AND RIFFLERS

These are the tools that follow coarse cutting instruments on wood, stone, plaster or hardened resins. They are followed, if necessary, by finer abrasives such as sandpaper or emery. The rasp is a shaped tool that has a myriad of sharp teeth protruding from its surface. When dragged over the work surface the teeth scratch and remove fine particles of waste to make a smoother surface. An almost infinite range of rasps and rifflers is made (the riffler is a fine double-ended rasp), with coarse and fine teeth. They are made of hardened steel and hold a cutting edge very well. Some materials such as cement are tough on these tools because of the hardness of the aggregate used and should be approached with caution.

Perforated rasps, such as the Stanley surform, allow particles of waste to pass through the blade without clogging it up. They are made of hardened steel and have throw-away blades. Made in a number of different profiles, these tools are good for use on wood, plaster, some resins and aluminium.

REINFORCING

The proper reinforcement of a sculpture, be it a casting or a direct construction, is a factor that can be easily overlooked. There are few materials, other than metals, sufficiently strong in themselves as to need no reinforcing. Even metals may need to be given added strength according to the size they are made to, and the site they are going to occupy. Most materials are brittle in their hard state and so require reinforcing to gain tensile strength. Jute scrim (hemp/burlap), glass fibre, terylene fibre, galvanized wire of various gauges, stainless steel, mild steel, high-tensile aluminium rod, expanded metal of various kinds, etc., are the most common materials used in sculpture to give adequate strength to a work. This strength is required at the points of strain where the sculpture is at its most vulnerable and likely to receive pressures great enough to fracture the structure or even break it completely. This is, of course, of prime importance when the work is put into a public place. Vandalism is sadly a constant factor today and has to be taken into account during the making of any piece.

If in any doubt at all regarding suitable reinforcing, seek the advice of a qualified engineer, who will be able to work out stresses and strain and thus any strengthening needed. Civil engineers can also accept the public liability for a sculpture, providing all reinforcing work is carried out to their specification, a point worth remembering for tricky sites.

It is advisable, whenever possible, to make hollow constructions relatively light in weight. The tube is a stronger form than a solid rod of the

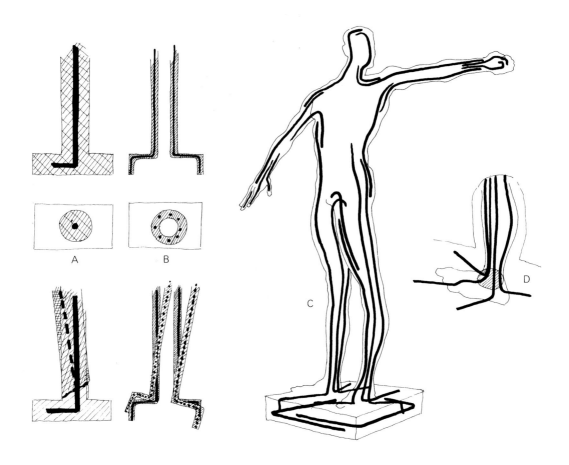

same dimension and similarly a hollow sphere has a proven strength. It was common practice in the past for plaster casters to place a heavy mild steel bar in the centre of a mass, and filling solid around it. This was obviously a very quick way of making a plaster cast, and jobbing casters were paid by the piece, usually for the work to be taken to a foundry for further casting. These solid plaster castings often crack, however, usually at the ankles, knees and wrists of figures where the form is at its weakest. It is true that the sculptures seldom break apart but plaster will burst away from the central reinforcing, and will require repair often. Small figures do not suffer as much as large works which will always suffer damage if cast in this way.

Cracking happens because the outer surfaces of

A Reinforcing with a central iron, when any strain will cause a crack.
B Reinforcing placed in a gaiter patter, providing strength where it will be most effective.
C Reinforcing placed strategically in a figure. Note that all the irons overlap to give maximum strength.
D An alternative gaiter patter.

a form receive the greatest stress: strengthening in the centre of the mass only does not benefit these parts. I advise that forms be reinforced on the gaiter principle, that is by placing the greatest number of narrow gauge rods in the thickness of the cast, which should be hollow. The material will

then be given maximum strength in its actual thickness. With resin lay-ups this principle can be readily understood, reinforcing being placed as the laminations are made after the surface coating. If all casting materials, other than those that are poured, are treated in the same laminating manner the gaiter principle can be easily applied (see diagram).

Building a form directly, using materials that allow you to do so, can be more complex, but it does give the sculptor the opportunity to build the strongest possible structure around which to hang the form. The same principle applies: a properly constructed hollow form is stronger than a solid. Design your armature accordingly, and whenever possible use the correct fibrous reinforcing, incorporating this into the material thickness. Make sure of the strength of the support, according to the weight it will be required to take, and that includes people

A page from the civil engineering study submitted to sculptor John Mills. The civil engineer, Sven Rindle, worked out the best method for mounting this one-ton bronze equestrian figre (*Jorrocks*) with only a two-point fixing and the need to spread the load over a wide space.

climbing over it if in a public place. Make sure the chosen material is well attached to the support, which should be securely anchored to its base.

Tall forms, subject to natural forces such as high winds, will require reinforcing through their entire length, with at least a third of the height anchoring into the ground (see diagram). The equestrian sculpture *Jorrocks* (see illustration below) weighs just over a ton, and is placed on a site over an underground car park. The civil engineer Sven Rindl was asked to design reinforcing that would give sufficient strength to the two front legs of the horse (which support the whole weight) and then to distribute its weight according to the loading of the floor/ceiling of the car park.

He achieved this by reinforcing the bronze casting with 50mm (2in) high-tensile stainless steel bars, that carry up through the horse to be welded to the upper back, cantilevering it. These bars extend downwards into a steel frame, through gaiter tubes, and are fixed by bolting. The steel frame spreads the load. I have included a sample of the drawings and calculations (see illustration) supplied by Sven Rindl that the foundry worked from.

When designing for specific sites and situations remember to allow for all contingencies. Make hollow form whenever possible, and allow for drainage, both of moisture off the surface and for a satisfactory drying of the work after soaking. If moisture remains in concrete, for instance, and freezes it will probably break, so the thinner the section through the material the quicker it will dry. Wood placed in a construction will be affected by moisture and by changes in temperature, so do not be tempted to use it as a reinforcing material in anything that needs to have a long life.

Get to know your materials; weigh up the pros and cons before embarking on a large-scale project. Plan the strongest possible job, and carry it out according to plan; it is worth taking time to design

and place sensible reinforcing, rather than to suffer setbacks later. Study structure; this, combined with the instinct for strength that most sculptors develop, will stand you in good stead. Study organic structure; there are some miracles of strength relative to weight in the organic world. Tensile strength is most often required by sculptors and is embodied in most living organisms.

RELEASE/PARTING AGENTS

These are solutions applied to a surface to prevent other substances from sticking to it. They are a vital part of moulding and casting, and vary in nature according to the chemical properties of the materials they are designed to separate. The following list covers the release agents used generally in sculptors' studios; manufacturers of special materials will always advise as to the best release agent for their product, so when in doubt seek their advice.

Soft soap and liquid detergent

Soft soap or liquid detergent can be used as a parting agent for plaster waste moulding. Dilute the agent in a small quantity of warm water to make a strong solution. Apply this solution to the mould surface with a brush, making a good lather. Leave the lather on the mould surface for about 10–20 minutes, then remove it using a clean brush and clean water. When this is cleaned off, the mould can be soaked ready to receive the plaster filling.

Some sculptors repeat the lathering process: most will apply a little light lubricating oil before soaking the mould. The parting agent seals the pores of the plaster mould, and the lightest possible smear of oil will ensure the mould surface is water repellent. A few drops of lubricating oil on the palm of the hand then

Kiosque l'Evide by Jean Dubuffet, painted bronze, 1964. Pepsico Sculpture Garden, Purchase, New York.

rubbed well into the bristles of the brush is enough to give the right amount to the mould surface: do not put on too much oil.

Clay

A film of clay left on a mould surface after the removal of the body of clay makes a most efficient parting agent for cement and concrete from a plaster of Paris mould. Do not wash the mould; remove any large particles of clay by means of a clay dabber, which picks up heavier deposits and leaves the light clay film that will form the barrier between the mould and the casting. It will not be heavy enough to blur the image or any of the detail on the surface. If by any chance a mould has been washed clean, a fine film of clay can be applied using a brush to serve as the release agent. The mould needs to be well soaked.

Clay mixed with soft soap or detergent makes a release agent for general purposes, such as effecting a release between coarse surfaces, not on moulds, e.g. between wood shuttering and plaster or concrete.

Shellac and wax

These are the materials used to seal a plaster mould surface completely, and can be used for almost any filling, particularly concrete when a minimum of plaster film on the cast surface is desired. It is effective, too, for resin casting from plaster of Paris moulds, or for treating other porous surfaces to be cast against. Apply dilute shellac – methylated spirit (denatured alcohol) – to the mould surface; two or three coats will do, allowing each coat to dry before applying the next. Do not apply undiluted shellac as this will blur any fine detail. When the surface is sealed and the shellac is hard, apply a coating of liquid wax evenly all over, and when this wax has hardened polish it with a dry soft brush or cloth. For resins it is best to apply a proprietary parting agent as well, such as a polyvinyl alcohol.

Wax

When used as a mould this material requires no parting agent. To remove the wax simply warm it and peel it from the casting. Warm it by immersing it in hot water when this is possible, or use a gentle heat. On very hard substances such as concrete it is safe to melt the wax off by using a flame, a blowlamp or torch. Plaster, cements, concrete and resin can be satisfactorily cast from wax moulds.

Polyvinyl alcohol

These solutions are manufactured by the plastics industry for use when casting with resins of various kinds. They are best applied over a wax priming. Particular parting agents may be best suited to particular manufacturers' products so ask their advice when you buy the resin.

French chalk/talc

This is a particularly useful parting agent for preparing the surface of a plaster of Paris piece mould from which a clay pressing is to be cast. It forms an efficient release agent between clay and almost any other material, and because of this fact it is essential that no French chalk gets between layers of clay during the pressing.

Graphite

This is applied to a plaster, or grog and plaster mould surface to make a good release and a fine reproduction of the surface of a lead casting.

Rape seed oil

This oil, which comes from the colewort or coleseed plant, is particularly useful as a release agent for polyester resin from plaster of Paris. Oil is applied to the very dry plaster mould until it is saturated; it is then safe to make a resin lay-up over the mould surface. When the lay-up is complete the mould should be soaked to aid the breaking away of the waste.

Tallow

A common release agent, this is used over a sealed porous surface, or directly on an impervious one. It is often used by jobbing plaster casters for separating all manner of surfaces.

Oil

In all its grades this is an effective parting agent. An old moulders' concoction was dripping or lard, derived from cooking fat meat, mixed in equal parts with engine oil. It is a thick parting agent but very effective when you are making plaster of Paris piece moulds: apply it over each completed piece of mould before going on to make its partner.

Expanded polystyrene/Styrofoam

When used as a mould, carved direct, this material requires no parting agent; it can be dissolved from the cast surface using almost any solvent. It can also be burned off, but beware of the noxious fumes it will give off. This material is often used to embellish shuttering for in situ casting.

Polythene sheet

Almost any plastic sheet can be used to assemble moulds, or to make surfaces to cast against. They are, of course, suitable only for cold casting compounds, being thermoplastic and therefore affected by heat.

Polishes

These materials are useful in so many ways; as liquids or creams they can be used in a host of casting processes. Usually they are the finishing coat of a release agent prior to making the cast. Silicone waxes are very effective, and often easier to apply than ordinary household polishing wax. Their drawback is their tendency to remain on the surface of the casting, making repair work or further work impossible until any residue of

silicone has been removed with a solvent. White spirit is usually all that is required, however. This is the case with all materials cast against wax and silicone wax so always ensure that you have an appropriate degreaser or solvent on hand to clean down the casting.

RELIEF
(*see* **Sculpture – Sculpture in Relief**)

The projection or recession of an image from a surface. The surface is typically, though not necessarily, flat.

In drawing and making a relief the artist must accurately represent three dimensions on a two-dimensional surface. In addition, relief demands the partial realisation of the form by modelling projections from the flat surface.

Letter cutting is a precise use of intaglio relief, cutting the design into the surface, and has become quite a specialist craft. The finest classical lettering can be seen on Greek and Roman carvings. The inscription on the Trajan Column set the standard for what was to become known as 'Roman Lettering', which influenced master letter-cutters such as Eric Gill.

Medals are small sculptures given as a gift or a trophy, and are usually fine examples of relief sculpture. Note that a medal does not necessarily need to be flat or small.

Coins are also examples of fine relief design with the finite requirement of extremely low relief.

RESINS
(*see* **Epoxy Resins, Plastics/ Polyester resin**)

Modern castables that form the basis of a range of synthetic materials peculiar to this century. They are referred to under the generic heading plastics (see Plastics).

The resins most commonly used by sculptors are polyester and epoxy resins. There are many more, of course, and technical manuals run to hundreds of pages describing those resins currently used in industry. It is probably safe to say that resins are produced to cater to almost every need. In the main they are expensive, or require expensive equipment, and are therefore not often used by sculptors. The two that are used, when compared to traditional materials for strength, durability and resistance to corrosion, colour, surface quality and relative ease of handling, match up very well. Both resins produce transparent or opaque solids that can be coloured with ease, and when inert fillers are included in the mix, including metal fillers, they offer a wide range of effects.

When set and cured these resins are very brittle and so require in most applications some sort of reinforcing. Glass fibre is the usual reinforcing material, but it can be provided by any inorganic fibre to make a satisfactory laminate. Wood and metal can be incorporated in the resins' thickness to give structural strength. Their widest industrial use is in the manufacture of car and boat bodies, and in domestic furnishings, baths, sinks, chairs, etc. Having the property of changing from a liquid to a solid at a controllable rate, these resins are particularly useful to sculptors. They have similar working characteristics to other castable materials – plaster, cement, wax, etc. – but with a greater variety of strength and durability. Resins can be cast, or worked directly over an armature. They can be painted over vulnerable surfaces to good effect, and are rapidly becoming, for a large number of sculptors, another good all-round studio material. Acrylic resins are more specialized in their use.

ROMAN JOINTS

Modified tenon joints used mainly in plaster casting, to make master casts in matched sections, for ease of transportation and to assist foundry work. This kind of joint is useful in other materials for the same reasons. It was the common means

of assembling bronze cast sections before the advent of welding. Roman joints were made on the pattern, reproduced in the bronze, then fixed together using rivets to secure the pieces together and the join peened and chased over. The blending in by the chasers was of such high quality as to render the joint invisible. Such joints can be detected today on some bronzes that have suffered badly through heavily polluted atmospheres in cities around the world.

RTV

The initials that identify some cold-curing flexible moulding compounds, standing for room temperature vulcanizing. These are the polysulphide, polyurethane and silicone substances that produce rubber-like solids of variable degrees of hardness and flexibility.

They can be used in the traditional flexible moulding manner, making a plaster case or jacket around the object, with a space between the two that is to be filled with the flexible compound (see Flexible Mould Making), but more often today they are painted on and built up.

Treat the original sculpture with a suitable parting/release agent. Prepare a brushing coat of the chosen compound according to the manufacturer's instructions, and carefully paint this over the sculpture – an air line will help to blow the material into deep texture. When this first layer has set, mix a paste of the same compound and build up over the first coat to a suitable mould thickness, 6mm (¼in). Shape any deep hollows to taper and make a plaster plug to fill the resulting void, that can be easily removed when the mould is peeled from the original and subsequent castings. The seam is now identified and a strip of pre-prepared rubber with registration keys is attached with fresh compound along the seam line; this strip should be as wide as the sculpture will allow (12–25mm/½–1in).

Build up a plaster jacket using scrim (hemp/burlap); section it using the clay wall method, along the centre of the seam strip (see diagram page 219). All sections of the jacket should be completed in this way to provide a complete housing for the flexible mould. When the jacket is complete, remove sections methodically, and using a sharp thin blade, cut through the rubber along the centre of the seam against the edge of the plaster section. Remove all sections of the case and any plaster plugs, and peel the mould from the object, completing any further cutting required, such as in deep hollows along the seam, then re-assemble the rubber and the plaster jacket ready for casting.

An alternative to this method is to make the bed as described in Flexible Mould Making, then to pour the first layer of compound over the original sculpture. By making a fast curing mix, according to the manufacturer's instructions, this poured layer can be contained. A clay wall made to define the edge of the mould will help to contain the compound also. Over this first coat, building up with a paste mix, make the mould thickness 6–12mm (¼–½in). Make any plugs required to fill deep hollows, and then the plaster case. Registration keys are cut through the layer of rubber that covers the dividing bed and these are then picked up by the plaster case. Each section of mould is built up in this way. It is wise to make the plaster case as thin as possible, so use substantial layers of scrim (hemp/burlap). Turn this section over to make the other side, or next section, repeating the technique of pouring, building up and plaster/case making. Remember to use appropriate release/parting agents when plaster sections meet.

RUNNER CUP

This is the funnel, attached to the main feed or runner, via which the molten metal is introduced. The methods of making the funnel are many and

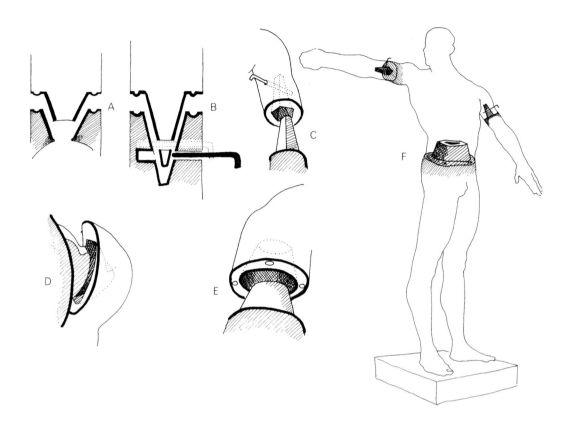

Roman joints:

*A The general shape, as used at the waist of
the figure F*

*B and C A tapered joint with a locking pin,
shown at the arms of the figure F*

D and E Shaped joints

various. Waxed paper drinking cups can be used, a paper cone can be made and coated with wax to facilitate fixing to the wax runner or specially designed cups can be made and moulded to make wax castings as desired (see diagram page 44). The principle of the cup should be understood, however, so that any adaptation can be reliably planned.

RUNNERS AND RISERS

The components that make up the pouring gate in metal casting. Runners are the channels or sprues through which the molten metal is poured to run through the mould cavity. The metal enters via the runner cup which surmounts the runners to make a main feed. Risers are the channels that allow gases and air to escape and the metal to rise, thus ensuring a proper fill of the mould.

In lost wax (*cire perdue*) metal casting the pouring gate is made from wax rods of appropriate diameter, attached to the completed wax image prior to investing. The precise number and arrangement of wax rods differs from sculpture to sculpture and the planning is never easy. It will help in such planning to place pins in the wax to work out the direction of the flow of metal and the escape of the air. When visiting foundries, pay attention to the systems being made there so as to become as familiar as possible with spruing up.

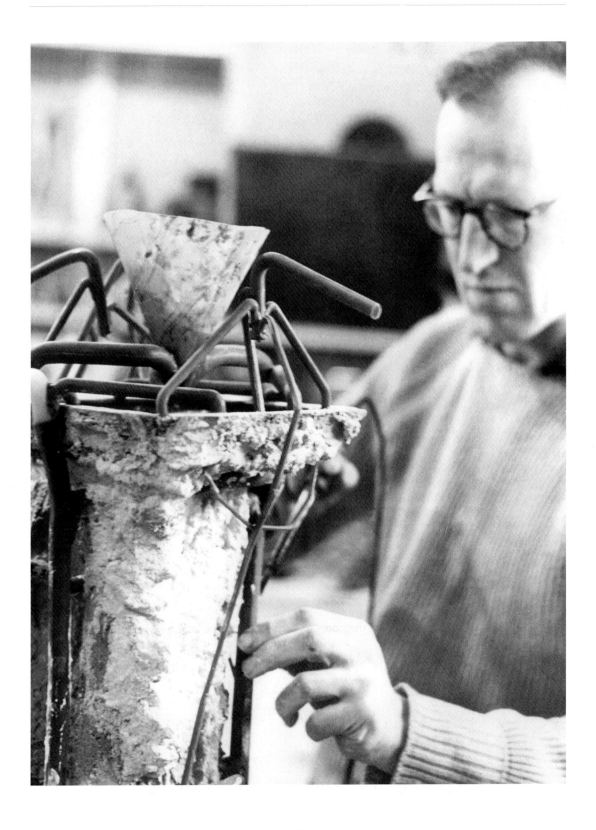

The wax rods can be made easily from plaster moulds routed out to make rods of various dimensions, or by making moulds from wood dowelling. Simple two-piece moulds are all that is required. Wax rods (sprues) can be purchased ready-made from foundry suppliers and from jewellery suppliers and wax manufacturers.

The object of the pouring gate is to fill the mould cavity at a proper flow rate for the metal being used, with the least amount of turbulence. The runners proceeding from the runner cup need to be thick enough to permit free flow of the metal, delivering it so that the mould fills from the bottom. The metal will then flow upwards pushing any air or gas ahead of it up the risers (vents). The pattern of flow can be by a direct feed into the mould; for instance, a head can be fed by placing the runners at the neck or on top of the head (see spruing diagram page 197), with the risers being attached to the highest point of the image in its pouring mode. Such direct feeding does present some hazards, however. The flow of metal can wash off detail from the surface of the investment, and in complex pieces air can become trapped which results in a poor casting, with a lot of work to do on the finishing.

Ceramic shell investment, because it is very hard, favours direct feeding and because the material to a certain degree vents through its wall thickness, the number of risers (vents) can be reduced. Some sculptors, however, even with ceramic shell, prefer to use the indirect method.

The indirect pouring gate of runners and risers is much safer. With this system a main runner, or series of runners according to the size of the sculpture, is led from the runner cup to the bottom of the sculpture. Side runners are attached to this main feed and to the surface of the sculpture. The molten metal will run down the main feed to fill it, and as it fills, the metal will run via the side runners to be evenly distributed throughout the mould. The side runners are placed horizontal to the flow of metal or on an upward incline, so that metal does not run down through them but is fed in as it flows upwards (see spruing diagram page 44). If the metal is made to run too far, it might freeze before reaching the planned area and so have a detrimental effect. Plan the flow according to the nature of the metal, and the thickness of the wax. The principle to observe is: 'the runner must be thicker than the section it is feeding'. If in doubt, add to the number of runners. The greater the number of runners used the cooler the metal can be poured, resulting in a better cast. The main feed helps conserve the heat of the metal and can be fitted with extra wax at strategic spots, to provide additional small reservoirs (Italian runners) of molten metal as required.

When planning the runners and risers, identify any solid sections and work out the appropriate size feed. Remember, the runner must be larger in volume than the section it feeds. Plan these points first and design the rest of the system accordingly. Do not plan for metal to enter at both the top and the bottom. During this planning remember also that the resulting metal rods have to be removed from the casting. The point where the rods are attached to the sculpture will require chasing, so easy access for cutting off the rod and for any subsequent working must be taken into account. Smooth areas are the most favoured, followed by heavy texture and strong surface detail; light surface texture is the most difficult to chase out satisfactorily, so be warned.

Risers (vents) are always placed at the top of the wax in its position of pour, and at any point

LEFT The completion of the pouring gate, showing the runners and risers as well as the funnel.

where air is likely to become trapped. Spend time identifying any possible traps. Such items as fingers or strands of hair, or shapes that correspond to these will require venting. Blind risers can be fitted. These are simply small rods attached to such high points to extend them and provide refuge for any air trapped without harming the form (see diagram page 197).

SAND BOX CASTING

A simple direct moulding technique that has proved to have a wide potential in the manufacture of relief sculpture. In essence all that is required is a container to hold damp sand – any fine or coarse sand will do. Items pressed into the surface of the sand will leave a fine impression. These impressions can be filled with a castable material, which when it has set and hardened can simply be lifted to reveal the casting. The surface of the sand can be modelled and shaped quite freely and combinations of techniques can be exploited. Once the casting has been made the surface can be embellished and worked on according to the skills required for particular materials. The element of surprise that can exist in this technique is a seductive factor also, imparting to this aspect of direct moulding a quality akin to working with terracotta. The Simple technique has been developed by sculptors in various countries to provide relief sculpture and architectural embellishment of great size and intricacy. Such large projects can often be carried out on site and can be very exciting, embodying a degree of adventure. The technique, of course, also allows for carefully considered modular systems and sophisticated imagery.

SAWBENCH

This is the supporting trestle used to hold timber secure for sawing. Sculptors usually make their own according to need. Some manufactured sawbenches are made to cater for use with the chain saw where absolute security is essential.

SCALING UP

The studio term given to the process of enlarging no matter what means of calibration is used.

SCULPTORS

Those practitioners in the fine arts concerned with three-dimensional imagery, produced in the round or in relief, by carving, fashioning in malleable materials, by casting or forming in metal, by assembling found objects or by combining all or some of these techniques.

SCULPTURE

Any three-dimensional design, in the round or in relief, that has no function other than to decorate a building, enhance a space, or make tangible symbols and images expressing human ideas.

The proper study of sculpture is sculpture. Study the widest possible range of sculptural imagery. Try to look beyond the historical context and behind any particular image, to identify the means by which a sculpture has been made. This will, of course, involve you in both history and social imagery. Questions arising from this kind of enquiry might include:

- How is it that all cultures with access to clay make similar images in their early development?
- Why is there such limited movement in archaic figures from all cultures?
- How did a greater freedom come about as technology developed?
- Would Michelangelo have achieved more with power tools?
- How many more Rodins would we have if he had had plastic bags?
- Is welding more than a sophisticated gluing system?

If you expose yourself to many and varied images and idioms, you are more likely to find your own. Your sculpture will become personal, and as original as your personality allows. Try not to be too concerned with a particular idiom too soon.

It is perhaps significant that when artists of any persuasion, and sculptors in particular, gather together, the talk is more often related to materials and techniques than to aesthetic expression. Images can be talked right out of your mind; they are more wisely expressed in three dimensions.

Sculpture in relief

It could be argued that the relief is the oldest form of sculpture. Prehistoric man scratching lines in mud, in sand or on stone was effectively making relief sculpture. This is the projection or recession of the design from a surface not necessarily flat but retaining that surface as an integral part of the composition. Relief sculpture is viewed from a fixed point, usually face on to the image. Intaglio relief is made by cutting into the surface, and the scratched line is its most basic form. The ancient Egyptians were great exponents of intaglio, practising it with refinement and sophistication, often combining it with other types of relief. Today the most common form of intaglio relief is the incised letter or inscription.

Projected relief sculpture falls into four categories: low relief, bas and mezzo relief, and high relief. *Low relief* is self-explanatory, being the lowest possible projection from a surface, raised just enough to catch the light. It is often supported by finely drawn incised lines. Low relief is probably one of the most exacting tests of the sculptor's draughtsmanship, depending as it does on a fine ability to allude to volume describing the speed of turn of form away from the viewer.

Bas relief is created by projecting up to half the volume of the form, but using no undercutting. *Mezzo relief* is similarly the projection of up to half the volume of the form but making use of extreme undercutting to take advantage of the dramatic effects of light and dark, to reinforce the impact of the image (it is often used to enhance the use of perspective in picture narrative). Lorenzo Ghiberti, making the second set of doors for the Baptistry of the cathedral in Florence, now known as 'The Gates of Paradise', employed all the categories of projected relief including *high relief*. This is the most extreme form of relief in which the volume is expressed in the round, while remaining attached to the flat surface in some way, taking its proper place in relation to the picture plane, and adding greater impact to the narrative.

Sculpture in the round

Form in the round is free-standing, occupying particular space. It may be viewed from all aspects and therefore must be composed in every view according to the subject, the material and the site.

The traditional understanding, relating to free-standing sculpture, is that successful sculptures have a principal view, to which all other views are subordinate. When the image is a narrative subject, or a subject drawn from life, this concept can be easily understood and applied. Non-figurative sculpture presents a greater problem, but it is well worth paying heed to the notion of a sculpture having a principal viewpoint. This can act as an aid to reviewing the work whilst in progress, and is of particular use as a guide when working a sculpture related to a specific site.

Based on this notion of a principal view, successful sculptures in the round are composed with a controlled progression of

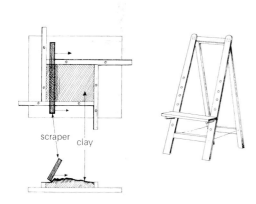

scraper clay

ABOVE An adjustable frame that makes the clay surface flat, which may be required for a relief.

RIGHT Study in Bas Relief by Annigoni.

LEFT *Italian Madonna* by Desiderio de Settignano, marble, 14th century. Victoria and Albert Museum, London.

BELOW *Wall Relief No 1* by Henry Moore, plaster for bronze, 1955.

Roman Stuccowork in the Palazo Farnese.

forms from one aspect to another, so that the work stands as a unit occupying its space with a presence similar to that of natural organic form. The juxtapositioning of the axis of masses, in their vertical, horizontal and diagonal displacements, helps to create forms of visual strength as well as structural power.

Auguste Rodin once described his method of modelling as being the result of making an infinite combination of profiles, templates through the masses, protrusions indicating organic and therefore structural dynamics. A close study of organic growth and the principles of natural structures will prove invaluable to the sculptor, as a further aid to the understanding, and the making, of good free-standing form.

SEAM FLASHING

The excess material present after casting, usually at the seams. The best moulds have seam flashing no thicker than the material used to make the mould division, i.e. clay wash or metal shim. Professional plaster casters pride themselves on the fineness of the seam. The finest seam lines are often left on to indicate the quality of the casting, particularly with plaster of Paris casting. It has been known for unscrupulous casters to remove any poor seam flashing, make good the surface, and then make a false seam using cotton thread dipped in plaster.

Temple of the Sun. Ancient Egyptian relief sculpture.

SEASONING

The process of preparing green (freshly cut) wood so that it can be worked. The green wood should be stored in as controlled a manner as possible. Stand logs in a fairly constant atmosphere, not subject to frost or dramatic changes in temperature or humidity. Place the logs off the ground to allow a free circulation of air. Cover the tops of the logs to prevent rain water penetrating the grain. According to the atmospheric conditions, the size and density of the log and the patience of the sculptor, the seasoning process will take anything from six months to six years. It is wise to turn the logs at regular intervals, keeping them out of direct sunlight to try to achieve the slowest, most even drying. This will minimize cracking and spoiling the log. By boring a hole through the centre of the log with a long auger, allowance can be made for shrinkage. As the log dries, the hole will reduce in size, alleviating stress and strain as the wood shrinks, and preventing cracks.

It is sometimes possible to hollow the log from the back of an image to allow for shrinkage. This is a method employed in the past to permit unseasoned or partly seasoned wood to be used. Indeed, quite large carvings have been made in this way and, of course, this procedure lends itself well to the method of assembling.

SHIM
(*see* Waste Moulding)

Shims are made from thin gauge metal sheet and used to separate sections of mould, particularly waste mould.

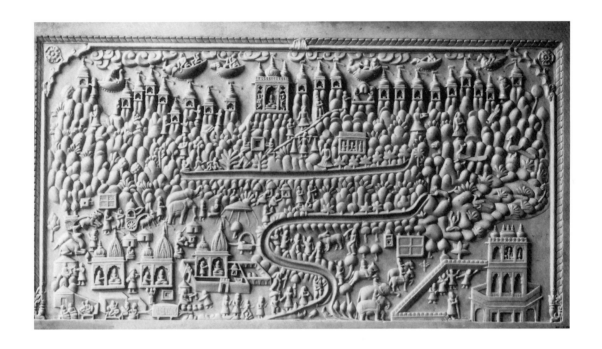

A 19th-century relief carving from Jaipur, Indian, marble. Victoria and Albert Museum, London.

SHUTTERING

Cast concrete as used in the building industry involves making moulds, mostly simple affairs but under certain circumstances very sophisticated. The earliest examples include the cast coffered ceilings of Roman architecture. The most widely used moulds today are constructed on site of wood, metal, plastic in its various forms, or combinations of these materials, and such moulds are referred to as shuttering. Most often the cavity defined by the shuttering is to make the foundation or footing for walls. Walls themselves can be castings, sometimes very complex, and this factor has given a particular identity to modern concrete building. Concrete is simply poured into place and vibrated to consolidate the mix and to make sure the fines (the smaller particles

of aggregate) settle out correctly. (It is the fines that pick up and reproduce the texture of the shuttering.) Steel reinforcing is pre-positioned, or added as the concrete is poured.

The shuttering is struck when the concrete has cured, to reveal the cast surface. Texture and sculptural embellishment can be included in the design of the shuttering (it does allow for some very elaborate work to be carried out) to become an integral part of the building's fabric. If the shuttering is dismantled shortly after the hardening cycle of the concrete setting, when the concrete is green, it can be easily carved.

This is an interesting stage at which to continue to resolve a form or surface. Although not a common practice, this is a widely used technique among those artists concerned with mural decoration, using relief and pattern embellishment. It is a welcome opportunity to work continuously on a sculpture, thus keeping the whole work fresh and under direct control. (*See Casting.*)

SILICONE, SILASTOMER, POLYURETHANE AND POLYSULPHIDE

These are all RTV (room temperature vulcanizing) compounds. Used cold, these materials allow good flexible moulds to be made with comparative ease from a wide range of solids. They are all fairly stable, enabling accurate reproduction of detail and volume, and are very widely used to make castings of all kinds (see Flexible Mould Making).

SKETCH MODEL
(*see* Bozzetto, Maquette)

SITING SCULPTURE

Siting a sculpture is an important factor when choosing a site. The happiest situation is where the sculptor is invited at the beginning of an architectural consultation to be included in the design team. This is a rare occurrence, however, and more often the artist is invited to view the site when it is nearing completion and once most architectural features are in place. The objective then is to choose a situation that best suits the image you have in mind. Some basic factors to consider are as follows:

- On exterior locations take particular note of the orientation of the site and the path of sunlight over it.
- Try to avoid close proximity to lamp-posts and bollards, and any other street furniture.
- Think about the materials being used, both structural forms and finishing surface.
- Take note of changes in height of the terrain; steps can be used to advantage and allow interesting changes in perception of the sculpture.
- Consider access to the site for transportation, placing and fixing of the work. This will mean taking into account the use of cranes or other lifting equipment and therefore the tonnage loading the

site can withstand. This is particularly important on interior sites or where a courtyard, for example, may be constructed over a basement garage.

- Take note of how high your work should be placed according to the site, which will help in designing the work and any supporting plinth or other structure.

The above factors will help in consultation with architects and civil engineers.

SLIP

A dilute mixture of clay and water with a number of uses in the sculpture studio, including as an adhesive for sticking clay to clay, a separator between plaster and clay, and plaster and concrete, or used with pigments as a surface decoration on terracotta.

SLUSH CASTING

This method of casting involves pouring the casting medium into a prepared mould. A measured amount is prepared and poured into the mould which is then rolled so that the casting medium will make an even coating over the mould surface. As the medium sets it is deposited on the mould and repeated layers will enable the casting thickness to be built up. This will of course vary according to the material. This kind of cast can be made using any of the casting mediums that set quickly – plaster of Paris, resins and waxes. The technique depends upon utilizing that stiffening of the material as it sets, to allow it to remain on the mould surface and not to drain off. Care must be taken to ensure an even build-up; hot wax, for instance, will have a tendency to wash off already deposited material from high points in the mould, so as the wax cools care should be taken to roll the mould to cover the high points. The mould surface can be painted with a first coat of material before assembly, pouring and rolling, to ensure a proper coverage of all surfaces,

Head of a Woman by Pablo Picasso, steel, outside the Civic Centre, Chicago. A fine example of fabrication from a small maquette.

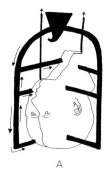

A B

A *The method of spruing for the indirect process of filling the mould. Molten metal travels to the bottom of the runner to fill the mould as it rises to ensure the flow.*

B *The direct system, when the metal flows directly into the mould cavity.*

and to build up any vulnerable high points.

Rolling the mould is a strenuous task, and large items will require rigging up lifting tackle to allow the free movement of the mould to roll. Placing the casting medium by painting and packing to build up a cast thickness is much more satisfactory. Some sculptors insist that the cast surface is crisper, too. But rolling does have its uses, especially on small items that are easily handled.

Slush casting is also the method of filling a mould with the casting medium and leaving it for long enough for the medium to settle against the sides of the mould to gradually build up a deposit. When a thick enough layer has been made, the remainder is poured off, leaving a hollow casting. Casting with clay is done in this way, and some waxes can be cast by this method, but with the danger of the remaining wax washing off some already deposited, being still warm enough to pour.

Casting achieved by this method can be very thin and even a feature of good slip casting.

SNOW AND ICE

In many people's minds snow sculpture is the ubiquitous 'snowman' – even the young Michelangelo produced a snow sculpture. There are today teams of 'snowcarvers' who travel around the world modelling and carving snow and ice. Both are obviously ephemeral materials, except when enclosed in permanent refrigeration or in the most frigid of geographical zones. Snow teams can be observed in such places as winter ski resorts, where they produce large works that stay in place for the ski season.

When compressed, snow crystals thaw a little and therefore snow can be modelled in temperatures below freezing. Thus when a ball of snow is pressed on to colder snow this slight thaw freezes again to form a solid enabling the sculptor to build up form. Some detail can be cut into a very hard compacted snow surface using sharp knives. Snow can be compacted in large moulds, made like a shuttering for concrete on a building, to form blocks which harden off when the shuttering is removed, leaving a carveable block. Any cutting tools can be utilized to carve the snow as it is a fairly user-friendly material.

The cold temperatures make snow sculptors work quickly, and the same can be said for ice carving; speed is of the essence. The principle is basic carving techniques and tools, with the added advantage of being able to repair an error. This is done by cutting out the erroneous portion and, after shaping a replacement piece of ice and putting it carefully in place, wetting both surfaces with water as you do so, waiting for it all to freeze together so that the work can continue.

SPRUE

This is the generic name for the channel that feeds and vents a mould in any kind of metal casting.

These channels are the system of runners and risers that make the pouring gate.

SPRUING UP

This is the action of designing, making and applying the network of wax rods that become the runners and risers that make the pouring gate. Spruing up is a common expression in USA foundry parlance, derived from the word 'sprue', the name for the channels that lead to and from the mould (see diagram page 197).

SQUEEZING

The method used to fix sections of mould when no access to the inside of the cast is possible. The method is to build up the casting medium at the seam edges, testing that the caps fit correctly but leaving a narrow space between the seam on the main mould and the cap. Then place fresh material on to both seam surfaces and push them together. This action will force the fresh material to bond and squeeze out any surplus.

This can be done with most castable materials, providing they can be mixed to a paste so that the filling will remain in place as the mould sections are pushed together.

STONE

Stone has been pressed into the service of man since the Stone Age. In strict chronology of the use of natural materials, stone follows clay and wood by the very nature of its hardness. Man took time over devising ways of using this abundant material but once he had mastered it stone replaced other things in many applications, toolmaking, weaponry, building, and image-making being the most common. Quarrying stone of all kinds together with all the related skills necessary to fashioning stone in the service of man, may have been the first example of man's industrial organization.

Venus of Willendorf, a prehistoric stone carving.

Any stone can be carved by one means or another to make an image; abraded or cut, pounded and polished, hammered and sawn. The best is stone fresh from the quarry, before weathering causes any kind of case hardening of the surface to occur, a failing of limestone in particular. The block of stone should be free from flaws. A flawless block of igneous rock, for instance, will ring when struck with a hammer, indicating a block free of cracks or faults. The stone should be set up for carving according to the natural lie of the bed, that is according to its natural horizontal stratification. If this bed is placed vertically the stone will eventually split; weather will

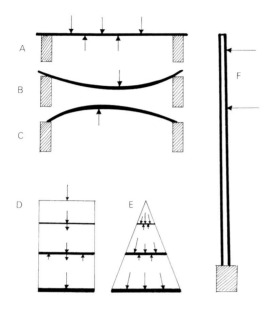

The difference between tensile and compressive strength:

A A line (form) in balance: support is equal to downward pressure, which holds the line tense.

B The result of greater downward pressure, when the line (form) will collapse.

C The reverse of B, with the line (form) making an arch or bridge, a strong supporting form.

D The compressive strength, with mass supporting mass.

E Compressive strength in pyramidal form. This configuration will enable sculptures to be built taller.

F The pressures that tall forms are most likely to suffer from.

penetrate these natural laminations between the layers of the stone, causing them to separate. The geological formation of the stone is of great importance to the carver and should be studied so as to gain the most value from the material. There are three main categories of stone – igneous, sedimentary and metamorphic rock.

Igneous rock

Rock formed by the cooling and solidifying of a subterranean molten mass as it is pushed through the earth's layers, as in volcanic eruption. Granite and basalt are perhaps the best-known igneous rocks. Obsidian is the result of the solidifying of fine particles and pumice is the solidification of the froth of volcanic eruption. Igneous rock is very hard, heavy and dense, difficult to use but most rewarding in the range of colour and high degree of polish possible, after much hard work.

Sedimentary rock

This stone results from the erosion of the earth's surface. Particles of most organic matter have been washed into valleys and plains and deposited as sediment. Soil and clay form the top layers of this bed of sediment. Deeper deposits become subject to greater compacting, which when combined with natural binding agents calcium carbonates and silicates, make a durable solid sandstone and limestone. Natural horizontal stratification is most marked in these stones.

Sandstone

A stone made up of grit particles with a high silica content, the grit deriving from crystalline rock broken down by erosion. These gritty particles, held together by a strong binding agent, can form a durable but soft stone which must be laid according to its natural bed. York grit stone, for instance, has an exceptionally hard surface and a good resistance to wear. It was once used to pave city streets and to make grindstones. In the main, sandstones are soft and easily worked but are usually suited only to being carved into a chunky kind of form.

Limestone

Formed from the sediment of calcareous material, the skeletal remains of marine life of all kinds

BELOW Royal Head, possibly Tuthmosis II of Egypt's 18th Dynasty, an example of rubbed stone sculpture.

LEFT *Queen Nefartiti*, stone. Cairo Museum.

containing calcium carbonate. Shells are a feature in coarse limestone and can present problems when carving fine detail. The finest, hardest limestones can be polished and allow relatively fine form and detail to be carved.

Chalk

The softest of the sedimentary stones.

Clunch

A slightly harder chalk.

Metamorphic rocks

Those formed from igneous and sedimentary stones that have been subjected to great heat, great pressure and consequent chemical reaction. The heat softens the stone which is then put under great pressure causing recrystallization of the stone. This process occurring under the earth's surface during volcanic movement causes this stone to appear in a number of forms, most of which are favoured by sculptors – marble, slate, alabaster and soapstone are some of them.

STONE CARVING

There are two basic methods of removing the waste stone in stone carving, abrading the stone being the oldest. By pounding at the surface of the stone it is gradually worn down to reveal the image slowly. Further careful pounding and rubbing produces the final surface which has a particular characteristic: sculptures made by this method are often softer in form and tactile, with an air of sensuality about them. Such sculptures were produced before the advent of metal tools hard enough to cut stone and include some of the finest sculptures in history, such as the marble figures from ancient Greece and the great carvings of ancient Egypt.

Various tools were used to pound and break

down the surface of the stone. Dolerite (a hard igneous stone), bronze and iron pounders were used in the form of hammers and chisels. With these tools, blows were directed straight at the stone at right angles to its surface. The resulting bruising of the stone could be rubbed away to show the form. The pounding and rubbing continued with the emphasis gradually changing to just rubbing until the image was complete. Thin slivers of hard stone with sand and water were used to draw in such detail as could be managed. Working granite today is in some respects a similar procedure, but with the aid of harder tool steel and tungste-tipped chisels. The action of bruising the stone away is the same with this hard stone.

The most common method of carving today appeared in the sculptor's repertoire with the invention of tempered iron, hardened iron that can maintain a cutting edge. It is possible to detect this point in history by studying Hellenistic Greek marble carving. In such works as the *Laocoon* it is obvious that the sculptor enjoyed a freedom of cutting that could only come from using a hard cutting tool. The forms are very intricate and refined, and could not have been made by pounding marble. Such cutting became the norm after that point in European history.

Stone carving tools

Designed for specific work, stone carving tools have evolved over the centuries and are used in a predetermined sequence by most sculptors, an order that has evolved with the tools.

Pitcher

This is used to begin roughing out the block. Striking from a flat surface, larger corners can be knocked off with comparative ease. The pitcher is struck with a pitching hammer designed to direct the maximum force to the edge of the pitcher.

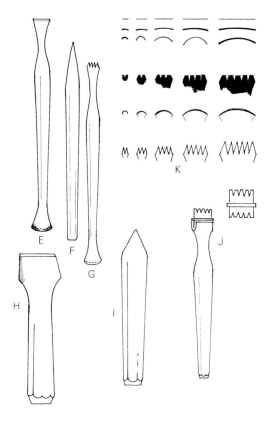

The angle of the carving tool against the surface of the stone:

A *The angle best used for cutting the stone.*

B *The angle used to bruise or stun the stone, used for very hard material and echoing the action of the bouchard.*

C *The angle of the striking face of the hammer on the chisel. You may need to grind this striking face to gain the best result.*

D *The effects on the surface of the stone of the various cutting angles.*

E *and G Mallet-headed chisels.*

F *Hammer-headed chisel.*

H *Pitching tool.*

I *A point.*

J *Adjustable claw tool.*

K *Some of the profiles of chisels and claws used by stone carvers.*

Punch or point

This is used in the next stage of roughing out. Its job is to burst the waste stone away. It is used in descending size and in varying degrees of weight according to the stone being carved, and the finesse desired. An experienced sculptor can carve close to a finished surface using just the point. A punch is usually a thick stubby tool used on granite and on hard coarse stone. Those points used on marble are slender tools of a harder temper. Points and punches used on limestones range between these two extremes.

Claw

Use of the claw follows the point. A broad chisel shape with teeth along the cutting edge, it is used to define the form by drawing it. The claw leaves a

Three Standing Women by Henry Moore, Darley Dale Stone, 1947–8. The effects of the carving tools can be seen here, illustrating the progress from stone block to sculpture.

cross-hatched texture on the stone; this texture breaks the light falling on the surface of the stone, enabling the form to be more easily read. Various sizes are used according to the nature of the stone and the degree of detail required by the sculptor.

Chisel

A cutting tool used to clarify the form, to cut in detail and to make final sharp statements. Used in diminishing sizes, the finest detail can be cut. Chisels

with tungsten tips are now commonly used on most stones. They are expensive and require care, but do give a special, constant sharp cutting edge.

There are powered variations of all these tools made for particular applications; mostly they are adaptations to fit mechanical processes, such as electric and pneumatic flexible shafts. These are machines designed to deliver power to hammer the points, punches, claws and chisels, in a rapid staccato rhythm. They are now widely used by masons and sculptors right through to polishing a surface with a suitable adaptor.

The imprint of each carving tool has to be experienced by carving. The feel of the tool and the stone is a combination of sensory responses that

Three Standing Women by Henry Moore, Darley Dale Stone, 1947–8. The carving process has progressed and now shows the upper parts of the figures.

cannot be substituted. As experience builds up, the study of great work becomes more meaningful, so as you practise carving, look also at the work of others. Read the progress of the point, claw and chisel in the work of Michelangelo, for example; they are all detectable. Don't forget to look at the image and the use of the stone at the same time.

Keep all tools sharp; a grindstone is essential and a piece of grit stone kept handy as you work will encourage you to maintain a sharp edge. A special green grit sharpening stone is required to keep an edge on tungsten-tipped tools; the tungsten is too hard for ordinary sharpening stone (see Tempering).

Hammers

The manual means of applying punching power to the carving tools. Hammers are made in a number of patterns, designed for specific jobs. The angle of the striking face is important on all hammers and should be tailored to suit the individual. The hammer face should hit the chisel head squarely, directing the impact straight down the shaft to the cutting edge. Iron-headed or lump hammers wear according to their user's hand, and become as individual as fountain pens; carvers will seldom allow another person to use a favoured hammer.

Bouchard

This hammer is of particular interest being the modern equivalent to the dolerite pounder of the ancient Egyptians. It is a slender hammer with rows of pointed teeth on the two striking faces. The teeth are bounced on the stone surface, at right angles to it, bruising and powdering the stone. Bouchards are made with coarse or fine teeth and do impart a particular quality to the form. They can, however, be over-used resulting in very soft forms. Bouchard-ended chisels are also now available, usually made for use with power equipment, and referred to as a bush hammer.

Stone particles are harmful, and should be brushed from the surface being worked. Try to resist blowing; if you are tempted to use an air line to blow away the dust make sure you are wearing a face mask.

Learning to carve, using the various tools, has to be done the hard way, bruised thumbs and all. It is very much a hands-on experience. There are, however, some practical points common to all carving activities.

Having selected the material, defined the block and the image contained within it, you need to set up the stone. Moving heavy weights is an occupational hazard for sculptors, obvious in the case of large blocks of stone or wood but ever present in the studio. Illustrated on the next pages are some practical aids to moving work.

The work has to be set up to make it secure to carve. I have illustrated some methods for holding small items to be carved, including the simplest devices of a sand box, a sand-filled bag and the advantages offered by slabs of polyurethane foam. Larger, intermediary blocks should be fixed more securely with baulks of timber or plaster of Paris while large monoliths dictate their own position.

LEFT *Three Standing Women* by Henry Moore, Darley Dale Stone, 1947–8. The completed sculptures, which are now in Battersea Park, London.

All carvings should be dressed at the base to make sure the stone stands correctly in relation to the final image. Lead inserted beneath large stone blocks will seat the stone, allowing it to settle, and will provide a buffer against hammer shock. The vibration caused during carving, particularly with power tools, must be considered and, according to the type of stone, this will dictate to some degree the sequence of carving. Dense igneous stone can build up oscillations that will focus on the weakest form, causing it to crack at that point, so beware!

Carving is not a speedy process; allow the tools you are using to dictate their own pace and rhythm. Always carve away from the mass; this is more effective and less tiring. Remove the waste material in small pieces rather than being tempted to break off large lumps. You will retain greater control in this way. Wield the hammer in a steady rhythm; carving is usually a day-long activity and furious attacks on the stone will seem only to be repelled by it, resulting in quick fatigue. Let the weight of the hammer do the work, and take care in selecting the best hammer for the work in hand. Identify your own rhythm and sustain your energy; direct it at removing the waste. A measured pace will enable you to think the form through as you carve and reveal the image.

Splitting stone

This can be done by cutting a groove around the stone, leaving a generous allowance clear of the image, and then striking against the waste with a heavy wooden mallet. The stone will break at the cut. It is a skill requiring some practice on small blocks and slabs

Feathers and wedges

Items of equipment that aid the splitting of stone, and enable the carver to deal with large blocks. They can be used to remove large sections of

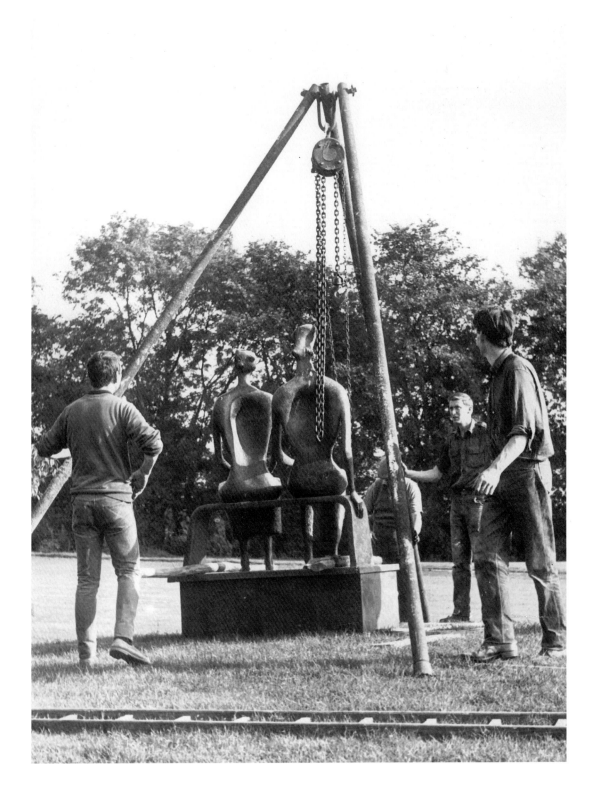

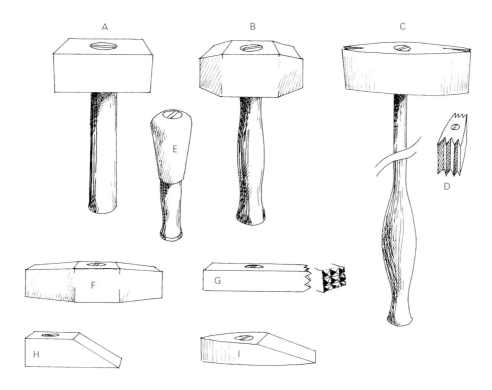

A *Lump hammer*
B *Carving hammer*
C *Granite hammer or axe*
D *Granite hammer with multiple striking edges*
E *Dolly, or dummy, hammer*
F *Pitching hammer used to strike the pitcher*
G *Bouchard*
H *Pitching hammer used directly on the stone*
I *Another version of the pitching hammer*

waste material prior to using the punch for roughing out. Care must be taken, however, to make a good allowance for clearance to carve up to the image.

To use, drill a line of holes across a block of stone or around an area to be removed, and insert the wedges with metal sheaths (feathers). These are then systematically struck with a hammer until the stone splits: the wedges are driven deep into the stone forcing the sections to crack apart.

The depth the wedge has to be driven is dictated by the density of the stone. Granite requires only shallow drilling, marble needs drilling deeper and limestone deeper still. Sandstone has to be drilled to almost two-thirds the depth of the block, and is probably better sawn (see Stonesaws).

LEFT The positioning of a Henry Moore sculpture with the use of Weston block and tackle.

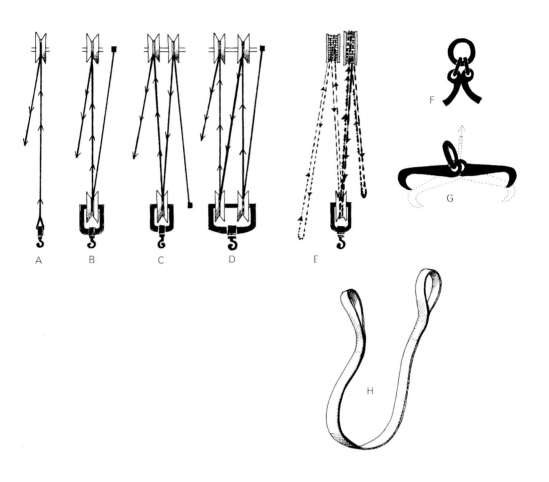

The principle of lifting weights with pulleys:

A The simple single pulley, suitable for light
 work. As the weight increases, so the
 number of single pulleys needed increases,
 and the lifting capacity can be calculated
 roughly by multiplying by the number of
 pulleys used.

B can lift twice the load of A.

C can lift three times the load of A.

D can lift four times the load of A.

E A Weston block and tackle, probably the most
 common lifting tackle in sculpture studios.

F and G Two kinds of grabs used in lifting
 stones. Both function by being inserted into a
 hole cut into the block and expanding or
 grabbing tightly as the device is lifted.

H Webbing sling used to wrap round objects to
 lift them safely when using a crane.

STONESAWS

Useful on limestone and sandstones, these are
variations on the traditional cross-cut and tenon
saws. They are coarsely set to cut in both directions,
on the push and on the pull strokes.

Saws are now available with tungsten-tipped
teeth. Power disc saws with a wide range of size
and type of cutting disc are used a great deal today
and can help to make light work of removing waste
material from most varieties of stone. Used with
due care, these machines are a great aid, but as with
all power tools they bring with them their own
hazard potential. Take care when using them. Do
wear protective clothing, particularly goggles and a
gauze mask.

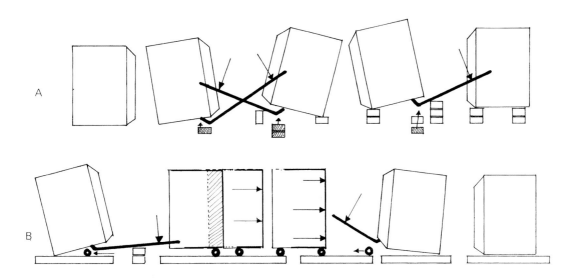

ABOVE
A Using crow bars and wooden blocks to lift a
 heavy weight in a vertical direction.
B Moving a weight along a horizontal plane
 using rollers (either metal or wooden).

BELOW
Methods of securing stone to facilitate carving:
A and B The stone fixed by a frame of wooden
 battens screwed down to a base board.
C Plaster of Paris and scrim (burlap/hemp) can
 be used to hold the stone securely.
D The stone settled into a sand box, which
 cushions the stone but allows it to be turned
 during carving.
E A sand bag, used to cushion the stone to
 facilitate carving and retain mobility.
F The stone must be dressed to stand vertical if
 carving a vertical form or figure.

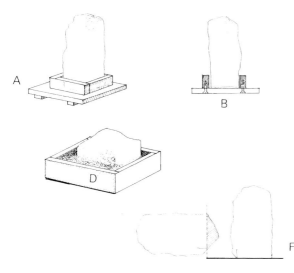

SQUARING UP
(*see* Enlarging *or* Scaling Up)

The process of imposing a calibrated grid over a subject, most commonly carried out by drawing the grid over a two-dimensional image. By relating this drawn grid to another calibrated grid, either larger or smaller, the subject can be proportionally enlarged or reduced.

SYNTHETIC CLAYS

These clays can be produced to counteract adverse conditions such as freezing, and can be left uncovered. This may be an advantage, for instance, if you have a large sculpture to be modelled for which you cannot use water-based clay, with all its attendant problems of moisture control, etc. These artificial clays can be produced in the studio, but they are also available ready made and come in a wide variety as to colour, consistency and hardening or non-hardening properties. The self-hardening synthetic clays are relatively easy to use, requiring an armature if slender forms are to be made. They are commonly used for small work. Non-toxic varieties are produced, suitable for working with children, but in the main they are too expensive to use on a large scale.

The artificial non-hardening clays used in bulk by sculptors, some made from mixtures of dry clay and wax with oil mixed, bring with them problems different from those of water-based clay. No allowance can be made for the swelling of wood included in an armature, so these structures need to be built in such a way as always to support the dead weight of the clay. The bulk of the armature will have to be greater than normal to reduce the effect of this weight. Also, as the clay is always soft it offers no resistance when you add fresh clay to a form. The advantage of modelling soft forms over hard clay to exploit the difference will not exist. Modelling techniques will necessarily have to be modified to cope with this factor; experiment for yourself.

TEMPERING

The art of hardening steel to make tools for cutting, as in carving tools of all kinds, and for making matting tools to be used for chasing metal surfaces. I call it an art because it requires a good eye and a good sense of form and colour.

The working end of the tool is made red hot and quickly plunged into cold water. This will draw out any residual uneven hardness in the metal, resulting from previous tempering or from forging to make the shape. The metal will now be uniformly hard but too brittle to work with, and so will require modifying to gain the correct degree of hardness at the cutting edge. This will vary according to the work the tool is required to do. For instance, marble carving tools need a slightly harder temper than those used to carve sandstone.

The correct cutting edge is achieved by first cleaning the steel with emery cloth to a bright surface, and then heating it slowly. Colour changes will be observed as the metal is heated, indicating the changes in the hardness as the molecular structure of the metal adjusts itself. The colour will change as follows: first a pale straw colour will show, followed by a darker straw, to be followed by brown (bronze colour), then violet will appear, changing to blue then to dull red. The dull red indicates no cutting hardness and the pale straw corresponds to the hardest temper.

Using gas heat such as oxy-acetylene or propane, the points of a tool can be tempered simply by heating the top 100mm (2in) to cherry-red heat, then quickly polishing it with emery cloth; the tempering colour will show as heat travels to the cutting edge from the shank of the tool. When the desired colour reaches the working edge, quickly plunge the tool in water to arrest the process.

Do not overheat the metal; white heat will burn the metal and it will be ruined. Try always to do any

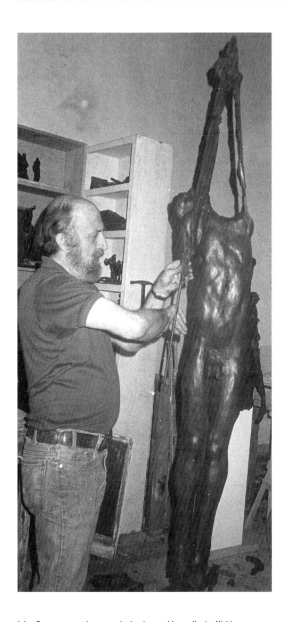

John Pappas at work on synthetic clay at his studio in Michigan.

tempering in natural light so as to gauge accurately the colour changes, to gain the correct hardness.

TEMPLATE

The pattern or gauge that acts as a guide for cutting, drilling or locating a sculpture or components in their correct position, either on a base or in relation to other pieces. Usually made of sheet material, the template should be stable, allowing for little or no distortion, to ensure a high degree of accuracy. The template is of vital importance when fixing a large sculpture *in situ*, especially if site contractors are being used. It is wise practice to get used to making templates as a matter of course for all manner of locating, adjusting and accurately fixing work to the best effect. A template is often a contractual requirement for a commission.

Templates can be used to aid enlarging a subject by cutting a form into slices and proportionally enlarging each slice.

TERRACOTTA

The word means 'baked earth' and it is the general heading under which all fired clay items are listed. A material nearly as old as man, it has been used by him to fashion all manner of artefacts and images (see illustration page 216).

Green (unbaked) clay, if stored carefully, can last for many years. In use, however, it is vulnerable and fragile, liable to dust away, and if it is made wet it will quickly crumble. The answer therefore is to make the clay a stable material by baking. It will become hard and durable and able to withstand most climates. Baking or firing clay produces a wide range of qualities varying in colour and degrees of hardness.

Minerals and oxides inherent in the clay body or applied to its surface can affect its colour, its durability and its resistance to weathering. Such factors are incorporated into the wide variety of clay bodies used by ceramicists. All their glazes and pigments as well as clays are available to the sculptor, and close collaboration with a potter can open up a new world of possibilities.

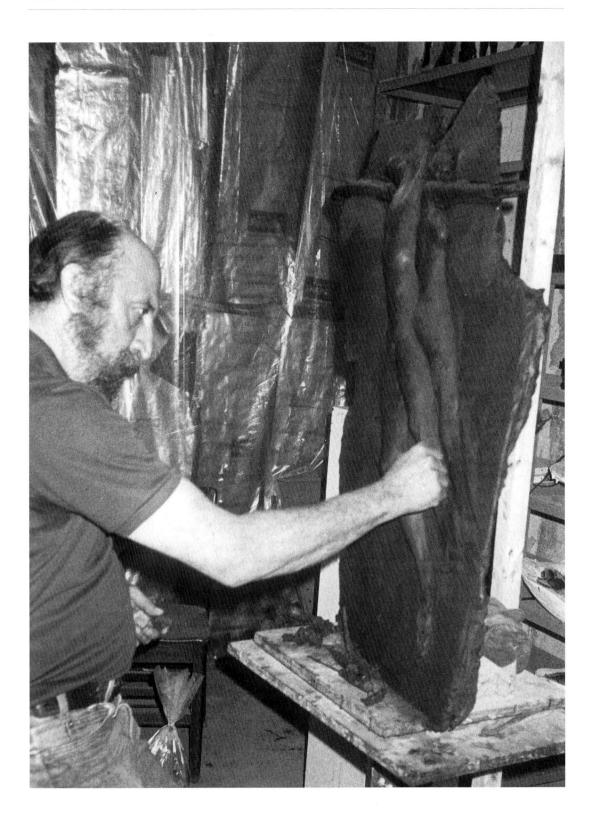

LEFT and ABOVE *Lovers*, work in progress by John Pappas, synthetic
clay.

Hellenistic Greek terracotta mould and cast. British Museum, London.

Earthenware

The most common form of terracotta employed by sculptors, earthernware is the result of a clay body that fires at a temperature of up to 1100°C. It is a porous, somewhat soft fired clay substance.

Stoneware

On the other hand stoneware is a hard non-porous fired clay baked at temperatures of up to 1400°C. If tapped, it will give a very satisfactory ring – a dull thud will be all that earthenware vessels will give out if tapped. If an earthenware body is fired at stoneware temperatures the clay will melt during the firing and often the shape will collapse.

Porcelain and china

These clays are rarely used by sculptors, being more often the domain of the pottery modeller. They can be modelled but are mostly cast to make fine translucent objects (see Piece Moulding).

All clay used to make terracotta must be clean, free of any foreign bodies that will react

unfavourably when subjected to heat and explode. This is a problem in sculptors' studios using a wide range of materials and processes. If small particles of plaster become trapped in the clay, they will expand and split during firing, making holes at least, or, if a large piece is trapped, even splitting the whole sculpture. It is a wise precaution therefore to store clay for terracotta away from any other substance likely to contaminate it.

To a basic sedimentary or secondary clay you can add various other substances to achieve particular qualities of colour, surface texture, etc. Experiment before starting work on a special project, however. During research take notice of industrial clay products and their accompanying processes. Some manufacturers are willing to permit sculptors into their works to exploit a particular clay or process. The equipment available in such instances is usually greater than anything the individual could afford himself. Inform yourself about such concerns as brickfields and manufacturers of industrial ceramic ware, including pipe extrusions.

Sand

Added to clay, sand will enhance the refractory nature of the body, enabling it to withstand slightly higher temperatures, and prevent warping.

Coarse sand

If applied to a wet clay surface, this will give an open, granular effect.

Flint

Include this in a clay mix to impart a certain whiteness and allow a higher firing temperature.

Kaolin/china clay

Increases the clay's rigidity and tensile strength, and makes it more plastic to work.

Ball clay

Has a large percentage of organic material present which, when mixed with other clay bodies, increases their plasticity. It is white when baked.

Bentonite

Added to clay, bentonite makes the mix more workable, increasing its plasticity. It can also be mixed with sand as a binder.

Grog

This is ground ceramic which, added to clay, raises its firing temperature to make the clay more stable. Added in large mesh size and in high proportion (up to 50 per cent) the resulting coarse clay will suit very bold, large work.

Lightweight inorganic materials that burn at lower than the proposed firing temperature can be added to the clay to give it bulk, making a thicker wall possible, an important factor when building large-scale sculptures.

No matter what you mix to make the satisfactory clay body, make sure the whole batch is prepared at once, so that there is an even consistency and quality throughout the sculpture. Make sure the clay is well consolidated. It should be wedged and kneaded.

This is the process of pounding the clay on the thick plaster or marble slab (it should be porous) in order to eliminate air pockets and achieve a uniform, even consistency through the batch.

VACUUM FORMING

A method of using thermoplastic materials in sheet form, using a machine that softens the material by heating, then by means of a vacuum sucks the heat-softened sheet over a pre-formed pattern. On cooling, the thermoplastic hardens and retains the impression of the pattern.

This process can be used to produce final forms, indeed it has become a part of the growing number of processes included in print editions because of the ability to produce a long run of identical items. It can be used also to make moulds from which castings can be made.

WARNING COAT

This is the coloured plaster used to make the first coat of a waste mould, and its function is to warn the sculptor that the cast surface is close so he can take care. It is essential if the material of the casting is fragile or is of the same colour as the mould; when the cast is of plaster then the warning coat is a vital feature of the waste mould. Any colouring agent (water-based, of course) used to make this warning coat should be tested to make sure it is compatible with the plaster; some colouring materials can kill the plaster.

WASTE MOULD

This is a mould that is made waste, chipped or peeled from the casting, allowing only one impression to be made. Waste moulds are commonly made from plaster of Paris, but wax or clay can be used, according to the nature of the original and the quality of the casting required. Henry Moore, for example, made simple clay waste moulds from found objects, such as stones or bones, and from these moulds he produced simple plaster casts that he would shape and change, carve and modify to explore and form an image. The quality of the castings as faithful reproductions was unimportant; the techniquewas facile and quick.

WASTE MOULDING

All moulds are made in sections, to allow removal from the original pattern, access to prepare the mould and make the casting, and where appropriate, removal of the mould carefully from the cast. The divisions (seams) of a plaster waste mould are made using either clay walls, or metal shim. Clay is the most available, and some sculptors say the seams can be made finer than with shim, being only as thick as the parting agent/separator used between sections of plaster mould. The finer the seam the more accurate the reproduction of the original volume.

Clay wall

Clay wall seams are made by making flat clay strips about 15mm (½in) thick. This helps to determine the thickness of the mould.

Mark a line on the original pattern, defining the main mould and section, then place the clay strips along the line. It is usual to make the main section of mould first. Support the clay with small buttresses on the side away from the seam face, which must be made as smooth as possible and given the correct slope to prevent locking sections. Where the seam face is in contact with the surface of the original, as fine a line as possible must be made. Next carefully place plaster of Paris, coloured if a warning coat is required, against the smooth seam face and over the surface of the planned section of sculpture being moulded. (Any reinforcing required is placed during this plaster build-up.) When this section is completed and the plaster hardened, remove the clay wall, cut keys or registers into the revealed plaster seam wall and apply an appropriate parting/release agent. One section of mould is now complete.

Make the next section in the same way, building further clay walls if more than two pieces are required. If not, simply make the remaining mould section, placing plaster over the sculpture surface and against the plaster wall of the first seam. Model the plaster at the seam to make a continuous raised band. Scrape the join where the seams meet to reveal the fine lines of the parting agent.

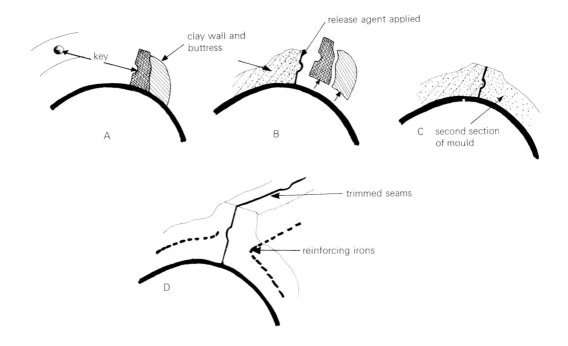

A A section through the clay wall used to make the divisions of a plaster mould.
B When the first section is complete, the clay wall and support is removed and a parting agent applied to the seam surface.
C The second section complete and the seam trimmed off.
D The seam carefully trimmed to reveal the thin line of release agent. Reinforcing in place as close to the seam as possible to give maximum strength.

Metal shim

Metal fencing (shim) divisions of the mould can only be made from clay, preferably without grog which will prevent the metal shim from being pushed securely into the clay. Brass shim is most commonly used, but any non-ferrous metal sheet of about 0.127mm (¹⁄₅₀₀₀in) can be used. This is cut into strips of about 50–75mm (2–3in) long by 15mm (½in) wide. The width can vary according to the size of the mould being made, and the plaster thickness required. Waste mould thickness is best kept to a minimum, to protect the casting when the mould is broken away. Properly reinforced, no mould need be thicker than 25–50mm (1–2in).

Draw lines in the clay with a fine pointed blade, to compose the sections of the mould. Place the shim along these lines to make a continuous wall, with as little overlap as possible. Try to maintain only the thickness of the metal shim. Push the shim fencing securely into the clay, leaving a projection equal to the proposed mould thickness. The metal shim will need to be able to withstand some force as the plaster of Paris is applied. The top edge of the wall must be even, with no sharp projections. Tailor the shim with sharp scissors or shears to make as neat and tidy a job as you can. Remember, the all-round

accuracy of the casting depends to a large degree on precise seam making (see diagram, page 219). Pay attention to the connecting point of caps and main mould. Try to avoid slender shapes that will easily break as the mould is being handled through many procedures.

Make sure that horizontal seams slope correctly so that they do not lock, making it impossible to open the mould.

When all the fencing is in place and thoroughly checked, apply the plaster to make the mould. Do this by covering the entire sculpture surface with plaster. The first layer should be coloured. This acts as a warning that the cast surface is close when chipping out (an essential feature if the casting is of plaster of Paris or is the same colour as the plaster). After each application of plaster, scrape the top edges of the shim wall. The reason for making an even top edge is now evident. This needs to be revealed all the time so that seams can be properly located and reinforced. Continue building up with plaster until the required mould thickness, including any metal reinforcing, is achieved. The metal shim projection provides a sensible guide to work to when building the mould thickness.

The mould at the seams should appear as a flat band following the brass fencing, with at least 15mm (½in) on each side. This will ensure that you have a strong seam edge, necessary to prise open the mould.

Building up the plaster thickness over the entire sculpture, with clay wall or shim fencing divisions is a skill that can only be acquired with practice. It is possible to do it quickly after some experience but it is never wise to rush mould making. Some sculptors brush on the first coat of plaster, often the warning coat if the casting is plaster or the same colour as the mould. This can be a

hazardous process, liable to affect any soft clay surface. It is more usual to throw the plaster against the sculpture with a flicking action. By dipping the fingers into the plaster enough material can be scooped up to flick on to the surface so that it stays on the sculpture and doesn't bounce off. The flick to throw the plaster is done simply by directing the fingers, knuckles first, towards the clay – not too hard. Throwing enables the mould maker to cover the sculpture quickly and easily. Also, the force of the action presses the plaster into any detail. Any air pockets can be detected and dealt with by blowing or piercing. Start to build the mould from the bottom of the work and proceed up and around. This will avoid plaster running down over projections, which increases the risk of creating air pockets below.

Place metal reinforcing as the plaster build-up is made; it should as far as possible be contained within the plaster thickness. Support for large main moulds is built as part of the mould build-up also (see Reinforcing).

When the mould is complete and the plaster has hardened, remove the caps. Do this by pouring water on to the seams – identified by the revealed fencing (metal shim) or parting agent (clay wall) – and inserting a plaster knife. These two actions will help break the suction between the mould and the clay caused by the hardening of the plaster.

Then, by gently levering the knife, the caps can be removed. Each cap should be propped on edge, and not laid flat, to prevent warping.

When all the caps are off, the metal shim, if used, can be collected up and stored for another time. The clay and armature is also removed and stored. Check the mould surface for blemishes, air bubbles, cracks, etc., and make good. The mould is now ready to be prepared and filled to make the casting.

WAX

As a naturally occurring malleable and castable material, wax has been used by man, almost as long as mud or clay, since he began harvesting honey in fact. Unlike clay, wax at a fairly low temperature is liquid when hot, soft when warm, becoming hard, although brittle, on cooling, and able to retain its shape and volume. This characteristic indicates its wide potential as an expressive medium.

Many formulas exist for preparing suitable waxes for sculpture. Some are simple modifications of beeswax, others are bizarre concoctions and often result in strange substances. The refining of oil has produced a number of by-products, and one of these is micro-crystalline wax. This is a very pure wax, manufactured for industrial application in a range of blends, providing wax of varying degrees of hardness, pliability and colour suitable for most sculptural applications.

Wax sculptures, although vulnerable because of their susceptibility to heat and their fragility, have always been made. Indeed pigmented wax preceded coloured resins in the depiction of super realism. Anatomical dissection was accurately recorded thus, and the technique used for this was applied to sculpture, culminating in Madame Tussaud's and other wax museums.

The most common use of wax is as a pattern-making medium incorporated in the lost wax or *cire perdue* bronze-casting process. For this a wax sculpture, or replica of a sculpture, is encased in a refractory mould and placed in a kiln which is then heated. The wax becomes molten and runs out of the mould, leaving a cavity into which molten metal is poured, thus reproducing the original wax pattern (*see* Casting).

Preparation

The preparation of the wax is important. It can be bought in pre-determined degrees of hardness

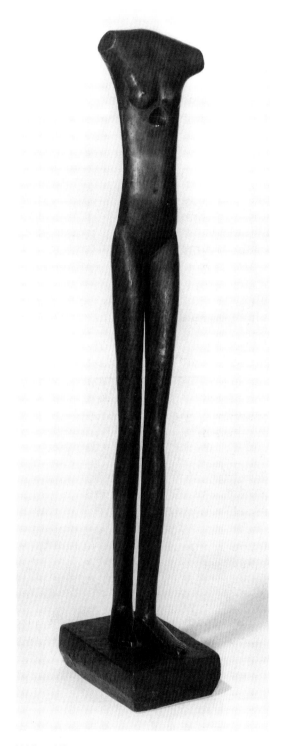

Walking Woman by Alberto Giacometti, bronze, 1932–34.

and softness. If a wax needs to be made softer, however, you can do this by adding to molten wax a proportion of pure petroleum jelly, up to 25 per cent; alternatively, a heavy, clean engine oil can be added, in the same proportion. To harden a too-soft wax add a small amount of amber rosin, but not more than 20 per cent or the wax will become very brittle.

To melt the wax use a metal vessel – a saucepan, bucket or small galvanized bath. Electric deep-frying pans or electric boilers fitted with thermostatic controls are also very useful. The vessel you use depends largely on the volume of form to be dealt with. Place it over a low heat. Some people prefer to cushion the vessel in which the wax is melted by placing it in a second vessel containing water, which slows the melting of the wax considerably. This method, though slower, is safer, as large amounts of wax, when melted over a direct heat, melt from the bottom, and can build up pockets of air, which expand to burst eventually through the cooler upper levels of wax. This causes the molten wax to spurt, which can be dangerous, especially in a class or workshop. To avoid this, either cushion the vessel in which the wax is melting, or push a heated metal rod through the wax to make an airway for expanding pressure to escape. Cushioning the melting vessel causes the wax to melt from the sides and avoids a pressure build-up. Be very careful of molten wax; it can cause a nasty burn.

Wax is made to a whole range of formulas to suit various industrial applications, dentistry, jewellery, etc., and suppliers will be willing to advise on these, and even make wax to order for specific jobs. The most widely used wax today, however, is microcrystalline wax. This can be softened by adding oil or petroleum jelly, and hardened by adding rosin. Both of these additives have their uses

and should be experimented with, but the wax softened with oil is usually too sticky to model with any pleasure. By keeping wax sheet, strip or rods under a low black heat, it can be made soft enough to model easily. When cool, the wax will regain its stability and can be made self-supporting; experiment with it. Depending on the ambient working temperature, micro-crystalline wax will maintain a stretched form quite well, and so will support the additive process of modelling. It is most useful in making small solid sculptures, hand-held, up to about 35cm (14in), to be subsequently cast directly in metal.

Hollow wax forms

Hollow wax forms can be made directly as follows. Make a rough clay volume, dip this in molten wax a number of times to build up an even layer of about 2mm (³⁄₃₂in). Let the wax harden, cut through it with a hot thin blade, remove the clay and clean the hollow sections, then dry these sections and weld them together using a hot metal tool. The hollow form thus achieved can be used to make a sculpture to be cast directly in metal or as a mould. By adding wax to the surface the sculpture can be elaborated making particular surfaces and detail. By dipping the whole piece in molten wax quickly, such modelling can be fixed, putting a range of textured and smooth surfaces at the sculptor's disposal.

The hollow wax forms can be filled with a refractory core material ready for bronze casting, or of course the core can be fashioned first, in place of the clay, and left in. This is basically the method used by the ancients and described so graphically by Cellini. The bronze casters of Benin also used this method for modelling with wax prior to bronze casting; it is known as the pre-determined core method.

Hot metal tools are used by sculptors to help with modelling. A spirit lamp is the most useful means of achieving this. Modified electric soldering

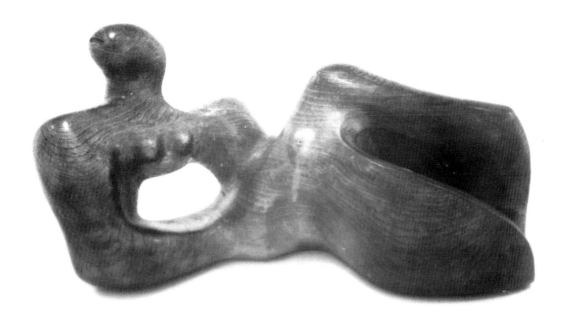

Reclining Figure by Henry Moore, elm wood, 1945–46.

irons are a handy aid also, giving a constant hot welding tool. Old worn rifflers make good modelling tools to be heated with a flame in this way, a spirit (alcohol) flame, gas, or a fire.

Moulding

Wax is a useful and often expedient moulding material. It was used as such extensively by Victorian sculptors to make castings from delicate clay forms, that would not withstand clay wall or metal shim moulding. Modern micro-crystalline wax is excellent for such mould making, providing us with a versatile pure material of varying degrees of hardness. The original, according to its size and complexity, is covered with a layer of wax. This can be done by repeated dipping in a bath of molten wax, or by painting the wax on to the clay. The build-up in each case needs to be about 12mm (½in) thick. Of course, very small castings can be

made using a lesser wall thickness, but it needs to be evenly layered. Open the mould by simply cutting through the wax with a sharp, pointed blade, and carefully prising the sections apart. Water will help this. The clay can then be removed, the mould cleaned and made ready for filling. Large wax moulds can be made; I have seen life-size figures moulded in this way, reinforcing being done with metal or timber included in the wax build-up and held securely with gauze bandage or jute scrim (hemp/burlap) dipped in molten wax.

Dried clay images can be moulded with wax by dipping or painting to build up the mould thickness. When the mould is complete and caps defined by cutting through, place the whole assembly in water. This will dissolve the clay, leaving easily manageable mould sections. Seal these mould sections ready for filling by welding the caps in place with a heated metal spatula, followed by painting hot wax over the seam to give greater security. Treat larger moulds in the same way as any waste mould (see Fillers).

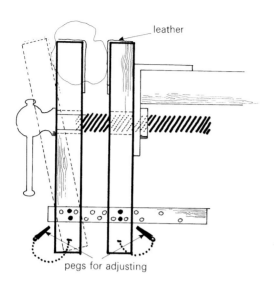

leather

pegs for adjusting

A studio-made adjustable vice, devised by Michael Gillespie, to hold objects of diverse shape and size. It can be made free-standing or attached to a work bench. The gripping surfaces should be shielded with leather.

The wax mould is easily removed from the casting by gently warming it to soften the wax, which can be carefully peeled off, offering no shock to the casting caused by chipping or levering. Some material develops exothermic heat as it sets up. This heat will soften the wax also, enabling it to be peeled off easily. Materials such as plaster of Paris, and some resins, can be used like this.

WET MIX

This term describes the technique and the nature of the concrete mix when water has been added, and the process of hydration begins. The consistency of the wet mix is in part dictated by what use it is intended for, be it casting concrete in various ways or building a sculpture directly over an armature. Pay attention to the basic rules for mixing concrete, however. Work out the correct ratio of aggregate to cement, and water relative to aggregate size and cement content (see Concrete Mixing).

WOOD

In its many forms wood is a very basic natural medium, the material that has always aided man. Using fire at first, then with stone, later with complete freedom after the invention of metal tools, wood has been fashioned by man into all manner of utensils, shelters, weapons, boats, toys, images of deity and for items of personal adornment. It is still a much-loved and much-used material.

Timber by its nature allows the sculptor to explore forms that require tensile strength. The fibrous nature of wood makes it possible to make elongated, slender forms, shapes not possible in stone. Wood therefore encourages a more adventurous attitude, and a wider disposition of line and volume. The ease with which wood can be added to wood extends even further the range of possibilities available to the sculptor. Assemblages of wood have become common in sculpture today: it is not unusual to see large works made from an assemblage of small and dissimilar pieces of timber. All timber products are now pressed into service in this way, proving it is possible to use any wood from any source to make an image.

Carving is the purest sculptural use of wood, but, no matter how wood is used, a certain knowledge of the material is desirable. All timber can be used but some woods are more suitable for carving than others. Over the ages the commercial exploitation of timber has resulted

RIGHT Japanese statuette in wood from the 7th century AD.

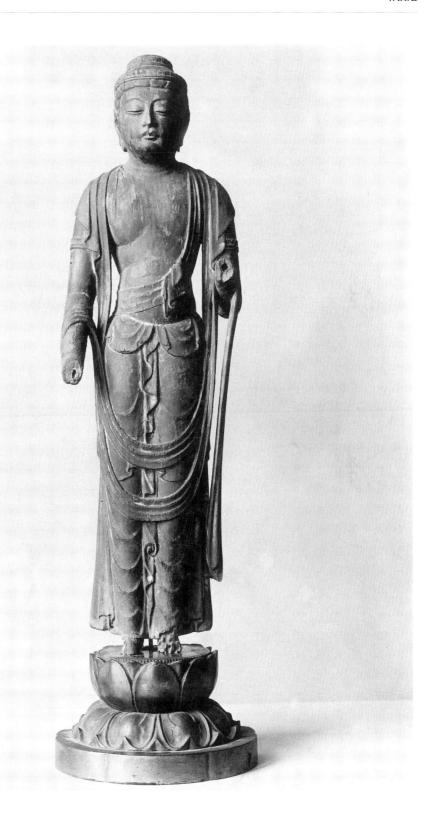

in two categories, the hardwoods and the softwoods. These titles do not refer to the degree of hardness of wood: hardwood comes from deciduous trees and softwood from conifers. In the main, hardwoods are the timbers most favoured by sculptors and other woodworkers.

Timber is widely available from a host of sources, such as builders' suppliers, timber merchants and tree surgeons. Demolition contractors and furniture restorers may also be worth approaching to find useful material. The wood-carver should be on the lookout for choice timber all the time, to build up a good store.

Green wood can be carved but there is an element of risk. Once timber has been felled, its natural moisture content, cell water, dries out. This drying causes the wood to shrink around the heart of the log and to crack. Seasoning is the controlled drying of the timber to gain an even moisture content (see Seasoning). If you carve green timber you need to remove as much of the heart wood as possible to reduce the effects of shrinkage as the wood dries. Henry Moore practised this on his large elm carvings. These were mostly carved green so the image was designed to pierce the heartwood to reduce shrinkage. In this way he both overcame the problem of seasoning and enhanced the hole as a significant form in sculpture.

Wood is always susceptible to atmospheric changes. Temperature and humidity affect it and it is important to remember this when selecting timber for a particular project. It may be wise to try to acclimatize the proposed wood, placing it in the same or a similar environment to the one it will finally occupy.

Woodcarving

Like stone carving this is easily comprehended but requires long practice. It is possible to fashion an image from a small piece of wood using just a sharp knife (whittling) but larger work needs care in setting up, so that the log can be considered and the image defined within the log, and then the wood made secure so that it can be carved safely. Tribal carvers often hold the log between their legs or resting in their lap, methods obviously available to every sculptor. The weight of large logs can be used to gain stability, and with the use of chocks (wedges) they can be held in the correct position for the artist to work, the log being turned so that the whole image can be carved. Smaller items can be secured to a carving bench by means of a vice, a bench screw or bench vice, and by means of clamps of various kinds. The vice illustrated (page 224) is a studio-made adjustable vice devised by Michael Gillespie to hold objects of diverse shape and size. It can be made free-standing or attached to a workbench. The main drive is from a large joiner's vice. The jaws are opened according to the work in hand and made of wood, with the gripping surfaces shielded with leather. The adjustment is made via the pierced and pegged rod at the base.

Carving progresses from roughing out with the saw, axe or adze, to defining the form using gouges in descending order of shape and size, finishing with the shallowest gouge, before proceeding to the flat chisel, if required. The rasp, riffler and sandpaper follow, according to the image and surface required.

As with all carving, direct your tools away from the mass. The objective is to remove efficiently the waste material, so cut with and at an angle to the grain, and away from the mass. Do not be tempted to take too big a cut, and always work within the wings of the gouge. Do not bury the gouge in the wood – it will simply break. Choose the correct mallet for the work in hand and allow the weight of the mallet to do the work. Establish and maintain a personal working rhythm. Some

The axe:
A *The axe shapes most favoured by carvers, available in all sizes.*
B *Axe handles; the best are made of hickory wood.*
C *The wedge, the best means of securing the axe head to the handle, as used on hammers and adzes.*

carvers philosophize over the nature of carving: 'remember it has taken many years for this timber to grow and many thousands for this stone to develop, so why rush to carve it?'

Tools

As with all tools these have evolved over generations and include all the sharp cutting and scraping instruments common to wood working. Direct carving is done using axe, adze, saw gouges and chisels (see diagrams above and pages 228–229).

Axe

Together with the saw, the axe is the tool used to fell timber as well as to split and shape it. It is basically a wedge with a hard sharp edge mounted on a wooden handle. Axes are made in various sizes to suit a wide range of uses. Wedges are often used in conjunction with an axe to split timber.

Adze

A development of the axe. The blade is held horizontal to the handle, and by swinging the blade wood is shaved from the log. They are made in a range of sizes; indeed it is a simple task to make an adze from a fork of a branch, cut to hold a metal

A.

B

blade that can be fashioned from broken tools, knives, hacksaws, etc. (see diagram above). Some tribal sculptures are made using only the adze, and show clearly how this tool can be used to carry out the whole process from dressing the log to carving relatively fine detail.

Saw

Along with the axe, the tool most associated with cutting wood, and with a similarly ancient history. It is a row of sharp teeth ground on the edge of a metal strip held by a wooden frame or handle. This can be used to cut quickly across the grain of the timber and if the teeth are given a particular set and shape it can easily cut along the grain also. Saws have evolved to take in a myriad of shapes and sizes, designed to carry out specific tasks. The

A *The adze, made from a variety of materials.*
B *The swinging motion used with an adze.*

number and set of the teeth are determined by the saw's use.

Long saw

Usually a two-handed instrument about 1.5–2m (5–6ft) long. Handles fixed at each end allow the saw to be pulled across the work. It can be sharpened to cut across and along the wood grain, and the teeth are set to cut in each direction.

Crosscut saw

A seven-point saw; that is it has seven teeth to the inch (25mm).

A long saw
B crosscut saw
C rip saw
D tenon saw
E Swedish bow saw
F bow saw
G fret saw

Rip saw

Similar to the crosscut, but with longer teeth set at a more acute angle so as to clear longer wood fibres.

Bow saw

Used for rough cutting logs and for lopping trees. The long, widely spaced teeth allow it to cut quickly through timber, green or seasoned.

Replaceable hardened-tipped teeth blades are now widely used with the bow saw.

Tenon saw

For precision work, cutting joints, etc. It has a fine-toothed, 12-point blade (12 teeth to the inch/25mm). This saw is used on well-seasoned wood, usually in cabinet making.

Fret saw

This is virtually a toothed wire, and is used for cutting or fretting intricate and complex shapes from sheet material.

Band saw

A mechanically driven ribbon of a saw blade, it cuts in a continuous loop. Made in a range of sizes and

Triangle and Arches by Alexander Calder, painted steel, 1969.
Rockefeller Plaza, Albany, New York.

tooth characters, it can cut through quite thick regular material in relatively complex patterns. Very large versions of the band saw are used in timber yards to trim whole tree trunks.

Jig saw

This mechanical hand saw, usually electric, has a reciprocating blade and is used for cutting intricate shapes from board.

Sabre saw

Similar to the jig saw but with the blade mounted in a horizontal plane.

Chain saw

A modern innovation, being a chain driven around a bar by means of a petrol (gasoline) or electric motor. Each link of the chain has a cutting edge that gouges out the wood to make the cut. It cuts through timber, green or seasoned, very quickly. It is basically a forester's tool, but is used more and more by sculptors. It can be a dangerous instrument and must be handled with care.

Circular saw

A mechanically driven disc with teeth sharpened around its edge, this is driven by every conceivable motor power, from water to electricity, and can be as small as a few inches or many feet in diameter. Used to cut timber in all its manifestations.

All saws are a potential hazard, and must be treated with respect. They should be kept sharp. a blunt saw is probably more dangerous than a sharp one. Keep the saw clean and put it away when it is not being used.

Wood chisel

This is a straight, flat metal tool held in a wooden handle. It is sharpened at the end and is driven through or across the wood by striking the handle with a mallet or by hand. The flat chisel is the versatile general-purpose tool that is common to all woodworkers, and is made in a wide range of sizes.

Wood gouge

In fact a sophisticated adaptation of the flat chisel. The name describes its use – it gouges the wood. It is directed to cut with the grain or at an angle across it. Gouges are also made in a wide range of sizes and wide variety of shapes, with profiles ranging from a semi-circle to a V-shape. Some gouges are made to be struck with a wooden mallet; others are equipped with handles like engraving tools and are designed to be pushed by hand through the wood.

WORKBENCH

This is a vital sturdy piece of studio equipment. Benches are manufactured to traditional patterns and come with various items of equipment, drawer space, storage space, etc. Whether the bench is bought or purpose-built it should have a strong wooden top, and be of a comfortable working height for the sculptor. It should be fitted with a vice with wooden jaws, so as not to damage the work or the tools.

The size of the bench depends upon the studio space available, but the larger the better and the more stable.

WORKING MODEL

This stage in the development of a sculpture is distinctly different from the making of the maquette. It usually means the definitive model, that determines precisely the final work. It can be made to scale at an appropriate size, one that allows easy reference in which the multiplications of dimensions are direct.

The working model can be actual size as in the clay *River God* by Michelangelo, which is simply copied directly on to the chosen finished material. A working model is usually made for transfer into stone by an artisan carver, and was the practice of most sculptors up until the 1920s when the cult of direct carving without reference to a maquette or working model came about. Bernini was a great practitioner of the working model to be translated into marble by skilled carvers in his studios. He also made working models at full scale to enable him to test the success of the concept of the work. By placing the model on site he could assess the volume and form, effect of the light, etc., and make adjustments accordingly. It is recorded that he continued to make elaborate additions to most of his large-scale works after making such tests. Without this practice and the employment of large numbers of artisans in his studio, Bernini could not have carried out the numbers of projects that carry his hallmark.

There are various methods for making satisfactory transfers from the working model to the final material (see Enlarging), some more successful than others; they include the use of pointing machines that allow for very accurate measurement and precise copying.

As I have mentioned already, the practice of making working models was frowned upon by those people in the 1920s and 1930s who advocated direct carving. The response to the block of stone or wood was considered to be of prime importance, almost of primeval importance. This I believed to have arisen from a misunderstanding of the impact of images from so-called primitive cultures. The influence of the direct carvers was aided by the writers who promoted them and themselves, and so the working model fell into disfavour.

It is interesting to note that Henry Moore, who was one of the advocates of direct carving, produced mostly working models during the latter half of his working life, and worked very much in the manner of Bernini, employing skilled artisans to produce the finished carving or master cast for the foundry. Jacob Epstein, however, produced a famous example of sculpture made via working models at full size, on the BMA commission carried out in 1920 where he designed and placed *in situ* 14 over life-size figures, carved from Portland stone, in 14 months. He employed jobbing carvers to make the copies, allowing him time to lay hands on each piece to do any essential finishing and to cut particular details. He never worked that way again but produced some very large carving by the direct method.

Today vast constructions are made by means of construction companies which specialize in sculpture, companies such as Lipincott in the USA. Such works are based on working models supplied by the artist to an appropriate scale, and then constructed entirely by the company. Many large-scale works now stand in public places, especially in the USA, many over 20 feet high, made in this way.

When a working model is used to make an edition of bronzes or any other kind of casting it is usually referred to as the master copy or master cast.

WORKMATE

This is a portable household workbench that has become a very popular item in many studios. It is in effect a very versatile portable vice, capable of a wide range of applications, being able to hold securely disparate shaped items of different sizes. It is a very useful studio aid.

BIBLIOGRAPHY

ANDRE, Jean-Michel, *The Restorer's Handbook of Sculpture*, Van Nostrand Rheinhold, New York

ANDREWS, Michael, *Sculpture and Ideas*, Prentice-Hall Inc, New Jersey

ANDREWS, Oliver, *Living Materials, A Sculptor's Handbook*, University of California Press

AYRES, James, *The Artist's Craft*, Phaidon, Oxford

BEECROFT, Glynis, *Casting Technique for Sculpture*, B. T. Batsford Ltd, London

CONSTAM, Nigel, *Sculpture*, Collins, London

HAMILTON, David, *Architectural Ceramics*, Thames and Hudson, London

HOFFMAN, Malvina, *Sculpture Inside and Out*, Allen and Unwin, London

HUGHES, Richard and ROWE, Michael, *The Colouring, Bronzing and Patination of Materials*, Crafts Council, London

MILLS, John W, *Modelling the Figure and Head*, B.T. Batsford Ltd, London

MILLS, John W, *Sculpture in Concrete*, Maclaren, London

MILLS, John W, *The Technique of Sculpture*, B.T Batsford Ltd. London

MILLS, John W and GILLESPIE, Michael, *Studio Bronze Casting*, Elsevier, London

MILLS, John W, *The Technique of Casting for Sculpture*, B. T. Batsford Ltd, London

NEWMAN, Thelma R, *Plastics As An Art Form*, Chilton Book Co, Pennsylvania

PADOVANO, Anthony, *The Processes of Sculpture*, Da Capo, New York

PANTING, John, *Sculpture in Fibre Glass*, Lund Humphries, London

PENNY, Nicholas, *The Materials of Sculpture*, Yale University Press

RICH, Jack C, *The Materials and Methods of Sculpture*, Oxford University Press, New York

Scopas Series of Handbooks, Alec Tiranti, London

La Sculpture, Paris Imprimerie Nationale MCMLXXVII, Paris

Sculpture, Modelling and Ceramics, Phaidon, London

SPEIGHT, Charlotte F, *Images in Clay Sculpture*, Harper and Row, New York

UNTRACHT, Oppi, *Metal Techniques for Craftsmen*, Robert Hale & Co, London

VASARI, Giorgio, *Vasari on Technique*, Dover Publications Inc, New York